The ART of Calligraphy

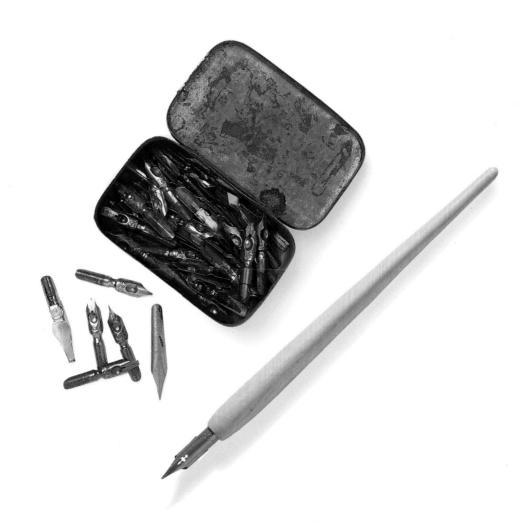

The ART of Calligraphy

DAVID HARRIS

fanctificatione firmetur. P. Secreta.

I d gloziam one tui nominis
annua felta reprentes lac
totalis evozdy. Ipstram abilandi
offermus. luplicative evozantes:
ut cuius munistriq iuce abi seni
mus immerit. suffragus cus ad
tamuracepti. P. Intra canonem.
anc igritur oblatione seni
tuitis mer quam tibi offe
to ego famulus tuus obdienim
quo me dignatus es in munistr
no sacro construiere sacrotam.
observo dne placatus acupias. et

A DK PUBLISHING BOOK

Project editor Louise Candlish Art editor Liz Brown **US editor** Mary Sutherland Assistant editor David T Walton Assistant designer Carla De Abreu Senior editor Roger Tritton Senior art editor Tracy Hambleton-Miles DTP designer Zirrinia Austin Managing editor Sean Moore Managing art editor Toni Kay Production controller Meryl Silbert Picture research Julia Harris-Voss, Jo Walton Photography Steve Gorton, Andy Crawford

> First American Edition. 1995 109 Published in the United States by DK Publishing, Inc., 375 Hudson Street, New York, NY 10014

Visit us on the World Wide Web at Copyright © 1995 Dorling Kindersley Limited, London Text copyright © 1995 David Harris

All rights reserved. No part of this publication may be reproduced, stored in a retrieval system, or transmitted in any form or by any means, electronic, mechanical, photocopying, recording or otherwise, without the prior written permission of the copyright owner.

Published in Great Britain by Dorling Kindersley Limited Distributed by Houghton Mifflin Company, Boston.

Library of Congress Cataloging-in-Publication Data

Harris, David. Calligraphy / by David Harris. -- 1st American ed. Includes index.

ISNBN 1-56458-849-1

1. Calligraphy--Technique. I. Title. NK3600.H28 1995 745.61'97--dc20

94-26722

Color reproduction by GRB Editrice s.r.l. Printed in China by Toppan Printing Co., (Shenzhen) Ltd

Contents

Introduction 6
The Development of Western Script 8
Script Timeline 12
Getting Started 14

ROMAN & LATE ROMAN SCRIPTS

Rustic Capitals 16
Square Capitals 20
Uncial & Artifical Uncial 24

INSULAR & NATIONAL SCRIPTS

Insular Majuscule 28 Insular Minuscule 34

CAROLINE & EARLY GOTHIC SCRIPTS

Caroline Minuscule 38
Foundational Hand 42
Early Gothic 46

GOTHIC SCRIPTS

Textura Quadrata 50
Textura Prescisus 54
Gothic Capitals & Versals 58
Lombardic Capitals 62
Bastard Secretary 66
Bâtarde 70
Fraktur & Schwabacher 74

Bastard Capitals 78 Cadels 80

ITALIAN & HUMANIST SCRIPTS

Rotunda 84
Rotunda Capitals 88
Humanist Minuscule 90
Italic 94
Humanist & Italic Capitals 98
Italic Swash Capitals 100

POST-RENAISSANCE SCRIPTS

Copperplate 102
Copperplate Capitals 106

ROMAN & LATE ROMAN SCRIPTS

Imperial Capitals 108

Script Reference Chart 120
Glossary 122
Bibliography 124
Index & Acknowledgments 125

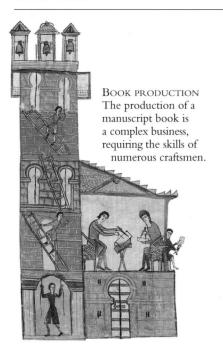

Introduction

For 2,000 years, the western Latin alphabet has developed and been modified by a vast range of social and technological changes, providing a rich and varied resource for the modern calligrapher to quarry. This book charts that development, presenting scripts in both historical and practical contexts. Calligraphers of all levels will be able to explore the origins of each script and understand anew the construction of the 26 letters that we use every day.

MAGNIFYING GLASS
A magnifying glass or
eyeglass is a valuable aid to
examining the letterforms
in historical manuscripts

shown in this book.

Generally, Latin-based scripts fall into two categories: formal — the scripts used as the instrument of authority; and informal — the cursive or quickly written scripts used for everyday transactions. History repeatedly shows formal scripts degenerating into cursive forms, which are, in turn, upgraded, finally achieving formal status as new hands in their own right. The pages of historical analysis in this book chart the rise, fall, and revival of these hands, and explain the emergence of other significant scripts.

Practical advice

Following the historical study of each script is a practical guide to the construction of the letters in that hand. A complete alphabet is included, showing the separate strokes needed to produce each letter, and indicating the probable sequence of these strokes. To the left of this alphabet, the chief characteristics of the script are described and demonstrated in a separate panel.

The appearance of a script is influenced by a range of practical factors, including the cut of the nib used to write it. Full information about tools is given for each script.

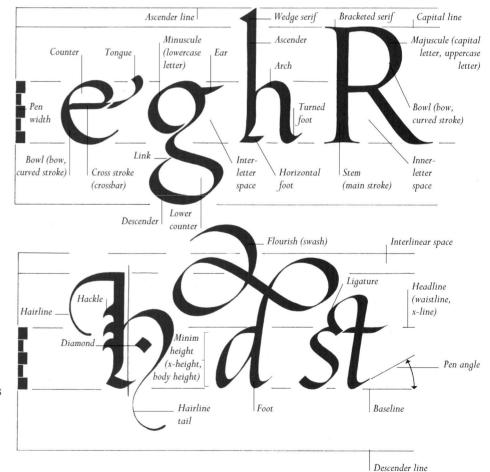

LETTER ANATOMY

In order to identify or construct scripts, it is essential to become familiar with the vocabulary of calligraphy. Unfortunately, there is no agreed standard nomenclature, so terms used in this book are those most commonly favored by calligraphers and paleographers. Alternative terms, including those used by typographers, are shown here in brackets. For example, the

headline is known to some calligraphers as the "waistline" and to typographers as the "x-line." Although these letters represent only a few characters, the terms used to describe their components are applicable to all the letters in the alphabet. A full glossary of the calligraphic terms used in this book is also included (pp. 122–123).

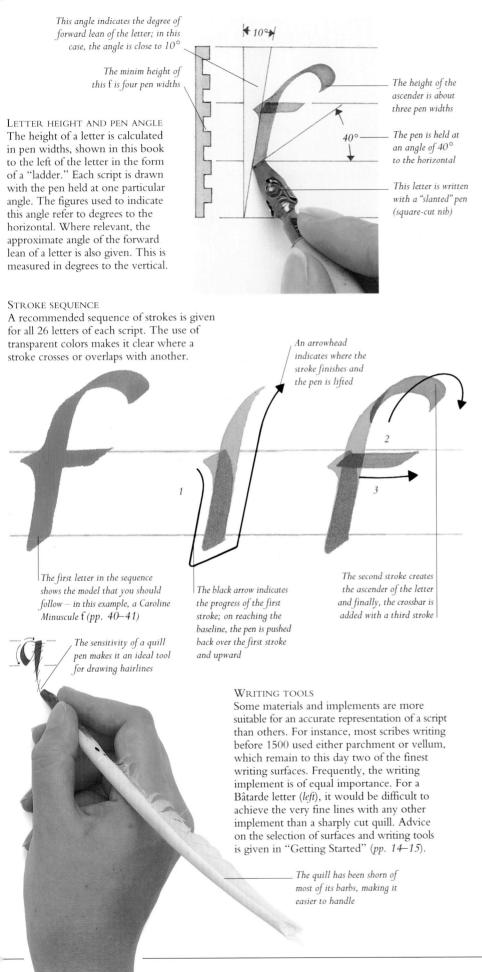

Model scripts

The search for a definitive model for any particular hand is virtually impossible. Within each script there are endless variations, ranging from the excessively formal to the almost indecipherable. Therefore the scripts included in the practical pages of this book are actually a synthesis of various different styles, and should be used to prompt your own personal redefinition of the hands.

Manuscript sources

By definition, a script is a system of handwritten characters, and the majority of the scripts included in this book come from manuscript sources. Where appropriate, an enlargement of a section from an important manuscript is shown, often revealing the basic ductus of the script under scrutiny and giving invaluable clues to the construction of letterforms.

Imperial Capitals

One significant script included in this book must be regarded separately from the rest — the Roman Imperial Capital. A product of the brush and not the pen, it was, until recently, not accepted as a script at all. Due to its complexity and importance to modern calligraphy and typography, it is explored in depth in a section at the end of the book. For the first time, the origins and structure of all 26 letters are demonstrated in an easily accessible way (pp. 108–119).

Left-handed work

The step-by-step letters demonstrated in this book are the work of a right-handed calligrapher. Left-handed calligraphers can follow the same angles and stroke sequences, but might find it useful to adjust their normal writing position to the "underarm" position: tuck the arm inwards, turn the hand to the left, and shift the paper down to the right. Nibs cut obliquely from top right to bottom left can also be very useful.

The Development of Western Script

The first alphabet evolved in Phoenicia in about 1200 BC. This was adapted in the eighth century BC by the Greeks, whose letterforms were borrowed by the Etruscans and, in turn, by the Romans. All subsequent Western scripts have evolved from Roman originals. The scripts in this book are grouped in six categories: Roman and Late Roman Scripts (pp. 16–27, 108–119), Insular and National Scripts (pp. 28–37), Caroline and Early Gothic Scripts (pp. 38–49), Gothic Scripts (pp. 50–83), Italian and Humanist Scripts (pp. 84–101), and Post-Renaissance Scripts (pp. 102–107). The duration of each script is shown in a timeline (pp. 12–13).

PROBABLY the most important event in the history of Western script was the Roman adoption of the Etruscan alphabet. By the first century BC, the Romans had developed several scripts. One was a quickly penned, cursive script used for correspondence, scratched onto a wax tablet or written with a reed pen on papyrus. This hand was influential in the development of the minuscule letter, including the Half Uncial (pp. 38–39). Another key script was the Rustic Capital, used in manuscript, signwritten, and inscribed forms (pp. 16–17).

Imperial Capitals

The third Roman hand produced by the first century BC, now known as the Imperial Capital, was used in both stone-carved and brush-drawn form (pp. 108–109). More than 2,000 years later, the letters of the script provide the basis of our modern capitals.

By the fourth century, the Square Capital, a modified deluxe bookhand, had also emerged (*pp. 20–21*).

Another important script that had its origins during the Roman period was the Uncial (pp. 24–25). Similar in form to the Greek Uncial that preceded it, this was developed for use by the early Christian Church.

ETRUSCAN LETTERS
These letters have been written in Oscan,

an ancient Italian language derived from Etruscan. In addition to the writing system, almost every aspect of Etruscan culture was adopted by the Romans, including the legal and military systems.

This terra-cotta tablet, of a type used to mark property and land, shows clearly recognizable letterforms, such as this character, which resembles an overturned E

THE LATIN ALPHABET

This inscription from the base of the Trajan Column, Rome, is one of the finest surviving examples of Imperial Capitals (pp. 108–109).

The oldest Latin alphabet contained 21 characters, as opposed to the Etruscan 20. By late Roman times, the Latin alphabet had 23 characters, the two additional characters – *Y* and *Z* – having been taken from the Greek Upsilon and Zeta. All of these characters have survived for modern use, with the addition in medieval times of letters *J*, *U*, and *W*.

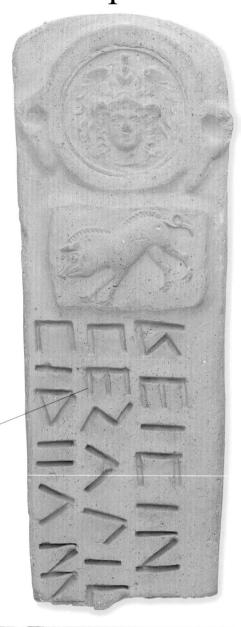

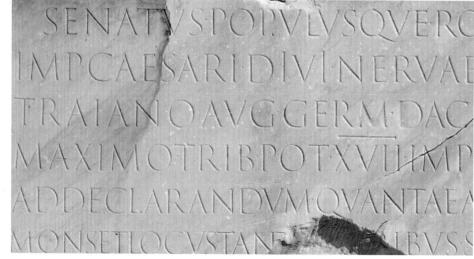

CHARLEMAGNE AND ALCUIN In many ways, the eighth-century Emperor Charlemagne modeled himself and his court on his Roman forebears. Roman influence in the Frankish Empire was particularly important in the areas of learning and scholarship, in which the emperor was aided by a prominent monk from York named Alcuin. Under Alcuin's abbotship from 796-804, the great scriptorium at Tours, France, was founded. Here, the Caroline Minuscule was created (pp. 38-39).

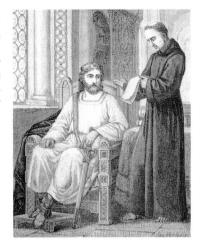

The rounded tip of the penknife suggests that it was also used for scoring lines on the page

The scribe casts a critical eye over the newly sharpened nib of the quill

The production of book covers was a separate craft requiring the skills of a team of workers

The parchment is stretched on a wooden frame and scraped with a curved knife

The finished manuscript book lends

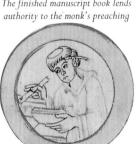

The book is bound and the scribe prepares to make any necessary annotations to the text

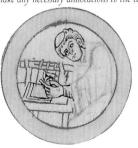

Once the leaves of the manuscript are placed in order, they are stitched together

be trimmed and scored in preparation for the scribe. The text would be planned in detail, with spaces left for the work of the illustrator and illuminator. After the scribe had completed his text, the illuminator would apply the gold leaf, which was then overdrawn by the illustrator. Finally, separate leaves were gathered and bound, and the cover fitted.

The punched holes are joined by scored

lines, between which the scribe would

then write the text

Once dried and cleaned, the parchment is trimmed to size

Teaching from written manuscripts was a key aspect of monastic life

Small holes are punched through the parchment, probably to provide guidelines for spacing

Insular and National scripts

After the demise of the western Roman Empire in the fifth century, numerous hands developed in the kingdoms carved out of the remains of the Empire. Irish scripts, such as the Insular Majuscule (pp. 28–31), derived from Uncial and Half Uncial forms, are now known as "insular" scripts. Elsewhere in Europe, national scripts included the Visigothic in Spain and the Merovingian in France.

The most important means of communication between different nations was the Christian Church, which kept the torch of literacy and learning alive. Irish monks formed many monastic centers in Scotland and northern England, as well as in Luxeuil and Corbie in France, and Bobbio in Italy. Meanwhile, monks from Rome entered southern England and were responsible for the widespread conversion to Christianity there. Caroline and Early Gothic scripts The first empire in the West to emerge from the remains of the Roman Empire was that of Charles the Great (Charlemagne). By the ninth century, his Frankish Empire stretched from the Pyrenees to the Baltic. A reformed hand devised by Alcuin of York became the established hand of the empire – it is now known as the

Caroline Minuscule (pp. 38–39). Outside the Frankish Empire, national hands persisted. In Italy, the Beneventan script was one of the longest surviving post-Roman scripts, used from the mid-eighth century until 1300 (pp. 84-85). In England, the Insular and Anglo-Saxon Minuscules sufficed until the tenth century (pp. 34–35), when the Caroline Minuscule was introduced. Over time, the Caroline Minuscule became more compressed, anticipating the angular, uniform aspect of Gothic letters. This compressed script is known as Late Caroline or Early Gothic (pp. 46–47).

Temetanquam lignum qo plantatum est lettus deturlus aquarti. Gothic Textura scripts

Gothic scripts

By the end of the 12th century, a complex system of Gothic scripts had evolved throughout Europe. For simplicity, these are often divided into two groups: the high-quality (deluxe), formal hands used for both religious and secular book text, and the cursive hands used for documentary work and, from the late 13th century, for vernacular book production. The two most important deluxe bookhands were the Textura Quadrata (pp. 50-51) and its twin, the Prescisus (pp. 54-55).

Bastard scripts

Gothic cursive scripts are known as bastard scripts, and they remained in use until supplanted by the Copperplate in the 18th century (pp. 102–103), some 200 years after the demise of the formal Gothic bookhands. Bastard hands are difficult to categorize, differing from country to country, town to town, and trade to trade. However, general differences can easily be discerned between English (pp. 66-67), French (pp. 70–71), and German (pp. 74–75) models. It was in bastard text script that minuscules and capitals of the same hand first appeared together – with the Gothic Capitals used to begin new sentences and denote proper nouns (pp. 58–59).

Humanist Minuscule This manuscript page from a translation of Pliny's Natural History shows beautifully penned Humanist Minuscule letters. The handwritten Renaissance script was used as a model for type by 15th-century Venetian printers. It quickly replaced the Gothic models favored by Johann Gutenberg, the German inventor of printing with movable type. Textura Prescisus is characterized by the "cut off" feet of certain letters, such as this r from the Windmill Psalter

GOTHIC TEXTURA SCRIPTS This detail from the 13th-century Windmill Psalter shows Gothic Textura Prescisus script (pp. 54-55). Both the Prescisus and its twin script, the Quadrata, were reserved for prestige religious book work.

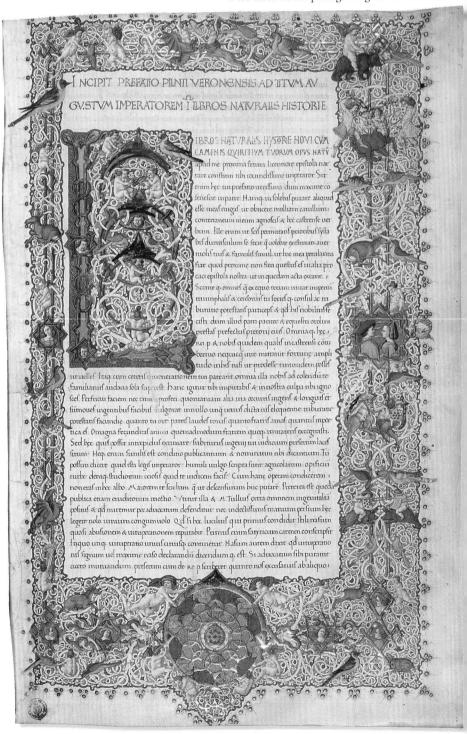

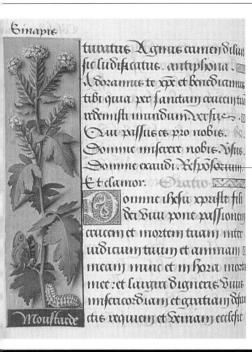

GOTHIC BASTARD SCRIPTS
This page is from a Book of Hours
produced in France after the introduction
of printing. Ownership of a handwritten
book at this time was an indication of
high social status. The elegant script is
a late Bâtarde hand known as *Lettre Bourguignonne* (pp. 70–71), which
contains a mixture of cursive and
Textura elements.

The Bâtarde letter f often has a distinctive forward lean, as does the long form of s

MODERN CALLIGRAPHY
This three-dimensional work, which
measures 9½ by 14 by 2 inches (24 by 35
by 5 centimeters), was created in 1993
by Denis Brown. Entitled *Phoenix*, the
page of Insular letters – reminiscent of the
great manuscripts of Kells and Lindisfarne
(pp. 28–31) – has been penetrated by
electric wires as a metaphor of the
phoenix creating new life from the old.

Italian and Humanist scripts

In Italy, the formal Gothic scripts never really secured a footing. Italian letterforms of this period — generally known by the name of Rotunda (pp. 84–85) — were rounder, with a much more open aspect than their Gothic contemporaries.

By 1400, a revised version of the Caroline Minuscule script known as the Humanist Minuscule had become the established writing hand of the Renaissance (*pp. 90–91*). Eventually, its adaption for type made it the preeminent letterform in Europe, and its use continues to the present day. A variant of the Humanist Minuscule that also remains in use is the Italic (*pp. 94–95*). Devised as a manuscript hand in 1420, it was adapted for type by 1500.

Post-Renaissance scripts

The final script of significance is the Copperplate (pp. 102–103). As the name suggests, this was originally hand engraved or etched on sheets of copper. Typified by delicately joined loops and exotic proportions, this cursive letter could be engraved with far greater ease than it could be drawn. However, in its simpler handwritten form, the Copperplate did have the advantage of being very fast to pen. By the 19th century, it was the standard script of business and education.

Modern calligraphy

A modern calligraphy revival began at the beginning of the 20th century with the pioneering work of Edward Johnston in England (pp. 42–43) and Rudolf von Larisch and Rudolf Koch in Germany (pp. 74–75). Since the 1950s, interest in calligraphy has proliferated in many cultures, both those with and without Latin-based alphabets. During the last 20 years, as calligraphers have explored and redefined letterforms, calligraphy has become an art form in its own right.

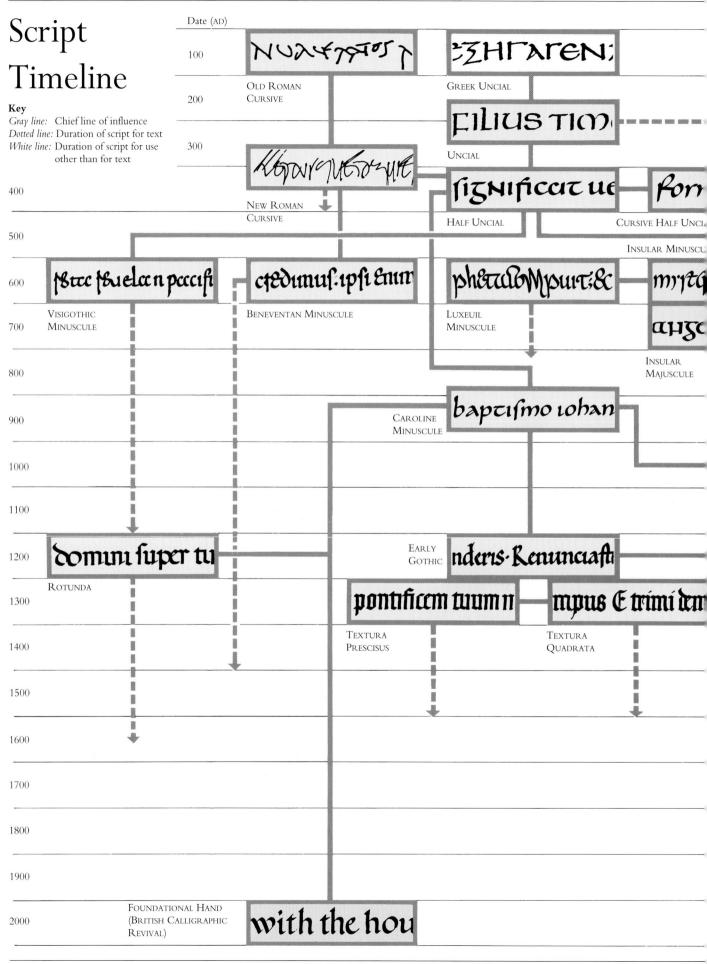

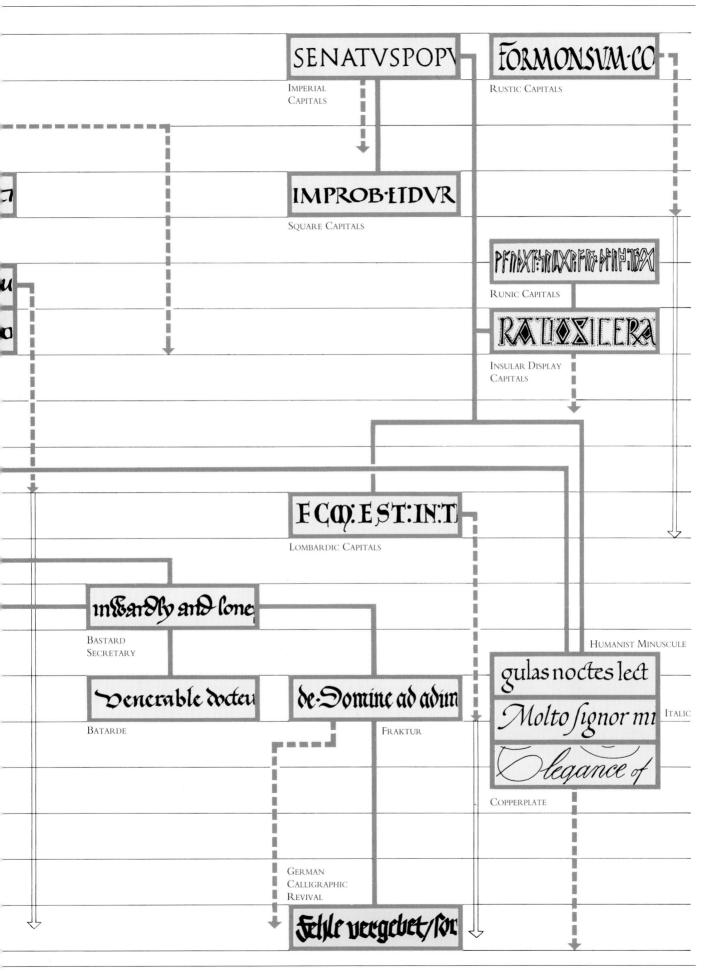

Getting Started

THE ART OF CALLIGRAPHY begins with the tools and materials, and these should be selected with great care. Often, a struggle to achieve a good result is an indication that the chosen surface or writing tool is unsuitable. Due to a widespread revival of interest in calligraphy, there is now an enormous range of pens, paper, and other equipment available. Here, basic information is given on the types of surfaces and writing implements you can use, and also on how to make the two traditional types of pen – the reed pen and the quill.

The reed pen

The reed pen and the quill (opposite) have been used since antiquity. Although both have now been superseded by other writing implements, the reed pen remains an ideal tool for expressive calligraphy. It is usually made from a hollow-stemmed garden cane (Phragmitis communis), but some calligraphers use a synthetic material, such as plastic tubing, instead. A sharp craft knife is required to make a reed pen – always take the greatest care when using it.

1. Cut a length of cane about 7 inches (18 centimeters) long. Use a strong craft knife to make a cut about 11/2 inches (4 centimeters) long to reveal the hollow center of the cane.

2. On the reverse side of the cane, directly underneath the first cut, make a shorter cut to create the flat top of the pen nib. Next, remove any pith from the core of the cane.

3. Return to the underside of the pen and carve shoulders between the two cuts. Make a square or oblique cut across the top of the nib as desired (see "Straight" and "slanted" pens, opposite).

4. Finally, make a longitudinal cut about ½ inch (1.5 centimeters) long through the center of the nib - this will make the flow of ink easy. The reed pen is now ready to use.

Surfaces For practice and trying out initial ideas, a lightweight designer's layout paper is ideal. For more formal work, good-quality paper is important - preferably a smooth, close-grained and acidfree type. Vellum, made from calfskin or goatskin, is the finest material for writing, with parchment a close second.

Use a sm

sable br

built

for draw

poin

WRITING IMPLEMENTS

In addition to the reed pen and quill, there is a huge range of writing implements from which the calligrapher can choose. Felt-tipped pens are ideal for trying out ideas, but for flexibility and economy, detachable nibs are an excellent option. The use of a fountain pen guarantees a constant supply of ink, although a spring-loaded dip pen is more convenient for changing ink

colors easily. A broad-edged brush is essential for constructing

Imperial Capitals (pp. 110-119).

A standard pen holder can fit a variety of detachable

Spring-loaded dip pens are ideal for large-The calligraphic fountain pen is scale work one of the most

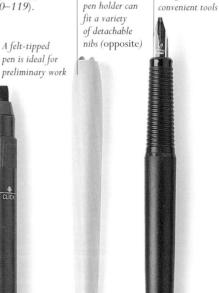

Parchment is made from sheepskin, and is tougher and more fibrous than vellum

A broad-edged synthetic or sable brush is essential for Imperial Capitals

Use a reed pen for expressive calligraphy

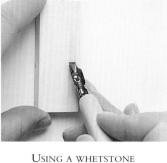

Using a whetstone To sharpen a steel nib, hold the pen at 45° to the whetstone and stroke the top side along the stone.

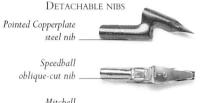

Detachable reservoir for Mitchell nib

The quill is the most traditional of tools

The quill

Although the quill is probably the finest of all writing tools, it is not as convenient as other implements and requires more practice in handling. Being of a softer material than a steel nib or a reed pen, it requires gentler pressure than you would expect, but the subtlety of line that it produces is far superior to that of other pens. Turkey, goose, or swan feathers are the most useful, and duck or crow may also be used for formal work.

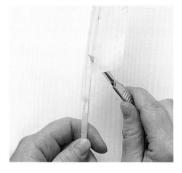

1. Cut the shaft of the feather to a length of about 73/4 inches (20 centimeters) and carefully strip the barbs from it using a scalpel or sharp craft knife.

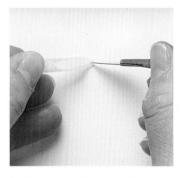

3. Make a short longitudinal cut through the center of the nib to ease the flow of ink. Remove the pith from the center of the pen and any remaining material on the outside.

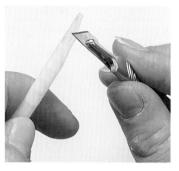

2. Holding the shaft firmly, make a long, sweeping cut on the underside of the quill. Carefully make a second cut to shape the shoulders and pare the edges to form the tip.

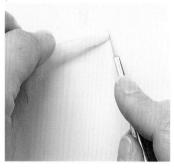

4. Place the tip of the quill on a cutting surface and carefully cut across the shaft to create the nib edge. Make a square cut for a "slanted" pen and an oblique cut for a "straight" pen (below).

"STRAIGHT" AND "SLANTED" PENS

Throughout this book, there are references to "straight" and "slanted" pens. This can cause confusion, as the meaning of these terms appears to be contradictory. The "straight" pen is held horizontally, producing thick stems and thin horizontal strokes. The "slanted" pen is held at an angle of about 30°, creating horizontal and vertical strokes of similar weight.

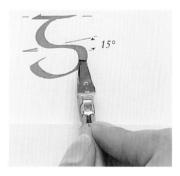

A "straight" pen has an oblique-cut nib, cut at an angle of about 70° to the shaft-it is ideal for scripts such as the Half Uncial (pp. 40-41)

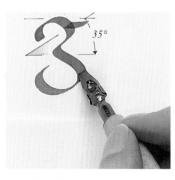

A "slanted" pen has a square nib, cut at right angles to the shaft - it is ideal for scripts such as the Caroline Minuscule (pp. 40-41)

Rustic Capitals

To the Calligrapher of today is sometimes confused by the rich variety of scripts available, both modern and historical, then the opposite must have been true for the scribe of the early Roman period, who had only three basic hands. The first was the magnificent Imperial Capital—the most complex of all scripts, used in stone-cut form on the great monuments of state (pp. 108–109). Second, for everyday needs, there was the cursive script—the quickly executed hand used by everyone writing in the Latin language. Third, there was the Rustic Capital, an elegant alternative to the Imperial Capital and popular with both signwriter and scribe.

From the first to the fifth century, the Rustic Capital was used for deluxe manuscripts, particularly works by Virgil. After the fifth century, it lost favor as a manuscript hand, although its use for titles continued for centuries afterward. As far as is known, the script was not used for Christian literature, and the conversion of Rome to Christianity in AD 313, with its attendant use of the Uncial (pp. 24–25), may be one reason for the demise of the Rustic as a bookhand.

Rustic Capitals also served as stonecut letters, often used in conjunction with Imperial Capitals on the less prestigious monuments. The nib would have been held at a near vertical for the upright strokes

VERGILIUS
ROMANUS,
ECLOGA II
This magnificent and
rare example of a
Virgil manuscript in
Rustic Capitals dates
from the second half
of the fifth century.
The words are

separated by a *punctus* (midpoint), instead of the *scriptura continua* (continuous script) typical of this period.

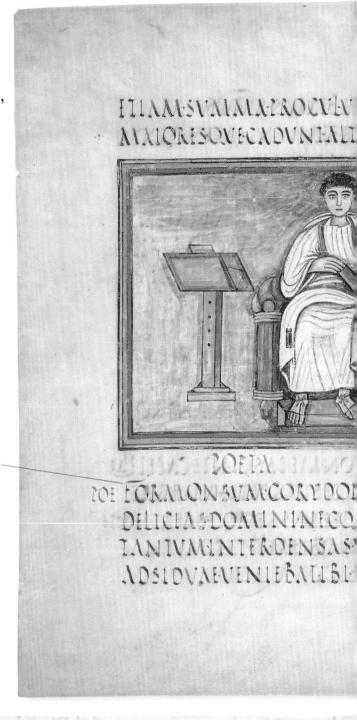

THE HIERARCHY OF SCRIPTS
Rustic Capitals were used for titles
until the late 12th century as part of
a so-called "hierarchy of scripts."
Rustics were used for chapter

Rustics were used for chapter openings, Uncials for the first lines, followed in this example by a fine Caroline Minuscule text (pp. 38–39).

NCIPIT LIBER TERTIVS.

ANCTISSIMA MARIAPAENITENTIS HISTORIAGUATTI nostari inlucam capute élibri etsioblaborem lez entium minuendum anouoinchoatur exordio rerumtamen secundilibri nectura finemrespitat Namquiasuperius suicexpersona euangelistae siucexdnisalustoris utquib;

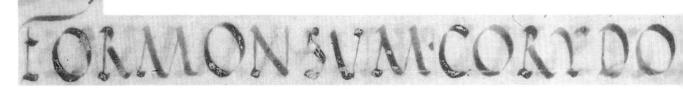

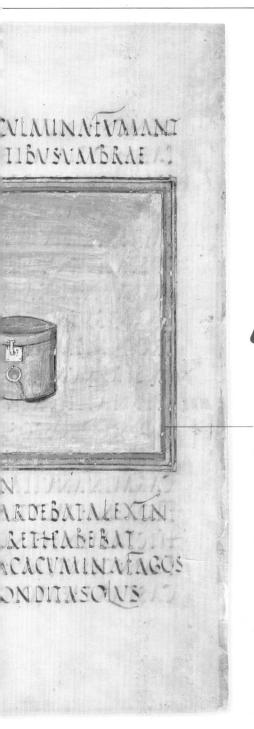

The interlinear gloss has been written in a modern Italic hand (pp. 94-95)

PETER HALLIDAY

This modern version of Virgil's Ecloque VII, written in black ink on cream paper, was penned by Peter Halliday in 1983. Note the contrast he achieves between the broad horizontal and diagonal strokes and the thin verticals.

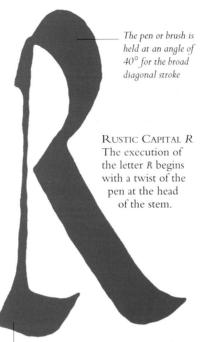

The feet of the letter turn slightly downward before finishing with an upward flick

The portrait illustration shows Virgil sitting beside a lectern, with a capsa for storing scrolls to his left

> Calligraphic flourishes occur on the F, X, and L

Writing materials

The fact that we have evidence of the Rustic Capital in both manuscript and signwritten form shows that two different writing implements were used. The script would have been written with equal fluency with either a reed pen – or after the fourth century, a quill - or a brush. The brush would have been a broadedged, flexible sable, held at a nearupright angle to create the thin stems and broad horizontal strokes.

A simple ductus

The basic difference between the Imperial and the Rustic lies in the complexity of the stroke weight. The strokes of the Imperial are even, with no sharp contrasts in weight. This effect requires numerous changes in tool angle (pp. 110–119). The ductus of the Rustic is simpler to pen, with a pronounced difference in stroke weight between the thick and thin strokes.

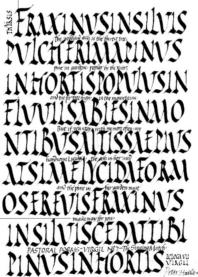

PAPYRUS LEAF Papyrus was the principal writing surface for more than 3,000 years until the late Roman period. It was made by pounding together two strips of papyrus leaf laid at right angles to each other.

DETAIL FROM VERGILIUS Romanus, Ecloga II

Rustic Capitals

 $T^{\rm HE~DUCTUS~OF}$ the Rustic Capital is different from the other hands shown in this book in that the pen angle can be as steep as 85° to the horizontal for the thin vertical strokes. This angle is relaxed to nearer 45° for the foot serifs and diagonal strokes. Therefore, from the top of the stem to the beginning of the foot, the pen must twist as much as 40° , and this transition is the key to well-executed Rustic Capitals. With its serif, thin stem, and broad foot, the L (below) typifies many Rustic letters. The letter height is generally between four and six pen widths, but can reach seven.

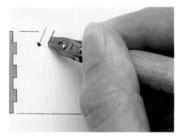

1. Using a square-cut pen nib, begin the serif of the letter L by pushing downward with the broad edge of the nib. The pen angle should be about 65° for this stroke.

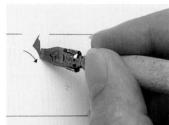

2. Pull the pen downward to the right, while twisting the nib from 65° to almost vertical at the line of the stem. Without lifting the pen, begin drawing the fine stroke of the stem.

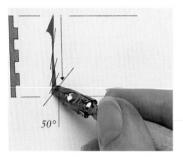

3. At about halfway to the baseline, anticipate the foot serif by gradually turning the pen to about 50°. This will create the distinctive Rustic thickening of the stem base.

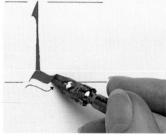

4. Lift the pen, turn it to 45°, and add the foot serif in one firm, downward diagonal sweep. The foot is a major element in the script for it leads the eye forward to the next letter.

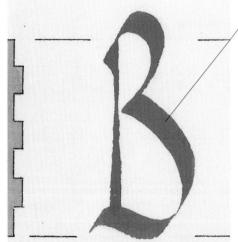

This broad sweeping curve is drawn in one smooth stroke with a pen angle of 45–50°

Diagonal sweep
It is the repetition of the downward sweeping strokes, combined with the near-diagonal strokes of the feet, that gives the Rustic Capital its characteristic rhythm. These strong strokes provide a counterpoint to the fine vertical stems.

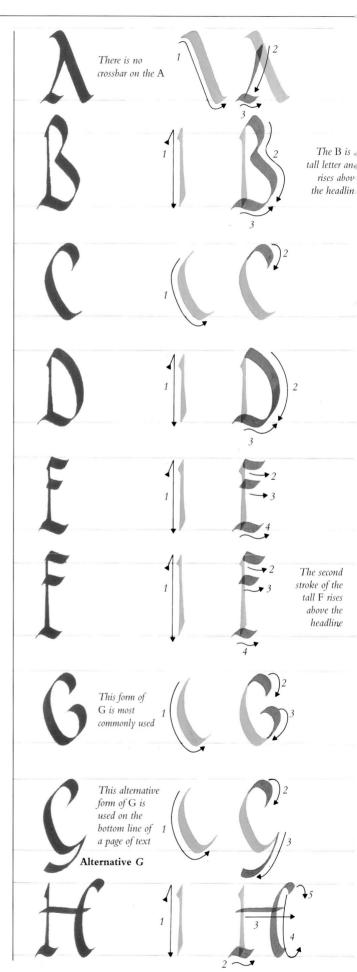

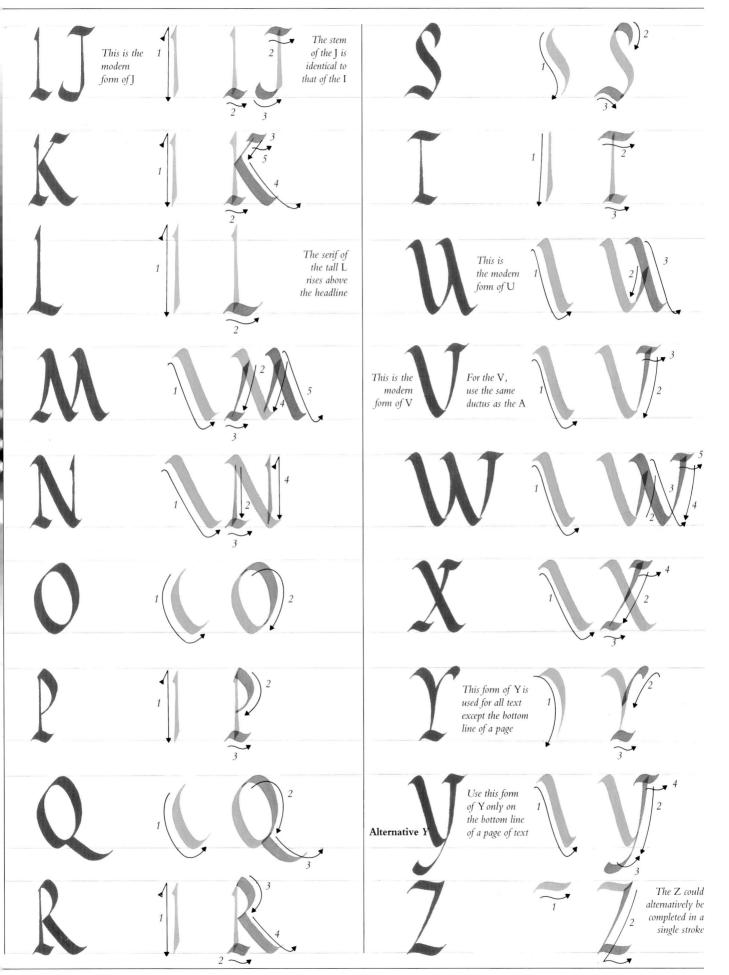

Square Capitals

As a late fourth-century Roman hand without precedent or descendents, the stately Square Capital (Capitalis Quadrata) falls awkwardly into the evolutionary pattern of Roman scripts. Because very few examples survive from this period, the duration of its use and the development of its style is subject to conjecture. The script remains, however, one of great dignity, its grace owing largely to the openness of the letterforms and the clear letter separation.

It is often believed that the Square Capital originated as an attempt to interpret the brush-drawn Roman Imperial Capital (pp. 108–109) in pen-drawn form. However, the thick downstrokes and hairline horizontal strokes of the Square Capital point to the use of a horizontally held pen, in contrast to the angle of 30° required to produce the visually balanced vertical and horizontal strokes of the Imperial Capital. This suggests that the Square Capital may have been derived from another source.

Contemporary influences

It is perhaps more likely that scribes writing in Square Capitals looked for inspiration to contemporary carved lettering, rather than to the brush-created capitals of their predecessors. One such example is the fourth-century plaque in the Church of San Sebastiano, Rome (*right*), in which stroke angle and letter proportion coincide with the manuscript hand.

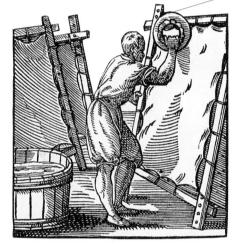

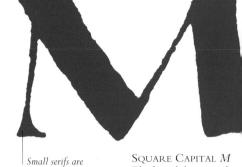

Small serifs are drawn with the corner of the pen nib SQUARE CAPITAL *M*The broad downward strokes of the *M* typify the Square Capital letter.

Parchment was stretched across a wooden frame and the residual flesh removed with a circular knife

PARCHMENT MAKER

In Rome, parchment was an established rival to papyrus by AD 300 and was the principal surface for writing late Roman manuscripts, such as the *Codex Vaticanus 3256* (*opposite*). It was invented in Pergamon, Asia Minor, in response to an Egyptian trade embargo in 197–158 BC that cut off the supply of papyrus.

SAN SEBASTIANO PLAQUE
The inscription on this plaque in the Church
of San Sebastiano, Rome, dates from between
the years 366 and 384. Notice the imaginative
ligatures of certain letters, such as *N-T*, *H-R*, *V-A*, and *T-E*, and the way some letters
have been inserted inside others.

EVTYCHIVSMARTYRCRVDELIAIVSSATYRANNI CARNIFICVMQ VIASPARIERTVNCMILLENOENDI VINEREQVODPOTVITMONSTRAITGIORIACHTISII CARERISINLVVIEMSEQVITVRNOMPOENAPERARTVS TESTARVMFRAGMENTAPARANNESOMNVSADIRET BISSENITRANSIÈRE DIESALIMENTANE GANT VR MITTITVRINBARATHVMSANŒVSLAMTOMNIASANGIS VVLNERAQMEINT VLERAFMORTISMET VENDAPOESTAS NOCTESOPORIFERAT VRBANTINSOMNIA MENTEM OSTENDITLAEBRAINSONTISQUEMMBRATENERET QMERIT VRINVEN VSŒLIT VRFOVETOMNIA PRESTAT EXPRESSITDAMASVSMERIT VM VENRARESEPVLER VM

INMINARIAENEN EREAR INTROBEIDVRISSVR

TO ALIVSTATIVATANDALAMVERBERATAMA ALIMPETENSPELAGOOMINSTRAHITVAHDALINA INMEERINGORAIQARGVENELAMAIINASERRAE NAXIPRIMICVNEISSCINDEBANATISSILFIIGNAI IVANVARIAEVENEREARTESLABOROAINTAVICHT INTROBEIDVRISSVRGENSIN REBNEGESIAS PRIMAGERISFERROMORIALISVERIEREFERRAM INSTITUTIONAHAMGIANDISMQARBNIASAGRA DETICERENTS IT VALLEVIOUN MODODONAN LONKE MONFIFRAMENTISLABORADDITYSYIMALAGGIAIS ESSEL ROBIGOS FOLNIS OLHOR REREMINARYAS HA CARDVVSINTERIVNISEGETESSABITASPERASISA INPOATO TRIBOTIO INTERO NITENTIA CALINIT INHUXLOUVMEISURILISDOMINANANAMANVEN OVOIDNISHEIADSIDVISTERRAMINSPOLIBERERA HISONUNIERREBISANTSHRVRISOPACIONATI ENCEREMIS VAIBRASVOUS QUOCAVERISIMBRE HENMAGNUMALIERINSFRYSTRASPECIABISACEN CONCUSSACHAMEMINSELVISSOLAVEREQUERO DICENDVALLIQUALSINIDVRISAGRESTIBIARMA

Instead of the more common thick first stroke of the letter R, a hairline stroke has been used

The tall L is often found in inscriptions and manuscripts from the late fourth century

DETAIL FROM CODEX VATICANUS 3256
In this detail, it is clear that the script is written without word division and punctuation. On the fine upright strokes of A, N, M, R, and V, the pen is turned from horizontal to vertical, which produces a strong contrast in stroke proportions. The triangular serifs that terminate the hairline strokes have been added with the corner of the pen nib.

CODEX VATICANUS 3256
This manuscript of Virgil's Georgics was written in Square Capitals in the late four

written in Square Capitals in the late fourth century. Perhaps one reason why it has survived is that it was written on parchment instead of the more fragile papyrus. Because of the scarcity of examples of Square Capitals, it is difficult to assess the duration of the hand, and there is no evidence to suggest that it survived beyond the early fifth century.

Surviving examples

Only two known surviving examples of Square Capitals exist, compared to some 400 of the other late Roman bookhand, the Uncial (pp. 24–25). Both manuscripts are deluxe texts of Virgil dating from the fourth century. One is the Codex Vaticanus 3256 (left), housed in the Vatican Library, the other a text from the monastery of St. Gall, Switzerland. From this scant evidence, it is clear that the Square Capital was the most shortlived of Roman scripts, and paleographers are forced to conclude that in terms of the evolution of calligraphy the hand represents a blind alley.

Time-consuming work

One reason for the short life of the Square Capital is the time it would have taken scribes to write each letter. The multiple angle changes and difficult serif constructions require considerable patience (pp. 22–23). While such time-consuming labor may have been acceptable for titles, it would have been highly uneconomical for text, particularly in comparison with the more practical Uncial or the Rustic Capital (pp. 16–17).

BLABOROAINIAVICIT.
NSINREBNEGESTAS

Square Capitals

The Square Capital is characterized by a combination of broad strokes (both straight and curved), delicate hairlines, and neat serifs. Of the dominant broad strokes, the diagonal is the most difficult to draw, involving a pen twist as great as 45° . The simpler vertical strokes are made with a single movement of the pen, held almost horizontally. Upright hairline strokes occur on the letters A, M, N, R, W, and X and can be made by skating the wet ink from the main stem stroke.

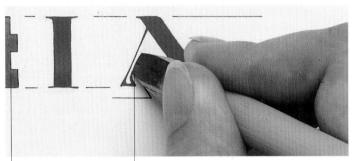

Most Square Capitals are about four pen widths high

The corner of the nib is used for adding the serifs

Basic elements

The Square Capital letter is about four pen widths high, with the letters F and L drawn slightly higher than the rest. The script is best drawn with a reed pen or a square-cut steel nib.

Complex letters

The perfectly balanced letter N is one of the most complex letters in the hand. It consists of one broad diagonal, two hairline verticals and three serifs. A series of angle changes is required for its construction.

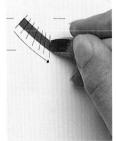

1. Begin the N with a pen angle of about 45°, progressively turning the pen to the vertical as it reaches the baseline.

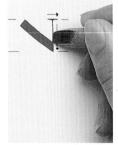

2. Make a small horizontal stroke on the headline, then pull the wet ink downward with the edge of the nib.

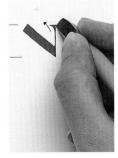

3. Return to the headline and build up the serif under the horizontal stroke.

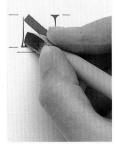

4. Now draw the leading vertical stroke with the corner of the nib and add the serif.

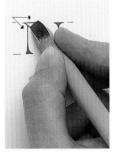

5. Still using the corner of the nib, add the serif at the head of the diagonal stroke.

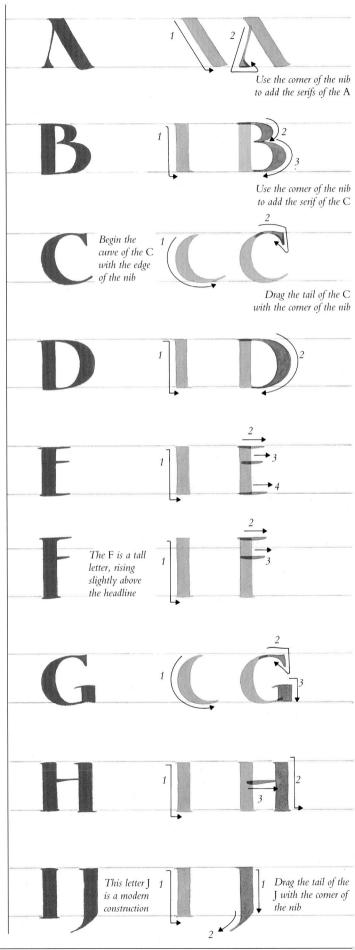

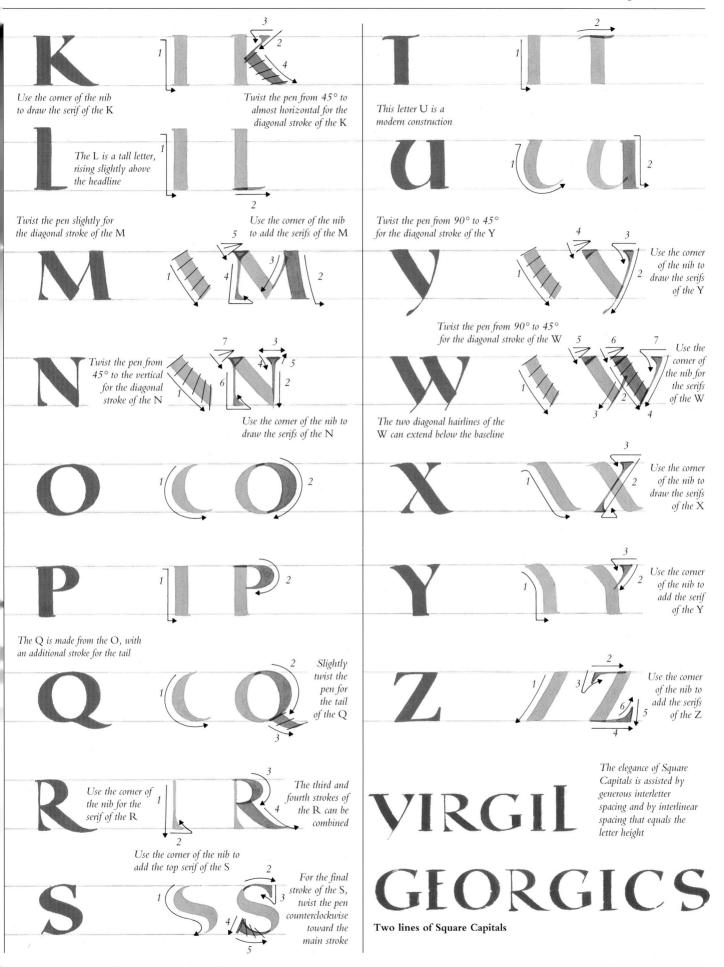

Uncial & Artificial Uncial

The Roman Uncial script (Littera Uncialis) originated in the second or third century AD, possibly in North Africa. Although its beginnings are subject to conjecture, there are noticeable similarities with the Greek Uncial — a curved, functional script that had been used since the third century BC and was the official hand of the Christian Church. By the second century, Christianity was increasing in influence throughout the Roman Empire, and it is likely that the early Christians consciously adapted the Greek Uncial to the Latin language as a script appropriate for their new religion.

THE UNCIAL SCRIPT was brought to southern England from Rome by the missionary St. Augustine in the year 597. Its name, meaning "inch" or "inch-high letter," is attributed to St. Jerome, a translator and compiler of the Vulgate (common) Bible. He possibly used it as a term of derision, in objection to the common practice of wasting parchment by using large letters for deluxe books.

Origins of minuscules

The beginnings of our modern lower-case letters can be discerned in the Uncial script. The letters d, h, and l rise above capital height while i, f, n, p, q, and r drop below the baseline. A further departure from the capitular form is the absence of any elaborate serif constructions. This simplicity makes the Uncial, together with the Caroline Minuscule (pp. 38–39) and the Foundational Hand (pp. 42–43), ideal for learning the basics of pen handling and calligraphy.

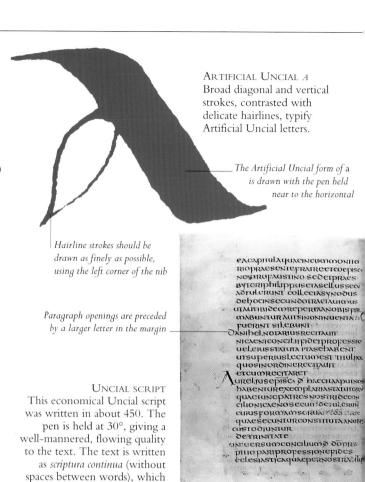

† CENOBRIOX O EXIONI COCRITO

GENERABILES AL GIXTORIS

GUEOD CAPATI CECLESIAE

OCOICAI ALTA FIOCS

PETRUS LANCOBAROORGO

CXTREODIS OCCINIB- ABBAS

OCCUOTI AFFECTUS

PICNORA CONTTO COCI

COCQUE COCOSQ-OPTANS

TANTI INTERCACIONA PATRIS

INCACLIS COCCOORCO

SCOPER DABERELOCCIO

was common for this period.

The revisions in the first line seem to have been made by a later, untutored hand

> The dedicatory verse from the Codex Amiatinus shows typically fine serifed Artificial Uncial letters

CODEX AMIATINUS The Codex Amiatinus Bible was written in Wearmouth and Jarrow before 716. Initiated by Abbot Coefrid, this imposing book is the earliest known Bible in Latin and was produced for presentation to Pope Gregory II. Although mistakes occur in the first, second, and fifth lines, the remaining script is a tour de force of the Artificial Uncial. The finely drawn hairlines and delicate serifs are of a superior quality to those in the Vespasian Psalter (opposite).

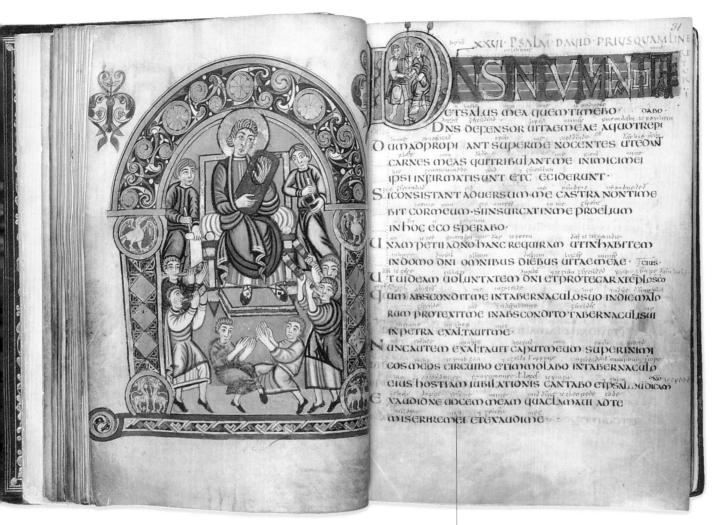

THE VESPASIAN PSALTER
The Vespasian Psalter was written at St. Augustine's Abbey, Canterbury, in the early eighth century. The interlinear gloss contains the earliest known copy of the Psalms in English. The opening *D* from Psalm 26, showing the figures of David and Jonathan, is the earliest example of a historiated initial in Western manuscripts. The illuminated title is written in built-up Roman capitals.

The interlinear gloss was added in the ninth century

DETAIL FROM THE VESPASIAN PSALTER
The serifs in this detail are slightly bolder
than those in the *Codex Amiatinus*(opposite), which indicates the use
of a less sharply cut quill.

 Artificial Uncial

The Uncial hand was well established in Britain by the time the twin abbeys of Wearmouth and Jarrow were founded in 674 and 682 respectively. Soon, the monks of Wearmouth, Jarrow, and Southumbria (England south of the Humber River) were producing manuscripts of a quality equal to that anywhere else in Europe. Their work included the landmark Bible, the *Codex Amiatinus* (opposite). However, the hand they were using was not the Uncial of St. Jerome, but a highly intricate and serifed version, with thin horizontal and thick vertical strokes, and serifs reminiscent of those on Square Capitals (pp. 20–21). This extremely beautiful calligraphic hand is known variously as Artificial Uncial, Late Uncial, or Romanizing Uncial of the Canterbury Style.

Uncial & Artificial Uncial

THE UNCIAL IS A practical writing hand and as such presents no difficulties to pen. The Artificial Uncial, however, is subject to considerable elaboration involving many pen twists and changes of angle. Both forms of the script are regarded as bilinear – written between two horizontal lines – but they show the beginnings of a tendency that ultimately leads to the development of our lowercase letters: F, I, N, P, Q, and R drop below the baseline, and D, H, and L rise above the headline.

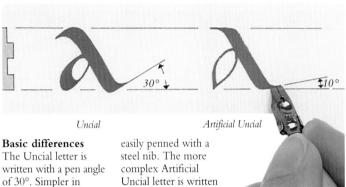

with a pen angle of 10°.

It can be penned with

a steel nib or a quill.

The Uncial letter is

of 30°. Simpler in construction than the Artificial variety, it can be quickly and

Pen twists

In the Artificial Uncial, the characteristic pen twist that occurs on the serifs of letters C, E, F, G, K, L, N, and T can be executed simply and quickly.

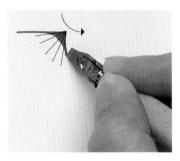

The serif can be left with the blob and indentation still visible

3. The serif can be tidied up by using the corner of the pen nib to draw a hairline stroke back up to the headline. This extension is then filled in with ink.

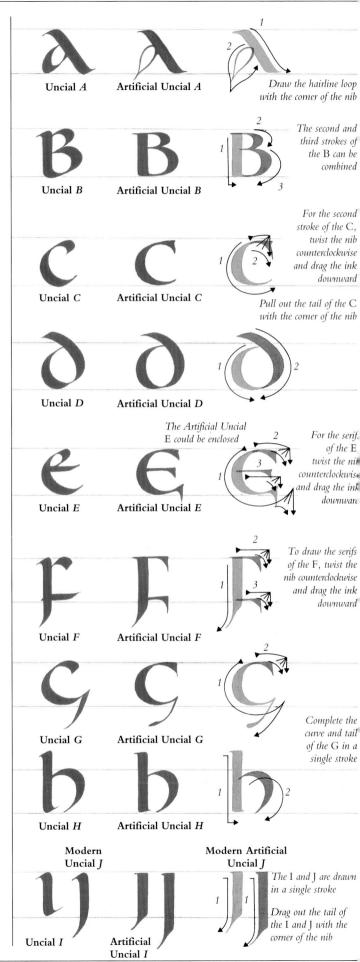

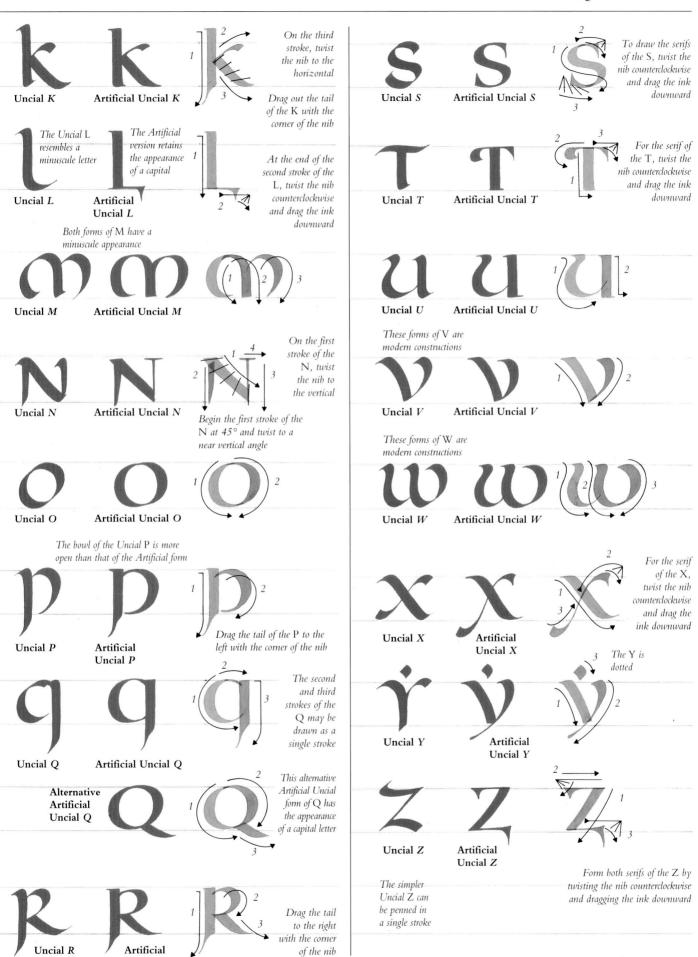

Uncial R

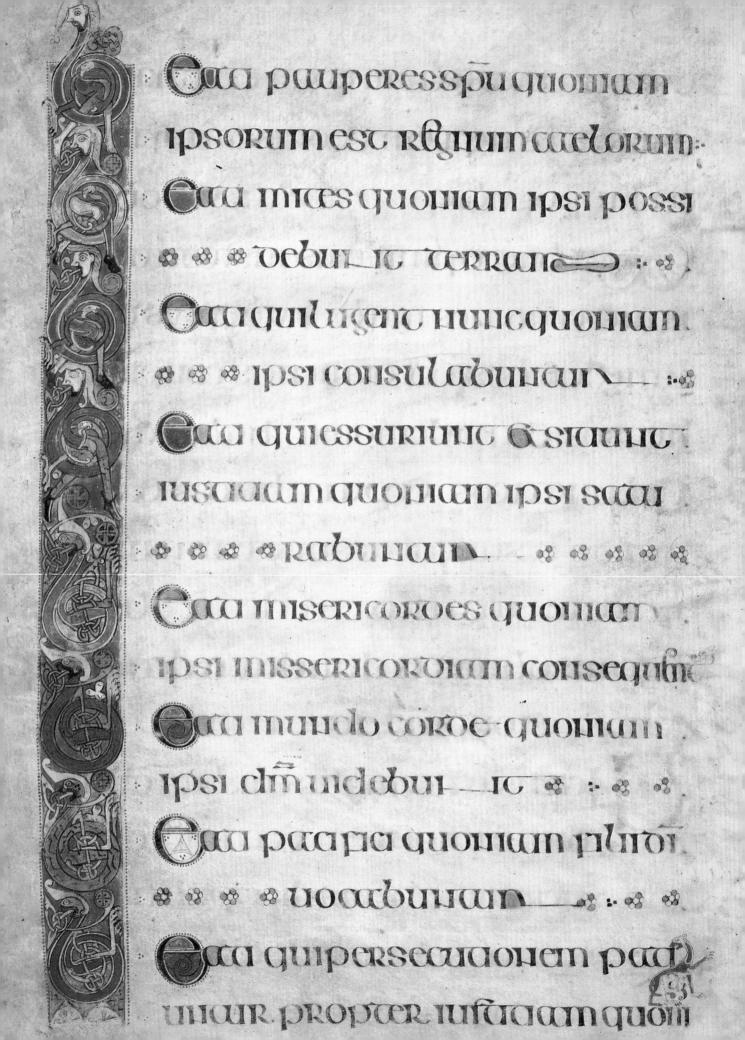

Insular Majuscule

THE INSULAR MAJUSCULE (Insular Half Uncial) derives its name from its origins in the islands of Britain and Ireland. "Insular" is from the Latin for "island," and "Majuscule" refers to the height of the letters, much larger and bolder than those of the complementary Insular Minuscule (pp. 34–35). As a prestige hand, the Insular Majuscule is characterized by letters drawn slowly and carefully, with many lifts of the pen (pp. 32–33). In early medieval Britain and Ireland, it was the favored hand for sacred manuscripts written in Latin, including two of the most beautiful books ever produced, the Lindisfarne Gospels and the Book of Kells.

BEATITUDES PAGE FROM THE BOOK OF KELLS The border of this page from the Book of Kells combines the eight initial *bs* and incorporates both zoomorphic and anthropomorphic decoration. The horizontal stroke over "*spu*" in the first line denotes an abbreviation of "*spiritu*" ("breath of God"). The horizontal stroke is used by scribes for frequently repeated words. Also typical is the letter *n* in the 13th line, which has been extravagantly extended in order to fill space. The use of red dots to outline initials and ornament text is more sensitive and restrained here than in the Lindisfarne Gospels (*pp. 30–31*).

Careful study of the thinner ink on the f gives clues to the construction of Insular Majuscule letters

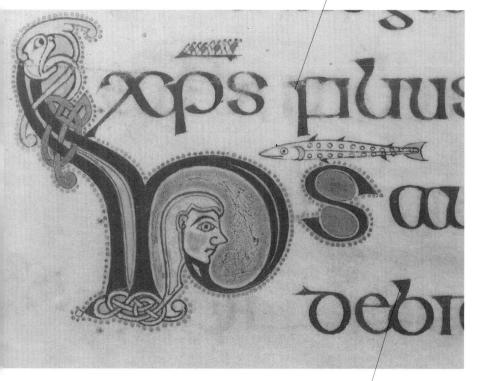

THE GOSPEL OF ST. MARK
The Insular Majuscule is without capitals as they are used in the modern sense. Chapter openings, such as this detail from the Gospel of St. Mark in the Book of Kells, began with a line of display capitals, a Versal (pp. 58–59), or a combination of both. Verses would open with a larger character, which was often decorated or filled with color.

The ascender of the letter b slants to the right, with the wedge serif balancing over the bowl of the letter

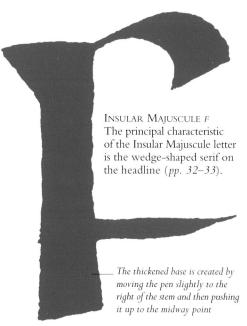

If EVER THERE WAS a golden age of calligraphy, it was the beginning of the eighth century, when Northumbria was one of the most flourishing centers of art and scholarship in western Europe. Interaction between scriptoriums of the twin Augustinian monasteries Jarrow and Wearmouth (see the Codex Amiatinus, p. 24) and that at Celtic Lindisfarne (see the Lindisfarne Gospels, pp. 30–31) led to the production of some of the greatest achievements of medieval art. The Book of Kells

The Book of Kells was written at some time in the second half of the eighth century and the early years of the ninth century, probably by Irish-Northumbrian monks. Its place of origin is shrouded in uncertainty and the first record we have of its existence is an account of its theft in 1006 from the monastery of Kells in Ireland.

The four illuminated Gospel texts in the Book of Kells were written by at least three scribes in insular versions of Uncial (*pp. 24–25*) and Half Uncial (*pp. 38–39*) letters. These would have derived from characters originally introduced into Ireland from the ancient region of Gaul by St. Patrick and his missionaries.

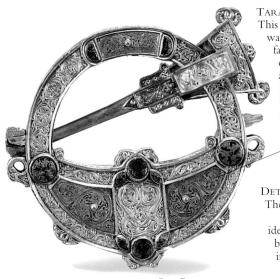

TARA BROOCH
This intricately decorated brooch
was found in Ireland in 1850 not
far from ancient Tara. The date
of its construction is unknown,
although striking design
similarities with some decorated
initials in the Lindisfarne Gospels
suggest an early medieval date.

These curvilinear patterns are very similar to those in the Lindisfarne Gospels (right)

DETAIL FROM THE CHI-RHO PAGE
The interlaced birds and curvilinear
patterns in this detail are almost
identical to decoration on the Tara
brooch. This style of zoomorphic
interlacing is of Germanic origin.

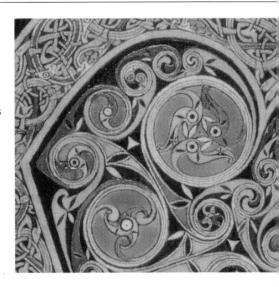

CHI-RHO PAGE
These ornate display capitals on the Chi-Rho
page of the Lindisfarne Gospels make this one
of the most impressive leaves in the book. A
variety of influences are evident, including
Greek, Roman, Half Uncial, and runic.
Eadfrith's use of the capitals is highly creative.
There are three different forms of the letter A on
this page: two on the second line, and a third,
OC form on the bottom line (pp. 32–33).

The Lindisfarne Gospels

The richly illuminated Lindisfarne Gospels date from the end of the seventh century, when the scribes of the Northumbrian monasteries were entering their most productive phase. The Gospels were written in Latin by a single scribe, Eadfrith, who became Bishop of Lindisfarne in 698. An interlinear gloss, providing a translation of the text into English, was added in the tenth century.

The Durham Gospels

In addition to the Gospels from Lindisfarne and Kells, there are a number of other books and fragments from this period that reveal well-executed Insular Majuscules. Among the most outstanding are the Durham Gospels, which are contemporary with those of Lindisfarne and may even have been written in the Lindisfarne scriptorium. The elegant, well-balanced hand is markedly similar to Eadfrith's. Other examples include the Echternach Gospels and the Book of Durrow.

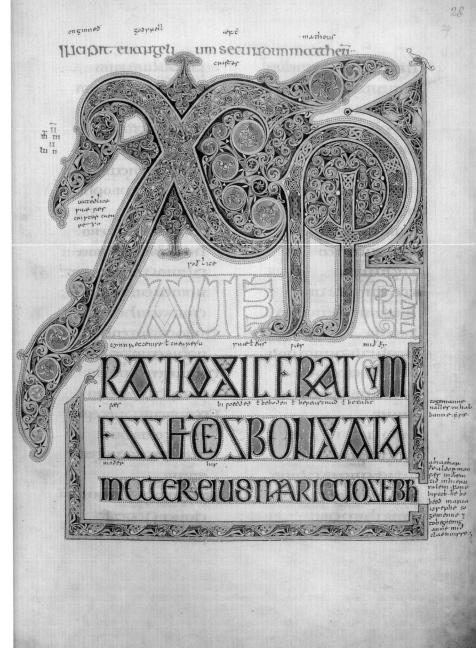

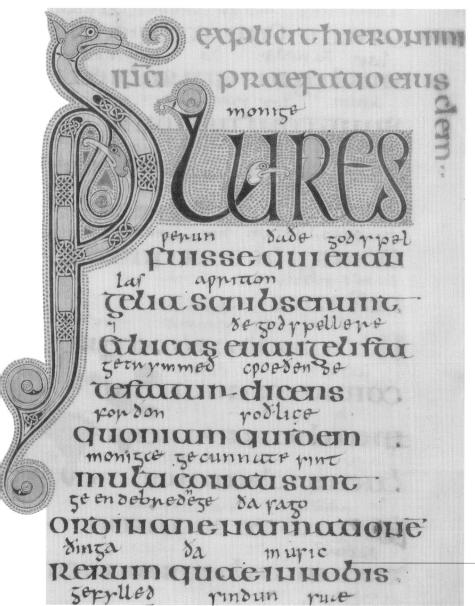

Manuscript decoration

The scholar Giraldus Cambrensis, writing in 1185, remarked: "...you may say this was the work of an angel, not of man...the more I study, the more I am lost in fresh amazement." He was describing, in all probability, the decoration of the Book of Kells (pp. 28–29). This, along with the illustrations in the Lindisfarne Gospels and other works from the early medieval period, represents the highest achievement of Western manuscript decoration. From the carpet pages (pages without text and filled entirely with intricate designs) to the decorated initials and display capitals, and from the shields, trumpets, spirals, and knots to the labyrinthine interlaces that dissolve into fanciful animal forms, the craftsmanship has remained unsurpassed. Today, we view the work with the same wonderment as Cambrensis, often requiring a magnifying glass to study the fine detail.

In this Insular Majuscule text, the distinctive wedge serifs have been executed with a horizontal flick of the pen

St. Jerome's Preface

This beautifully decorated page from the Lindisfarne Gospels shows the preface to the text of St. Jerome. The abundant use of red dots around the initial letters is a common design feature of the book. As well as outlining the letters, the dots provide a background of delicate color. One folio in the Lindisfarne Gospels is decorated with over 10,000 such dots. The rubricated letters at the top of the page indicate the end of one text and the beginning of another.

The interlinear gloss, written in an Anglo-Saxon minuscule (pp. 34-35), is the earliest surviving translation into Anglo-Saxon of the Four Gospels

In this work by Denis Brown, the medieval Insular Majuscule letters have been recreated in a modern context

Denis Brown

This calligraphic piece, entitled Cultural Decomposition, was created by the Irish calligrapher Denis Brown in 1993. At 471/4 by 63 inches (1.2 by 1.6 meters), it is a work of great scale and power. The medieval artistry of the Insular Majuscule letters is seen to be systematically corroded by the symbols of modernity, the electric cables.

Insular Majuscule

The Insular Majuscule is among the most prestigious of scripts. Most letters in this hand are built up from a series of composite strokes and involve multiple pen lifts. Ascenders and descenders are minimal. The script tends to be bold, with a letter height of between three and five pen widths. Clear spaces should be allowed both within and between letters, and interlinear space is generally equal to about two minim heights.

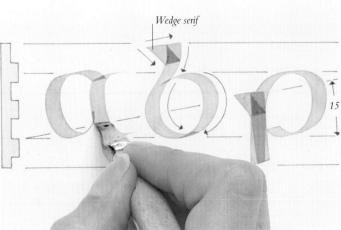

Pen angle and wedge serifs Insular Majuscule letters are written with an oblique-cut nib, with the pen angle between the horizontal and 15°. The distinctive wedge serif, such as that on the b, is made by drawing a short downward stroke at about 45° into the main stem. This can be preceded or followed by a hairline stroke along the top of the wedge.

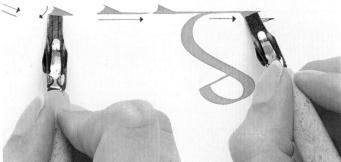

Horizontal darts

To create the darts that appear on letters d, g, t, and z, use the back of the pen nib. Begin by drawing a diagonal stroke to the right, followed by a short

downward stroke, then pull the pen to the right to make a long horizontal stroke. Letters *g* and *t* have a second dart; create this by twisting the pen downward to an angle of about 15°.

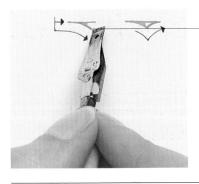

The corner of the nib can be used to draw the short dart

Alternative dart

An alternative technique to that described above is to use the corner of the pen nib to define the dart before filling in the outline with ink.

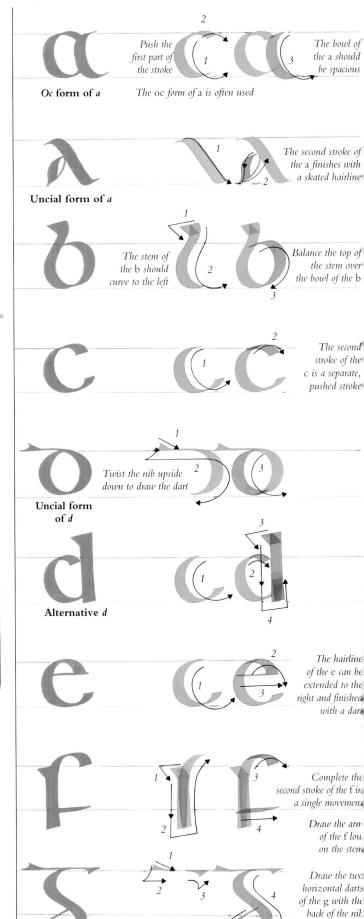

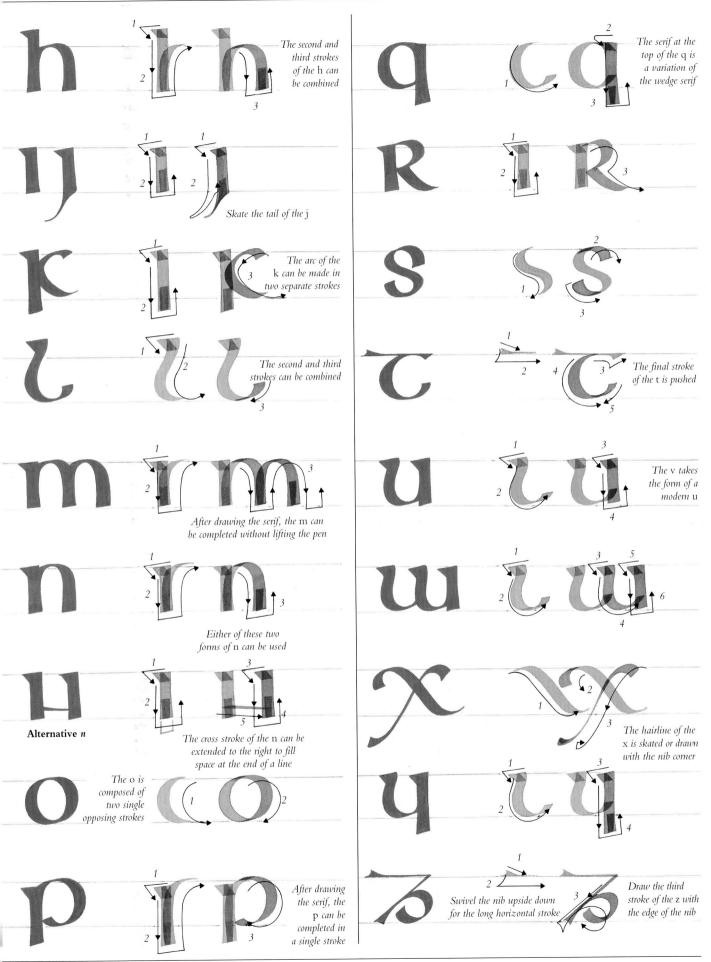

Insular Minuscule

ALONGSIDE EACH OF THE MAJOR prestige formal hands, there has usually developed a functional complementary hand for use in everyday transactions and for writing non-sacred manuscripts. In the case of the Insular Majuscule, the complementary script is the Insular Minuscule, which dates from the late fifth or early sixth century. Its use continued in England until after the Norman Conquest of 1066, and in Ireland it has survived for Gaelic use into the 20th century, making it one of the most enduring of all Latin scripts.

THE INSULAR MINUSCULE was brought to the British mainland from Ireland by St. Columba and was taught at the monasteries of Iona and Lindisfarne. As with the Insular Majuscule, the script was then disseminated on the Continent by missionary Irish monks. The term "insular" is applied by paleographers to indicate a shared culture between Ireland and Britain, free from Continental influence.

Anglo-Saxon hand

After the Council of Whitby in 664, the influence of the Celtic Church weakened in England, Scotland, and Wales and a more distinctive Anglo-Saxon hand began to emerge. Its quality is classed in four grades: hybrid, which contains half-uncial elements and the oc form of a; set, a carefully executed, formal hand; cursive, the basic, functional hand; and currens, the quickly penned, informal hand. By the early ninth century, the most favored hand in southern Britain was the pointed cursive minuscule, and it is this that we use as our model (pp. 36–37).

LINDISFARNE
The Priory of Lindisfarne was founded in 1083,
on the site of the earlier Anglo-Saxon monastery.

POINTED MINUSCULE *P* The name derives from the characteristic long sweep of the descenders. This is in contrast to the squarer descenders of the set minuscule.

The descender

tapers to a point

ARABOLAE SALOMONIST Nounmponit ticulum quianouum Shur locutionip Indipit. utnon picut ppiup difin sulip bonopii malopii

IN PROVERBIA SALAMONIS
In Proverbia Salamonis, a work
by the great Anglo-Saxon
historian Bede, was written in
an Insular Minuscule script that had been
perfected in Wearmouth-Jarrow by 750.

MERCIAN PRAYER BOOK
This page of set minuscule from a Mercian
prayer book was written in the early ninth
century, possibly in Worcester, Britain.
Compare the relatively restrained decoration
of the initial letter with that of Bede's
Historia Ecclesiastica (opposite), which
features spirals, frets, and knot interlaces.

Onacio Primis obsano puppla obnicis proceeding summany Rectornosans analotation of atquilled ram seat Induduacy: countary almirate Ve me misdrum Indiguings bumunculum a demoine digitain. Im omnipochice pitgrem depriecon qui creauto caelum à thuan mane comma quae meis 50. qui-Inommbus asuparomnia debanedic To dimiccate milit omina I cus Insecula porata mea atque chimina quae pai deenabuly hundraray mede usq in hanc action honory. To pacon much by thuist Immsu Ingresqu Inautora Incacco olpacco uellan nottas ream noculares Impou nel Incompone Delinquay commist Roto fimilian acanium of filming our ommpochrechy qui or squi chat

The cross stroke of t is frequently used to link letters

The central stroke the leading stroke

The central stroke of the large e forms the leading stroke of the following p

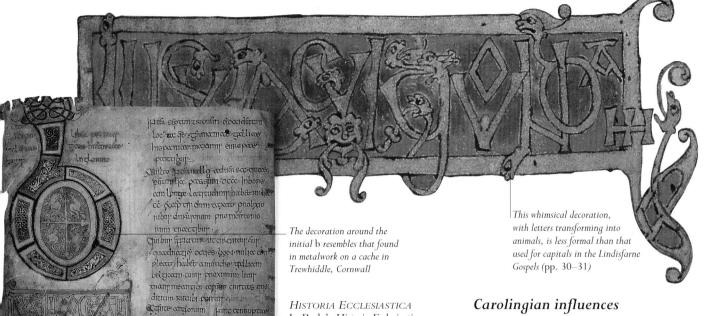

In Bede's Historia Ecclesiastica

southern England in about 820,

the descenders are made in a

single stroke and terminated

by an upward flick. The pen

is lifted between each stroke.

Gentis Anglorum, written in

The state of the s

onum-eccel

infraccogram no cococ.

Httlir poèteomann acces fornacco

morunorum garcif Grone proximo

sue un qui dan sompane faudi

thatatunilum gun que conce

Actività hunder oceano Insunta

The boxed capital letters demonstrate runic influences

The short s is used both medially and terminally

Jun bur bestercure

DETAIL FROM THE *HISTORIA ECCLESIASTICA* Note the two different forms of r that occur at the end f the first and second words of this detail. The use of ne upright form of the letter d in the second line is a eparture from the Uncial form (pp. 24-25).

tumone meeta. Zephalcum houe Letti-cun litoina ber latti kuhou bakentua upecturen pere basah kituman kodu atti peru batah kituman upertum niputu lumpa lumpa lumpa kentua pita upenan merepham aping bara ber pepultum nepes ha teru kepta masam mitata merepham aping bara ber pepultum diku mpaman mitata merepham aping bara ber pepultum diku mpaman mitata merepham aping bara ber perutum merepa perutum mitata merepham aping bara ber perutum mitata merepham aping perutum mitata merepa perutum mitata perutum m

ID SIP MADOLAD

porto home online jehe maje mah ha oph

appean polea genor piture opene piture gelah

mone laene maham hine prom mongangun eh

te ompeon hemro allahibe pade piture gelan

poun youl hees ceningt han go polee afan

poun poul hees ceningt han go polee afan

poun poul hees ceningt pah logur ongone

poun poul hees ceningt han go polee afan

oon youl hees per semona gepan pelone

oon youl feet te mount it pah heest fol gehen pelon

oon youl hees gehyde jaturu ligan on of the

oon youl heest pelone pelone

pour pelone man pelone proposed to gehen pelone

oon youl heest pelone

pour pelone man pelone proposed to gehen pelone

pour pelone man pelone proposed to gehen pelone

pour pelone man pelone proposed to gehen pelone

pour pelone pelone pelone

pour pelone pelone

pour pelone pelone

pour pelone pelone

pour pelon

EXETER BOOK
Written during the second half of the
tenth century in a fine Anglo-Saxon
square minuscule, the Exeter Book
is an anthology of vernacular poetry.

By the tenth century, the Insular Minuscule was undergoing changes, first becoming angular and upright and then, under the influence of the Caroline Minuscule (pp. 38–39), becoming more rounded. By the 11th century, the script had entered its final phase of change, with the letters gaining a squarer aspect.

Changes of pen angle

Throughout the development of the early Insular Minuscule, it was the changes of pen angle that allowed the scribes to express their calligraphic virtuosity. This element of play seems progressively to have diminished as the hand became squarer.

To the modern eye, the long, spiky descenders of the pointed cursive minuscule are made all the more dominant by their appearance on letters r and s (pp. 36–37). The other minim characters are rounded and compressed, which gives a more flowing texture to the page than any of the later Insular Minuscules.

A decorative sweep on the final leg of m may occur at the end of a word or line

Insular Minuscule

CALLIGRAPHERS MAY WELL find the ductus of the Insular Minuscule one of the most satisfying to accomplish. In the Anglo-Saxon pointed minuscule shown here, the characteristic pointed aspect — most noticeable on the descenders — is created by progressively turning the pen to a steeper angle as the stroke is drawn. The pen begins at the headline at an angle of about 40° and on reaching the bottom of the descender has turned to a near vertical. The minim height is about five or six nib widths.

1. Using the edge of a square-cut nib, begin at the headline with a short downward diagonal stroke.

2. Return to the headline and begin the downward stroke with the pen at an angle of about 40°.

3. Continue to pull the pen downward, gradually turning the nib counterclockwise.

4. At the baseline, the pen angle should be about 65°, reaching 75° at the tip of the descender.

5. Once the descender has tapered to a point, begin retracing the stroke before separating at the baseline.

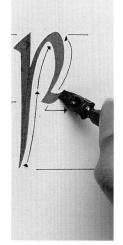

6. On reaching the headline, the pen should be at its original angle. Now proceed with the next part of the letter.

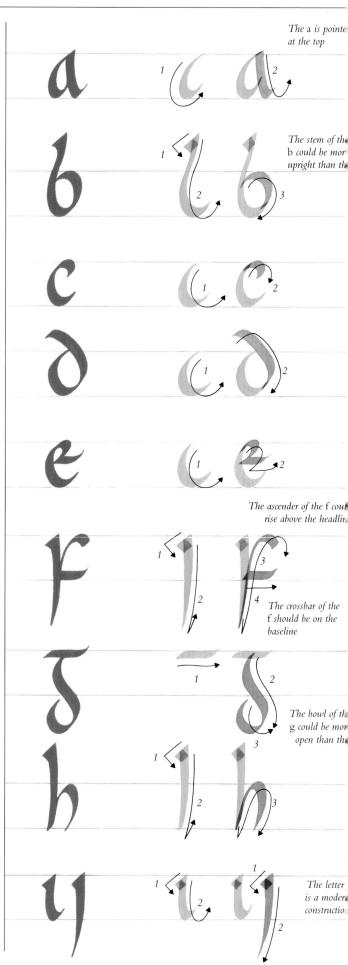

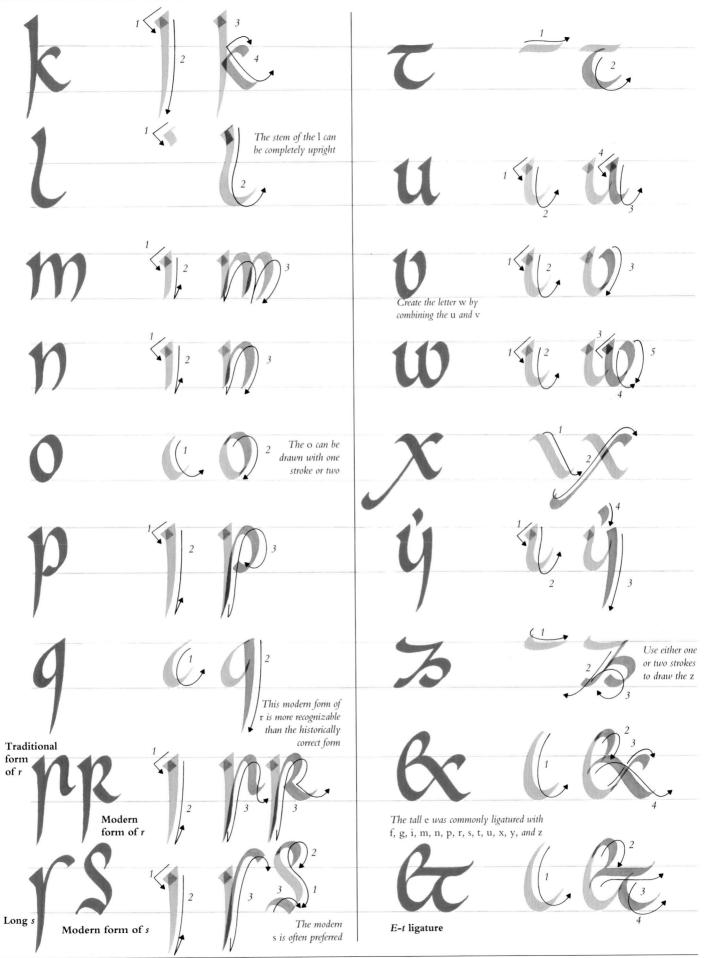

Caroline Minuscule

At first sight, the differences between the Caroline Minuscule (Carolingian Minuscule) and the late Half Uncial scripts (see Vatican Basilicanus, below) are not clear. The main distinction between the two is in the pen used to write them, the Half Uncial using a "straight" pen and the Caroline a "slanted" pen (pp. 40–41). In fact, the Caroline Minuscule was developed in the eighth century as a reformed version of the Half Uncial. It survived in this form until the 11th century, before evolving into the Early Gothic (pp. 46–47) and Rotunda (pp. 84–85).

The ascender is equal in height to the minim

CAI MIN

The Min write squa with helde (pp.)

CAROLINE MINUSCULE *H* The Caroline Minuscule is written with a square-cut nib, with the pen held at 30° (*pp.* 40–41).

The minims adhere strictly to the headline and baseline, creating neat, legible lines of text

BY THE LATE eighth century, Charlemagne (Charles the Great, King of the Franks), had created a Frankish Empire that stretched from the Baltic to northern Italy.

Inspired by the glories of antiquity, Charlemagne instigated a great cultural revival. The prominent scholar Alcuin of York was made Abbot of St. Martins in Tours, France, where he established a scriptorium and Court School. It was here that the existing Half Uncial was reformed to create the Caroline Minuscule.

A dominant script

Characterized by its clarity and uniformity, the Caroline Minuscule gradually became the dominant script in Europe. It arrived late in England, but was adopted in the tenth century for Latin texts, such as the Ramsey Psalter (pp. 42–43).

More than 400 years later, it was rediscovered by Renaissance scribes and, in turn, adapted by Nicholas Jenson and other type designers in Venice for their early printing types (pp. 90–91).

VATICAN BASILICANUS
The Half Uncial is usually defined by its capital form of *N* and by the oblique-cut nib used to write it (*p. 40*). Although lacking in subtlety, this early example, probably from the late fifth century, shows clear and unambiguous letterforms. Note how vertical the script is compared to the slanted Caroline of the Grandval Bible (*opposite*).

upontroumraumicarifelentrudohabitetinepo 951772841 fiver opacrirer edoce quo modocorporation 0230014N haecineomhabitetplenitudo henimcorporali TATITUE modopacreminfilyocredif pacerinfilyohabitan 201110112 NONE X CONTRIBLE PROPERTY OF THE CONTRIBLE PORTER CONTRIB ralicer IN COMMENT CHUINICATENCTURALINEO TAKE diexdo fignificat herreacem dumineodrere Nonautperdignationem autperuolumtatem redpengenerationemi derarettoturcorpora precundumre plenicudinemaneni dumquod interit idecidmper naciuicace matinamina dumert, nequediverium autour ferentaliquide indoere "chaodoorporalicerhabitetinopo" Bequidquidinhabitateorporalyter idipfurecun dumanumroacireto plenioudines quidhumana recourse quidina nium deception um docom un whereh quidminad ferrunanimicacem, cancondiamicreacurams plenicudodiumica punskypercoorporalicer cenuralicem eciaminhood boot fider ruael ezem uccor poragement probable and an expension of the motor intensit document sendumonem implumente ranmo decidene : Necal Tenur naturalin rellegentiam furor innelgiolateramperer habital Hierim in the plent sudodium tratificon рорациони неспиривантностератавитель duminectopy acquirement prays entrudine corporation bles ir adoné dir cervicur i Nechabi cantidum cative appearance la procete dumine a empalaracion de compandiciones de la compandición

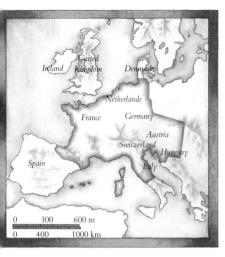

FRANKISH EMPIRE
The extent of Charlemagne's Frankish
Empire in the early ninth century is marked
in red on this map of modern Europe. As
the empire expanded north of the Alps,
Latin and Greek learning was carried with it.

These modern Caroline letters have been written in gouache on a background of watercolor Capital letters, loosely derived from Uncial and Roman models, have been created to harmonize with the minuscule hand

Three white Trees,
equidistant, arise like plumes
From the gray-white floor of mist
Between the mountain chains
In morning sun, which slowly burns
the valley fog away.
The three trees change to sinister mushroom shapes
which stay awhile; and then dissolveIn morning light, a snowfield I could walk upon.
My trees are gone, miles past,
Returned to parent vapor

SHEILA WATERS Composed in 1990 by the English-born calligrapher Sheila Waters, this work is part of a triptych entitled Cloud Conceptions from Above. The text is arranged asymmetrically in a stretched, modern version of Caroline Minuscule. The even height and straightness of the lines allow subtle color changes to be made to the letters without the overall design becoming too busy.

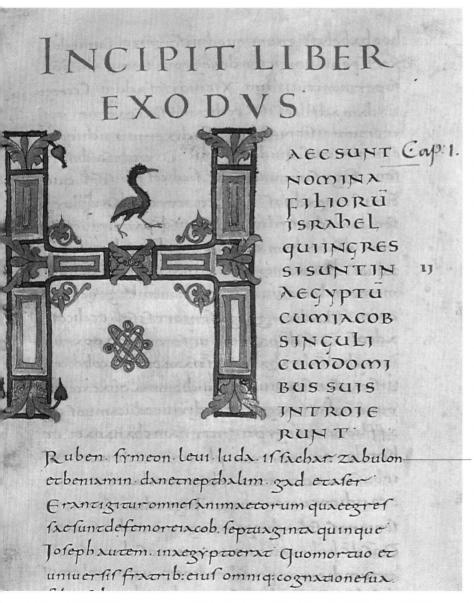

A square-cut nib

The major difference between the Half Uncial and the Caroline Minuscule is in the cut of the pen nib. The earlier hand is written with an oblique-cut nib, which produces an upright letter with contrasting thick and thin strokes. The Caroline is written with a square-cut nib, which produces letters with strokes of even proportions (pp. 40–41).

Textural color

When viewed as a page of text, the textural color of the Caroline Minuscule is quite distinct from that of the Half Uncial. While the Half Uncial letters have a static aspect, the Caroline letters have a slight forward thrust, an element most noticeable on the ascenders and descenders. Minims adhere sharply to the headlines and baselines, which emphasizes the script's ordered and logical aspect.

The square-cut pen nib gives the Caroline Minuscule letters a slight forward thrust

THE GRANDVAL BIBLE

There is a subtle forward thrust to these exemplary Caroline Minuscule letters. They are written between four imaginary lines: the minims adhere to the central two lines, the ascenders reach the top line, and the descenders reach the bottom line. The ascenders and descenders are exactly the same height as the minims.

Caroline Minuscule

The Caroline Minuscule is one of the easiest hands for a calligrapher to master. As a reformed script, its original function was to communicate legibly (pp. 38-39). The letters are without embellishments, the word spaces clear, and the ligatures minimal. Although closely related to the Half Uncial, from which it derives (below), the Caroline is always written with a "slanted" pen whereas the Half Uncial is usually written with a "straight" pen.

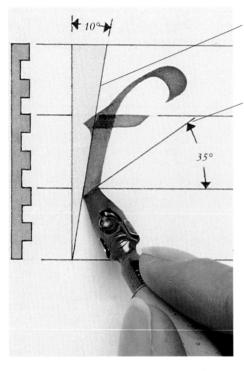

A forward slant of about 10° is characteristic of the Caroline Minuscule letter

The pen angle for the hand is about 35°

Basic elements

The minim height of the Caroline Minuscule is between three and five pen widths, with a further two or three for the ascenders and descenders. The serifs on the ascenders of b, d, h, k, and l have a clubbed appearance. Other letters, such as i, m, and n, have slightly wedge-shaped serifs.

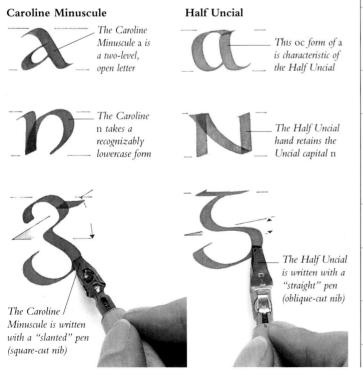

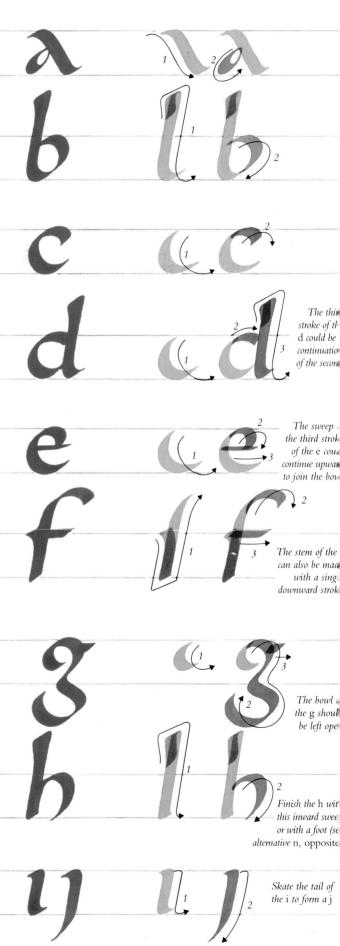

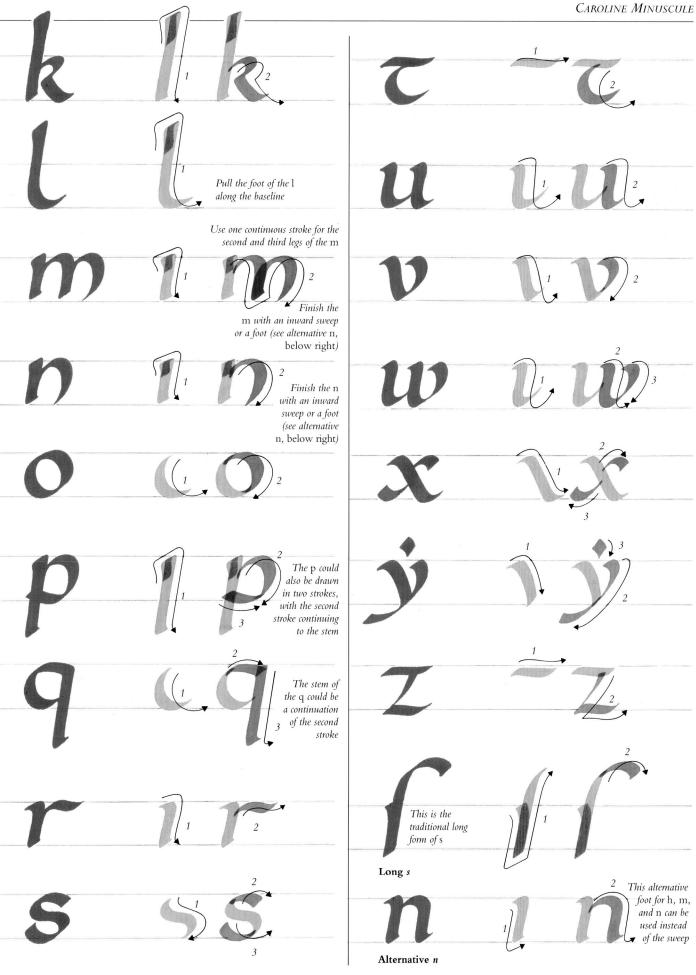

Foundational Hand

No Book on the mechanics of calligraphy is complete without a reference to Edward Johnston's Foundational Hand and its simplicity and integrity. Historically, it belongs to the early 20th century. However, the basis for the script is a manuscript dating from the year 966, the Ramsey Psalter. Believed to have been produced by scribes at Winchester, the Ramsey Psalter was written in a hand now known as the English Caroline Minuscule, an Anglicized version of Frankish Caroline Minuscule (pp. 38–39).

FOUNDATIONAL *P* With the pen held at 30°, the weight of each Foundational letter appears to be evenly distributed between horizontal and vertical strokes.

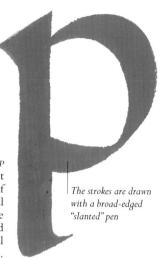

BY THE END OF the 19th century, under the influence of the Arts and Crafts movement in England, a whole new philosophy was emerging among artists and craftsmen. The basis of this philosophy was that the honest construction of an artifact was achieved only by the correct interaction of tool and material. Medical student Edward Johnston readily endorsed this idea and began, in 1897, to experiment in writing letters with a broad-edged pen. In 1899, his work came to the attention of W.R. Lethaby, Principal of the Central School of Arts and Crafts in London, who invited him to teach classes in Calligraphy and Illumination. In 1901, Johnston also began lecturing at the Royal College of Art, London.

In this detail, the "lumped" serif on the l has been completed after the stem has been drawn

THE RAMSEY PSALTER
The Caroline Minuscule of the Ramsey Psalter
was one of the hands on which Johnston's
calligraphic work was based. In Writing and
Illuminating and Lettering, he stated, "it has all the
qualities of good writing in a marked degree, and
I consider it, taken all round, the most perfect
and satisfactory penmanship which I have seen."

O ignare due die isto: sine peccato nos custodire. m sserere nri dne miserere nri :: nat misericordia qua dne sup nos quem admodum speraumus inte nce dne speraul nonconfun hymnus Trium Puero Rum. enedicite oma opera dni dno laudate & super exaltate cum insecula ... B en angeli dni dno b celi dno ... en aquae omfquae sup celos sunt dno. 6 om surtutes dni dno ... B en sol el una dno benedicite stellae celi dno :: en omisimber & ros dno.

This example is made heavy to show the contine of me peti See Source (weep).

Various characters can be developed from it by (a) making lighter (b) making rounber (c) lengthening stems (d) flourishing e.g. back by (service formal formal) for heavy (e) coupling the letters (in test formal formal).

SMALL-LETTER HAND derived from the Foundational hand (1

PLATE 6.—"SLANTED-PEN" SMALL-LETTERS. Note: a "straight pen" form may be developed from these: cf. Plates 10, 14.

1. Foundational Hand: an excellent formal hand for MS. work and to develop into later forms (Ref. W. & L. collo. VIII. & pp. 305-310).

11. Italie Hand: a rapid and practical hand for modern MSS. (Ref. W. & L. collo. XXI. & pp. 311-315).

111. Roman Small-Letter Hand: suitable for the most formal modern MSS. (Ref. W. & L. collo. XX. & pp. 310, 481).

11. and III. may be taken as MS. models for practical adaptation to printing, painting, carving, &c.: cf. Pls. 10, 11, 14, 16.

School Copies and Examples, No. 2. Sir Isaac Pilman & Sons, Ltd., Parker Street, Kingsway, W.C.2

Et hace scribimus vobis ut gaudeatis. & gaudium wstrum t plenum.

Et haccest annunciatio, quant audivinus ab o & annunciamus vobis: Quoniam Deus lux est. A tenebrae in co non sunt ullac.

Worksheet

In 1909, in collaboration with the artist Eric Gill, Johnston produced a series of student worksheets on which he described the Foundational Hand as "excellent for formal MS work and to develop into later forms." On the sheets, he modified the Ramsey Psalter script by making it lighter and more upright, and he included his characteristic "sharp-headed" serifs.

Careful consideration of text size, letter weight, and spacing is demonstrated in this mature work by Johnston

STUDY SHEET

The main text of this study sheet from 1919 is written in Johnston's own fully developed Foundational Hand. The ascenders are more ordered and shorter than those demonstrated on the earlier worksheet (above). Johnston's mastery of Italics (pp. 94-95) is also clear.

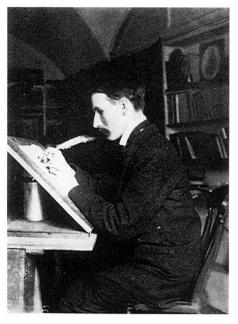

EDWARD JOHNSTON Through his calligraphy, design, writing, and teaching, Edward Johnston became one of the the most influential pensmen of the early 20th century. He is pictured here using his favorite writing instrument, the quill.

"Slanted" pen letters

Johnston was encouraged in his work by Sidney Cockerell, the former secretary to William Morris, who introduced him to the Ramsey Psalter. It was then that he wrote to a friend: "And so the idea came – to make living letters with a formal pen." In his great instructional work Writing and Illuminating and Lettering, published in 1906, he explained his preference for "slanted" pen letters, such as those in the Ramsey Psalter, over the Half Uncial letters written with a "straight" pen (pp. 38-39). Drawn with a broad-edged pen held at 30° , the "slanted" letters had the greater strength and legibility, and the text they produced was of an even weight.

"Sharp-headed" serifs

The most marked difference between Johnston's letters and those of the Caroline Minuscule is the serif on ascenders. Regarding the "pushed" pen strokes used for "lumped" serifs as forced, Johnston advocated the use of "sharp-headed" serifs made from "pulled" pen strokes.

Foundational Hand

ALMOST AS IMPORTANT in calligraphy as the letterforms is the manner in which the words are laid out on the page and the textural effect that they achiève. With its regularity of ductus, in which arches, curves, widths of letters, and internal spaces all relate, the Foundational Hand demonstrates a perfect evenness of texture (see Interletter spacing, below). The pen angle is about 30°, increasing to about 45° for diagonal strokes. Minim height is four or five nib widths, with a further three for ascenders and descenders.

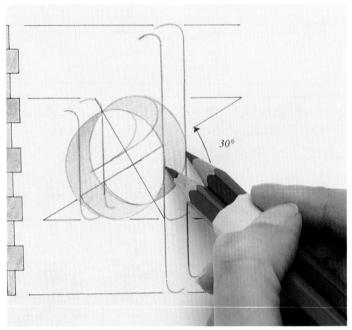

The key letter

As this composite character of a, d, e, n, and q shows, the o is the key letter of the hand. Take time and care to compose its two curved strokes. It is

useful to explore the construction of Foundational letters by drawing them with two pencils taped together. The pencil points relate to the corners of a pen nib.

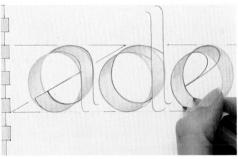

Internal spaces

The elegant oval of space within the letter θ provides the model to which all other spaces in the hand should ideally conform.

Interletter spacing

The spaces between letters should be as consistent as possible. Many scribes train their eyes to study interletter spacing as keenly as the letterforms themselves.

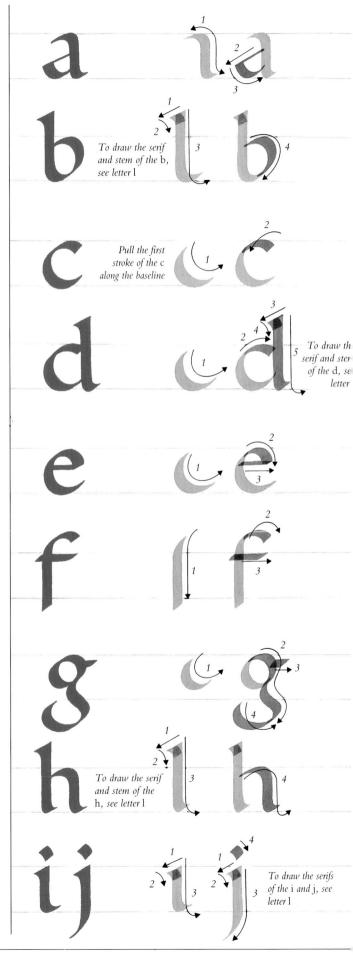

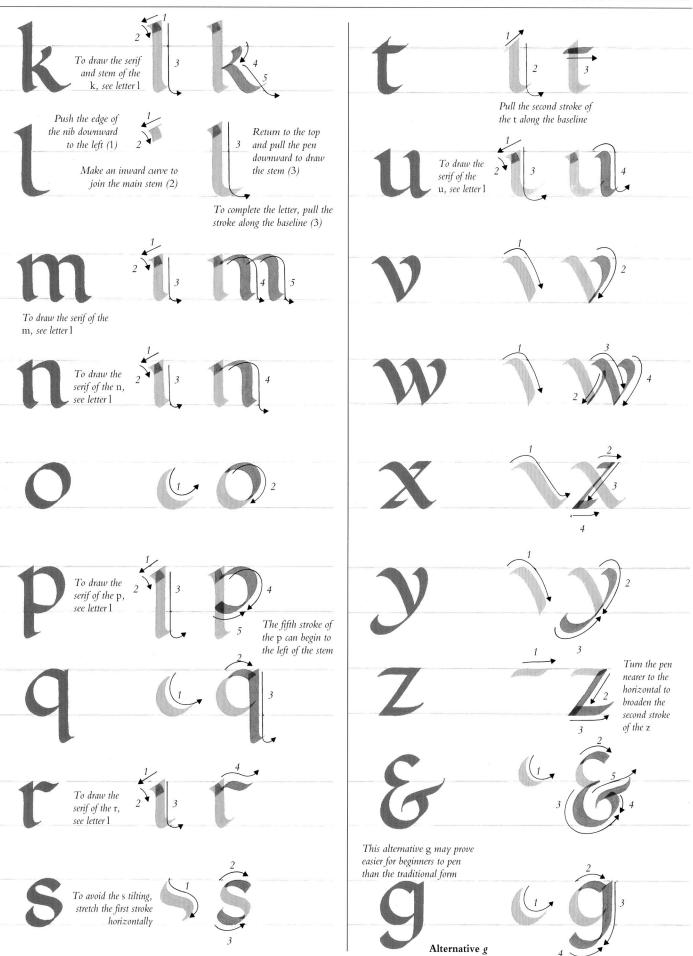

Early Gothic

The Early Gothic script (Proto-Gothic, Late Caroline) was used widely in most of western Europe from the late 11th century to the mid-13th century, a period that fell between the end of the Caroline era and the beginning of the Gothic. In retrospect, the script can be seen as transitional between the Caroline Minuscule (pp.~38-39) and the Gothic Textura hands (pp.~50-57), for it contains characteristics of each, including the rounded bows of the Caroline and the split ascenders of the Quadrata.

THE EARLY GOTHIC script

evolved directly from the Caroline Minuscule. It was more compressed and oval than its predecessor and greater attention was paid to such details as serifs and the feet of minims. Its development was possibly the simple result of scribes altering their pen nibs from square-cut to obliquecut. This produces more angular letters and gives an upright aspect to a page of text. The difference between letters written with a square-cut nib and those written with an oblique-cut nib can be seen when comparing the Winchester Bible with the Grandval Bible (p. 39).

The Winchester Bible

The Winchester Bible is one of the most outstanding books of the Early Gothic period. Commissioned by Henry of Blois, the Bishop of Winchester, Britain, it dates from about 1150. Written with a "straight" pen held at an angle close to the horizontal, the script features short, neat ascenders and descenders. These create more interlinear space than longer ascenders and descenders would, and so aid the reading of the line. Many of the Lombardic Capitals in the Winchester Bible, used both as display capitals and as capitals within the text, are among the finest of their kind (pp. 62–63).

The initial illuminated P
is extended to fill the
length of the column of text

ST. AMBROSE, DE MISTERIIS I This page is from a theological tract probably penned at Rochester Priory, Britain, in 1130. The Early Gothic hand used is in complete contrast to that of the Winchester Bible (above). Although the nib is square, the pen is held at an angle close to 40°, which results in a strong headline, reinforced by a sturdy baseline.

The flick at the head of the stem can either be drawn as an initial stroke or added on completion

The bow is quite compressed, giving it an oval aspect

EARLY GOTHIC B
This Early Gothic letter is written with the pen at an angle of about 40°.

THE WINCHESTER BIBLE
The illuminated initials in the Winchester
Bible represent a high point in medieval
artistry and are the work of six different
illuminators. This initial letter *P* from
the Book of Kings shows Elijah being
consulted by the messengers of Ahaziah.

These rubricated capitals reflect the use of Rustic Capitals for titles, (see The hierarchy of scripts, p. 16)

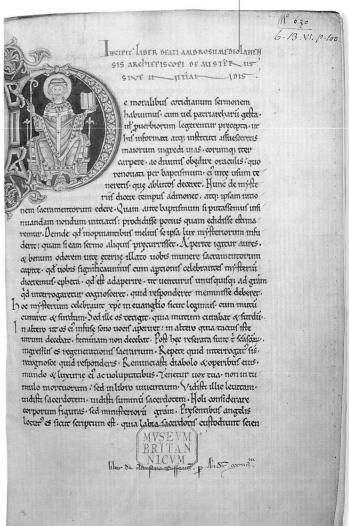

This Versal letter I departs from Gothic conventions in the extreme informality of its decoration

The pen is held at a shallower angle than in the St. Ambrose, De Misteriis I manuscript (opposite),

resulting in less legible lines of text

sacri eloquii inter texti a myste rium tanta est libratione pensans? ut utriusq; partif lance moderata bune nea; mmie discussions pondus deprimat ineq; rurlus toppor inci rie uacui relinquav; Mutte quip pe emf semence tanta allegoria; conceptione sunt grande it glas eas ad solam tenere byfloria nitre." carú nocrcia p suá incuriam puet; Nonnulle uero tta exteriorib; peep til inseruunt ut si quis eas suba lus penecrare desiderac "une quide nil inueniar. sed hoc fibi eva quod forf locuntur abscondat; Unde bene quoq: narramone historica per significatione dicitur: Tollens iacob urgaf populeas urrides & amigdalinas explatants exparte decorticauit eaf detractifg: corticibus in his que expoliata fuerant candor apparunt, Illa û que integra eraf. umdinpmanserunc arq: inhunc modu color effectus e uarrus Vbi & subdicur; Posuirq: eas incanalib:

PAPER MAKER The earliest European paper was made from rags of cotton or linen, which were chopped, soaked, and laid on a sieve before being pressed and dried. In Britain, relatively fine paper was available by the 12th century.

Moralia in Job

The Moralia in Job volumes were completed in 1111 by scribes and illuminators at Cîteaux, France, one year before St. Bernard arrived and imposed the hard discipline for which the Cistercian order became known. The humor and vibrant color in the illustration of this page from the manuscript are in sharp contrast to the work produced in the austere times that followed.

These letters are less compressed than is typical for Early Gothic script

Development of Early Gothic

The Early Gothic script originated in the areas that were subject to Norman and Angevin influence – mainly England and France – before spreading to northern Germany, Scandinavia, Spain, Sicily, and part of Italy. As a result of English influence, more attention was paid to the feet of the minims, which were formally applied, as opposed to the upward flick favored on the Continent. As the script developed, minims generally became more compressed.

The demise of the hand

The hand is perhaps best regarded as the midpoint of the pendulum swing between the Caroline Minuscule, with its clearly defined letterforms, and the Gothic Textura hands, in which the overall textural effect is of the greatest importance. Although influenced by the Caroline, scribes quickly realized that if they increased the compression of letters, they could alter the textural color of the page. This reached its extreme form in the Gothic Textura hands, which quickly grew in popularity and displaced the Early Gothic.

Early Gothic

Chas an upright, compressed aspect. The wedge serifs on the headline of the minim characters help create a strong horizontal stress to the text. The minim height varies between approximately four and six pen widths, and ascenders and descenders frequently equal the minim height. Because of the great variation in pen angle – between 10° and 40° – various types of serifs are included in the hand. The most distinctive of all is the split serif on the ascenders of letters b, d, h, k, and l.

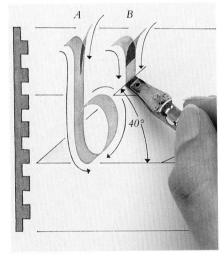

Split serifs

Create the split ascender with a pen angle of 40°, drawing the left serif and main stem first, then adding the thinner right serif (*A*). Alternatively, extend the thin serif into the stem (*B*).

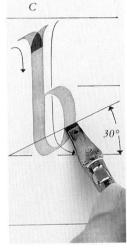

"Filled" serifs

A third method involves "filling" the split serif (*C*). The pen is held at a constant 30° for the whole letter.

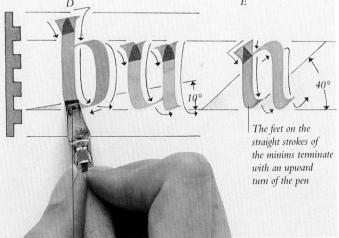

Early Gothic letters should be written with an oblique-cut nib

Flat-headed and wedge serifs

A fourth serif variation is the flat-headed type (D), created by overlapping two strokes, with a pen angle of about 10° . A fifth serif type is the wedge serif (E), which appears on the letters i, m, n, p, r, and u, as well as the modern letters j, v, and w. This can be drawn in one or two strokes, with a pen angle of about 40° .

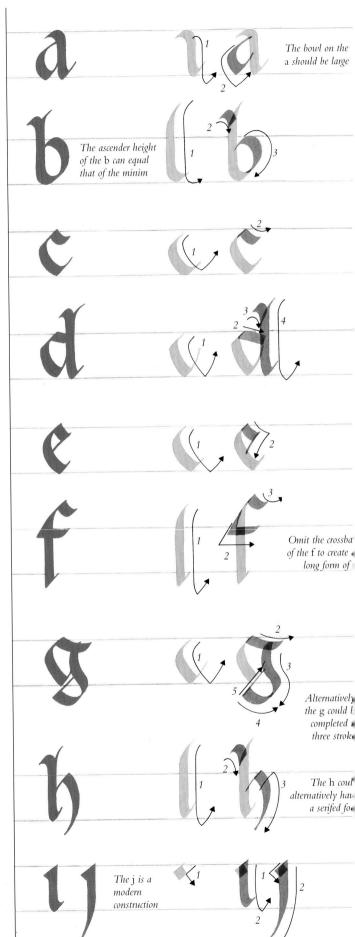

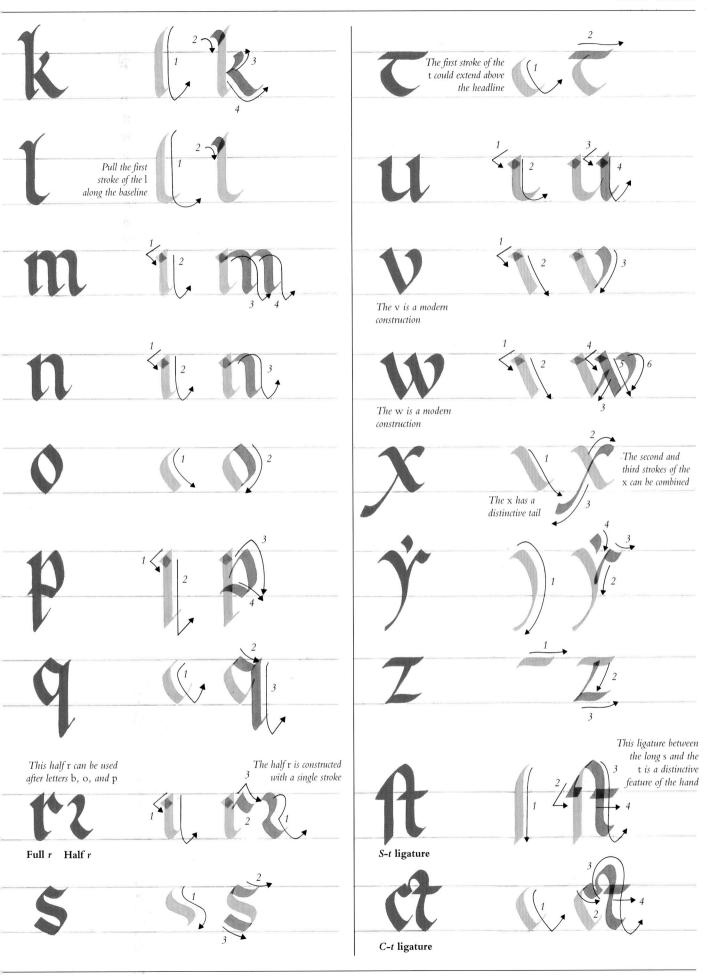

Textura Quadrata

BY THE BEGINNING of the 13th century, the Early Gothic script had evolved into a noncursive, angular hand known as the Textura Quadrata (Black Letter, Old English). The name indicates the woven appearance of the lines of text, "Textura" meaning "an even effect in weaving." The script represented a revolutionary change in calligraphy — after centuries of emphasis on clear letter recognition, individual letters were suddenly subservient to overall textural effect.

TEXTURA QUADRATA
The script's most distinctive feature is the
diamond-shaped terminals of the minim stroke

WITH ITS DENSE, angular strokes and diamond-shaped heads and feet, the Quadrata letter is to many people a graphic embodiment of the Middle Ages. In northern Europe, it was used into the 16th century for high-grade liturgical manuscripts, second only in prestige to its twin script the Prescisus (pp. 54-55). The Quadrata's decline as a deluxe bookhand may have been partly due to its large size; the demand for smaller, handheld books meant that more modestly sized scripts such as the Schwabacher (pp. 74-75) and Humanist Minuscule (pp. 90–91) were more suitable.

However, the Quadrata did survive into the 20th century in the form of cut letters, stained glass letters, and titles on deeds, as well as being much favored in Europe by signwriters, shop owners, and designers of newspaper mastheads.

The outlines of Versals and illustrations were drawn in the spaces provided by the scribe. Here, they have been outlined in metalpoint, with the gold and color still to be applied

The Metz Pontifical This beautifully crafted page from an early 14th-century French manuscript shows Textura Quadrata at its finest. The even, textured effect of the page is created by the scribe's meticulous regulation of spacing and minim height. The scribe may have used an oblique-cut nib, which would have made the production of fine hairlines particularly easy (pp. 14–15). Note the rubricated capitals S and I, preceded by the capital P. The stroke through the stem of the P denotes the contraction of "par," "per," or "por."

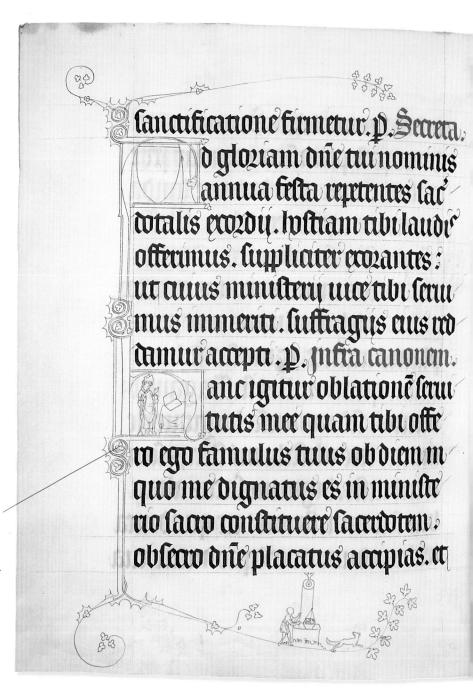

PAINTING IN CHICHESTER CATHEDRAL This painting shows Bishop Sherbourne asking King Henry VIII to confirm the charter for Chichester Cathedral. By the time the work was painted in 1519, the Quadrata would have been obsolete as a text hand, appearing only occasionally in brushdrawn form. The artist has padded out the text on the top line with awkward word breaks. The inelegance of these breaks is possibly exacerbated by the requirement to place the word "Rex" above the King's head.

he split ascenders nd descenders have en exaggerated, articuarly on the escender of the p

The text on the book includes the alternative Gothic a, which features a double crossbar through the counter

DETAIL FROM PAINTING IN CHICHESTER CATHEDRAL The split ascenders and descenders are particularly developed in this brush-drawn version of Quadrata, but they have caused the artist difficulties - the ascenders of letters d and t clash with the descenders of the ps.

.b.n.d.a.k.P e.f.g.ha.k. 1.m.n.o.p.q.r.2.f. s.t.v.u.x.y.z.t.2. 1.f.f.f.t? X lis lanchficetur no

Dotting the i and j

The characteristic uniformity of the Textura Quadrata letter produced an interesting innovation that remains in use today. Having been easily mistaken for other letters, the *i* was distinguished from other letters by a flick (by the late 14th century, this had developed into a dot). The letter i also doubled up as a j, acquiring a tail when so used. This change, along with the late medieval inclusion of the w and the differentiation of v and u, gave us our 26-letter modern alphabet.

Script status

The status of a script is generally determined by the number of separate strokes and pen lifts used in its creation, a distinction particularly discernible in the Quadrata. Generally, the more angular and compressed the letters, the more strokes will have been used in their construction. A useful indicator of the status of a script is the bowl of the letter a, which can range from a low-status, almost cursive form (see the Painting in Chichester Cathedral, above) to a high-status, rigidly geometric form (see the Gothic alphabet, *left*).

he counter of this large ersal P is used to display he coat of arms of the

Orgemont family

Many strokes, such as those

on the s, terminate with hairline flourishes

evidence of the scribe's

virtuosity

GOTHIC ALPHABET This page from a combination calendar, hymnal, and prayer book belonging to Guillaume d'Orgemont dates from about 1386. It shows an almost complete alphabet of Textura Quadrata letters, including two versions of a, r, and s. Close examination of the letters suggests that the pen may have been cut obliquely. his would explain the thickness of the stem strokes, compared to the diagonal and diamond strokes.

Textura Quadrata

T HE ESSENCE OF THE Quadrata is the formal, upright letter with strokes differing as little as possible from one another. Curves are practically eliminated and the formality is only broken by the use of hairlines. These include the skating strokes that occur on letters a, e, and r, created by dragging the wet ink with the corner of the nib. The Quadrata's other distinctive features are the split ascenders and the diamond feet on the minims, applied with only a small space between each one.

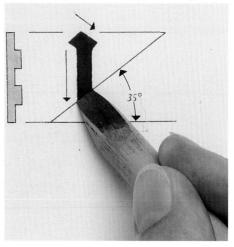

Basic elements A "slanted" pen (square-cut nib) is used for the Quadrata. The pen is held at an angle of between 35° and 45° for stem strokes, adjusted to a shallower angle for connecting strokes. Minim height is generally about five pen widths. The relatively large size of the letters makes the use of a reed pen ideal.

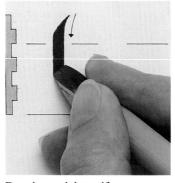

Drawing a right serif
The split ascender is drawn in two
strokes. Begin the right serif above the
headline, pulling the pen down to the
left to complete the stem in one stroke.

Adding a left serif
The pointed left serif should be a
little shorter than the right one. Turn
the nib onto its left corner and use
the wet ink from the previous stroke.

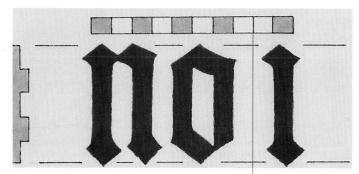

Textural effectTo achieve the ideal textural effect of Quadrata, innerletter spaces and interletter spaces should each equal the width of one stroke.

Interword space should be equal to about two nib widths

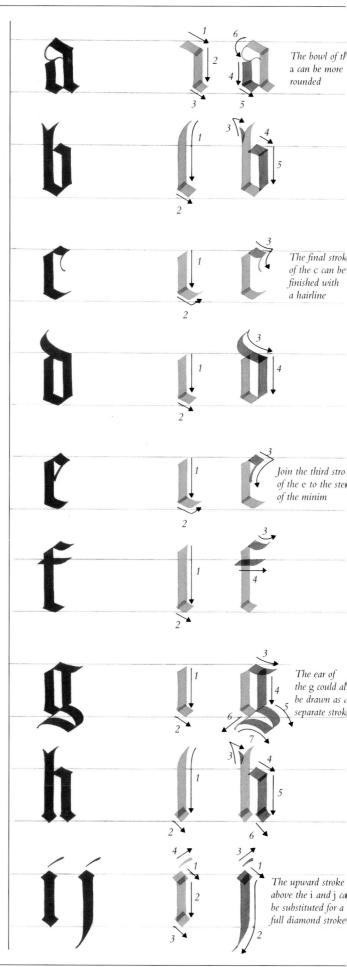

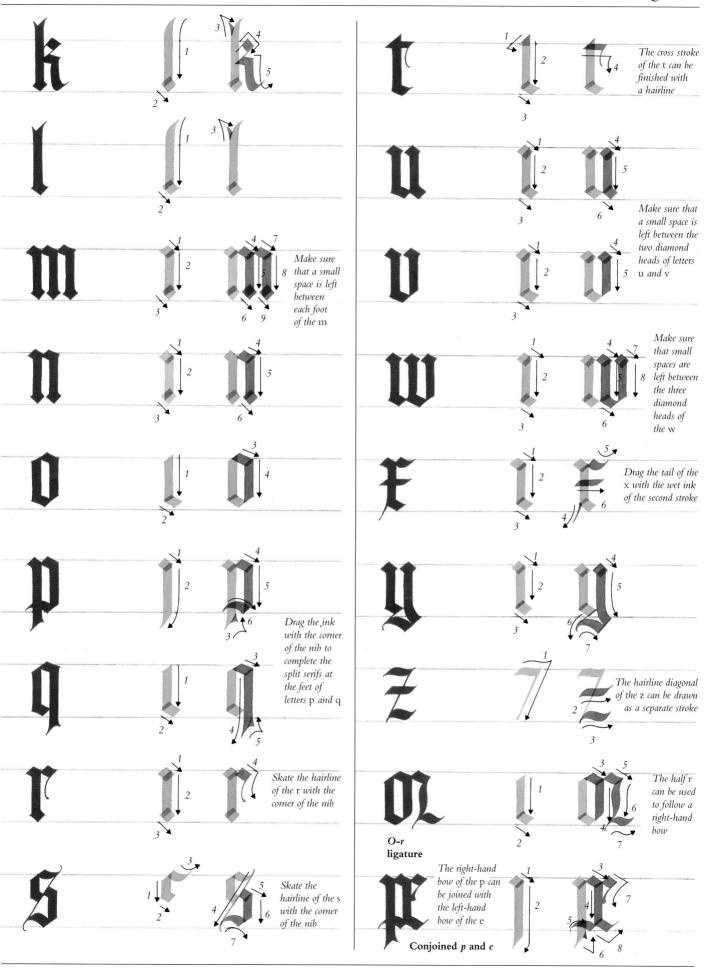

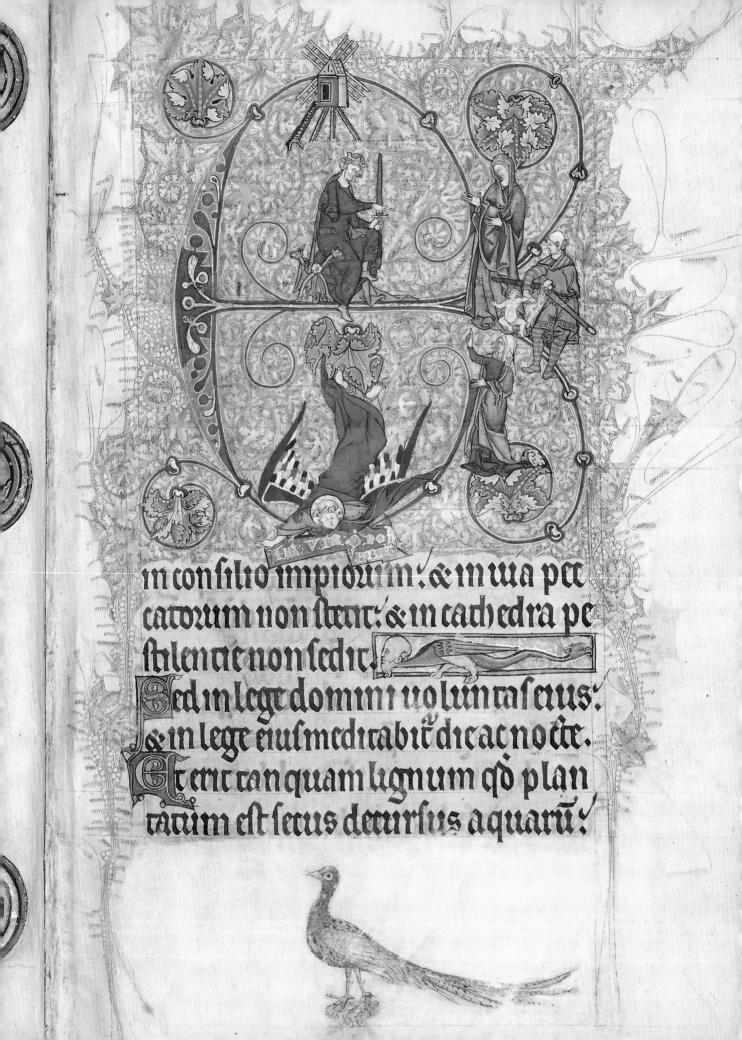

Textura Prescisus

Letter) paralleled that of the Quadrata (pp. 50–51), both its duration as a bookhand and in the development of its extural style. The two scripts even used the same Capitals and Versals (pp. 58–59). The chief difference between them is indicated by the adjunct to the Prescisus's name, vel sine pedibus, which translates as "with its feet cut off." This refers to the square-ended bases of the minims and descenders in the hand.

THE WINDMILL PSALTER

The Windmill Psalter was written in England in about 290. In this folio from The Judgement of Solomon, the ine filigree work is done with a sharply pointed quill. The teep pen angle used for the text produces typically angular etters with strong diamond heads and narrow minim trokes. Stroke width and inner letter spacing are equal.

The Ormesby Psalter The Ormesby Psalter, written in East Anglia in about 1300, reveals a more relaxed form of Prescisus than that used in the Luttrell Psalter.

THE LUTTRELL PSALTER
The Luttrell Psalter, written for a wealthy Lincolnshire landowner in about 1325–35, is Prescisus writing at its finest. The lines of text are uniform and condensed, each stroke neat and precise. The thickening of minims toward their base may indicate a twisting of the pen (pp. 56–57).

The square-ended Prescisus feet contrast with the diamond feet of the Quadrata

TEXTURA PRESCISUS M
The flat feet of the
Prescisus are the script's
most characteristic feature.

BOTH THE **QUADRATA** and the

Prescisus evolved from the Early Gothic script (pp. 46–47) and date from the end of the 12th century. Paleographers are uncertain which of the two came first. It is possible that the Prescisus originated in southern England and spread to France, where scribes were inspired to develop the Quadrata. The arrival of the Prescisus was most likely the result of a creative burst from a calligraphic virtuoso. But, whatever its origins, the script rapidly became a more prestigious bookhand than did the Early Gothic.

A precise hand

As a script, the Prescisus was a tour de force. It was as precise as its name suggests and scribes needed a particular dexterity to use a "slanted" pen to produce the artificially constructed feet that imitated the work of a "straight" pen (pp. 56–57). The length of time it took to write the script meant that it could be used only for large, prestigious books. Use started to decline during the late Gothic period, and the introduction of printing saw its final demise.

The half r is used when following a curved stroke

The diamond heads of minims are characteristic of both Textura scripts

The half r is used when following a curved stroke

The diamond heads of minims are characteristic of both Textura scripts

The half r is used when following a curved stroke

DETAIL FROM THE LUTTRELL PSALTER

DETAIL FROM THE LUTTRELL PSALTER

Textura Prescisus

The Principal difference between the Quadrata and Prescisus is the latter's absence of diamond feet on letters a, f, h, i, k, l, m, n, r, t, and u. The split ascenders on b, h, k, and l are reduced or flat-headed (square-ended) and, in the extreme form of the script, letters a, c, d, and e are even deprived of a baseline stroke. Prescisus has a more clearly delineated base than the Quadrata and interlinear spacing is approximately equal to the minim height.

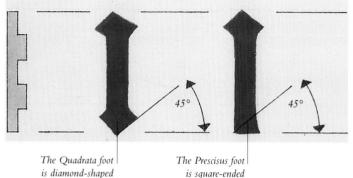

Common elements

The Quadrata and Prescisus have a number of elements in common. Both have a minim height of

approximately five pen widths and both are written with a "slanted" pen (square-cut nib). A pen angle of 45° is usual for both Textura scripts.

Filled feet

To make the square foot, draw the stem at an angle of 45°, then add the outline of the foot by dragging the ink with the corner of the nib. This is then filled in with ink.

Pen twist

A second method involves twisting the pen from 45° to the horizontal in a short, swift movement (*above*). Alternatively, begin twisting at the top of the stem (*above right*).

Numerous tools are suitable for writing Prescisus letters, including the reed pen

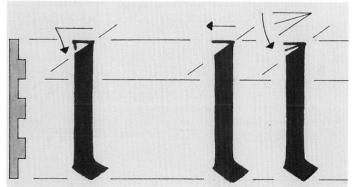

Flat-headed serifs

Like the square feet, the flat-headed serifs are created artificially with a "slanted" pen. One method is to outline the serif with the corner of the nib before filling it in with ink (above left). Alternatively, add the serif by twisting the pen downward from the horizontal of the ascender line to the 45° angle of the stem stroke (above).

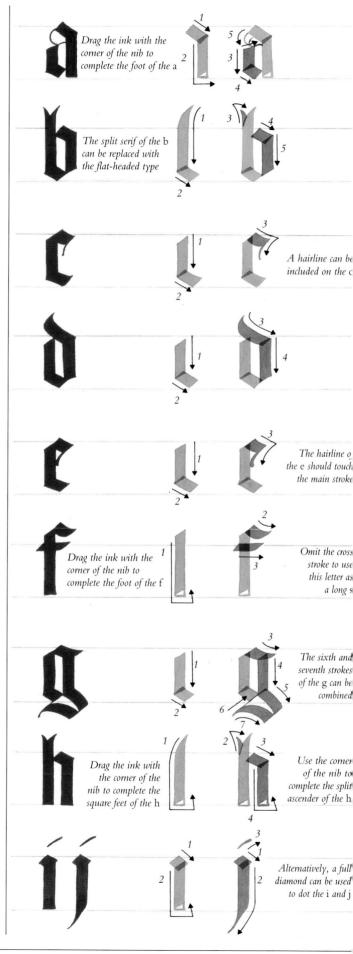

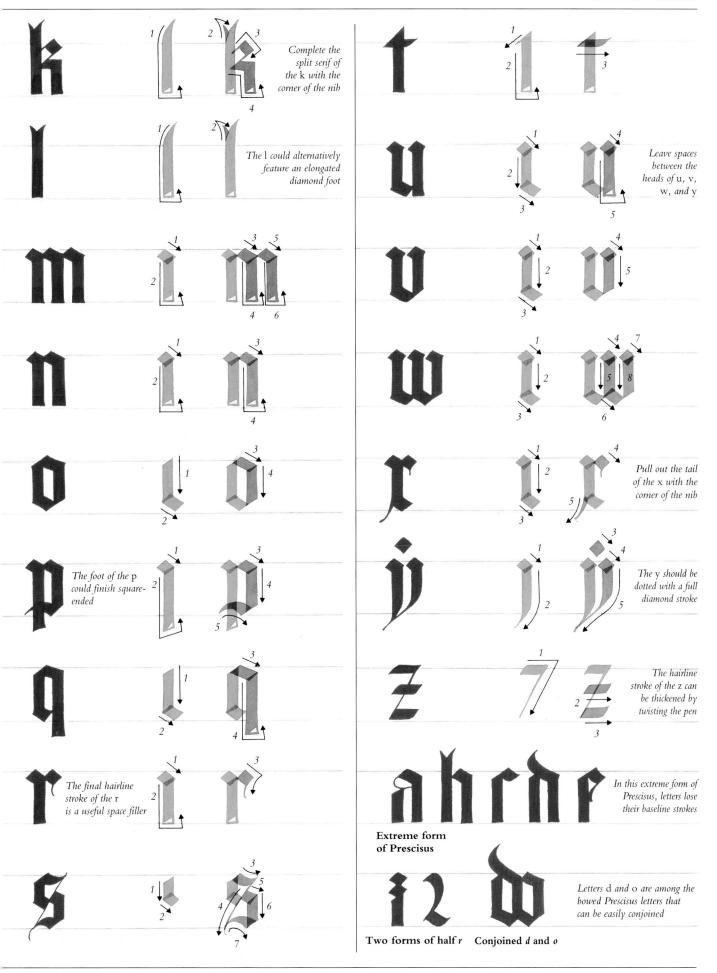

Gothic Capitals & Versals

THE PRINCIPAL DIFFERENCE between Gothic Capitals and Versals lies in their construction: Gothic Capitals are written with single strokes, whereas Versals are composed of several built-up strokes. A Versal is a single initial letter, drawn larger than the text script and used to indicate a title, chapter, or paragraph opening. The size of the Versal and the amount of gold and color used to decorate it is directly proportional to the perceived status of the initial within the text. Although less impressive than Versals, the Gothic Capital is far from plain, with elaboration in the form of hairline verticals and diagonals.

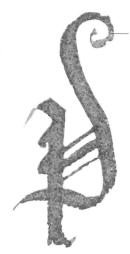

Exuberant flourishes of this kind are limited to opening letters or letters on the top line of a page of text

GOTHIC CAPITAL *P* Decorative diagonal strokes and hairlines reduce the amount of white space in the letter's counter and enhance its status in a page of text. In this *P*, the thick diagonal is complemented by hairlines above and below it.

IT WAS IN GOTHIC text that capital and minuscule letters of the same hand first appeared together. Gothic Capitals, which used the same ductus as the minuscules (pp. 50–57), were used within text script to begin a sentence or denote a proper noun.

In important sentences or verses, Gothic Capitals were frequently usurped by Versals. In its simplest form, a Versal can be an outline letter filled with a splash of color. In more sophisticated forms, it can be historiated (see the Winchester Bible, p. 46), zoomorphic (see the Book of Kells, pp. 28–29), or floriated (see the Book of Hours, p. 84). Alternatively, the decoration can be abstract, with spirals, frets, and interlaced knots (see the Lindisfarne Gospels, pp. 30–31).

Rounded bulges have been added to the stems to give extra emphasis to the letter

The counter of each letter has been decorated with vertical and diagonal hairlines

SAMPLE ALPHABET
Two sets of Gothic Capitals have been drawn
on this incomplete sample alphabet, which
dates from about 1400. Although the letters are
not the finest examples of Gothic Capitals, each
stroke is clearly shown, making them useful
models for the modern calligrapher to follow.
Note how the scribe has created extra weight on
some bowed letters by adding an extra stroke.

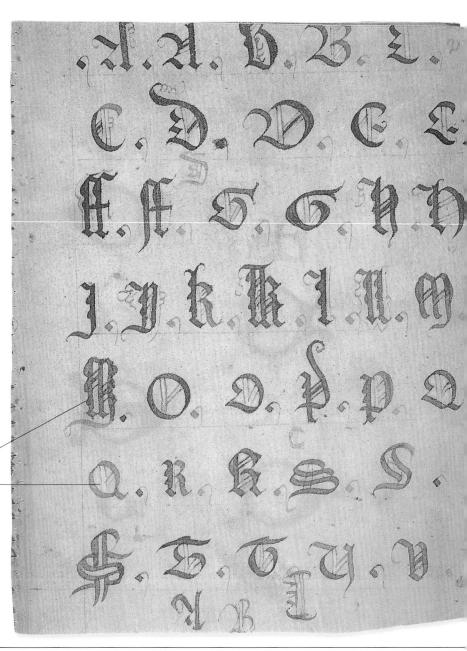

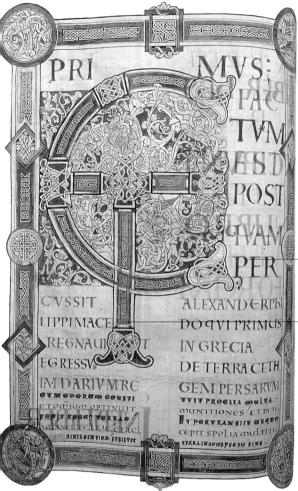

THE ST. VAAST BIBLE Written in northern France in the early 11th century, the St. Vaast Bible is a product of the Franco-Saxon school, which had been producing books of the highest order since the mid-ninth century. At first glance, the manuscript looks ahead of its time, so sophisticated is the page design. However, the plait and knot decoration around the Versal betrays the manuscript's Saxon pedigree (pp. 28-31).

The suggestion of a bracketed serif shows that these capitals were modeled on Imperial letters (pp. 108–109)

In this Versal, the initial letters E and T have been combined (this combination is the origin of our modern ampersand)

SIMPLE VERSALS
These Versals may be by the scribe responsible for the sample alphabet (opposite). They have been freely penned, with the letters drawn first and the decoration added afterward.

Models for Versals

Over the centuries, Versals have been modeled on a variety of etterforms. During the Gothic beriod, they were generally based on Lombardic Capitals (pp. 62–63). In the Caroline and the Renaissance eras, Imperial Capitals were often used as models (pp. 108–109). Possibly the most ornate Versals ever drawn were those in the deluxe Northumbrian manuscripts of the early medieval period (pp. 28–31). These were derived from Roman, Greek, and runic models.

Cadels

The other important model for Versals was the Bastard Capital (pp. 78–79). Enlarged and embellished by a series of interlacing strokes, this type of Versal is known as a Cadel (pp. 80–81). Cadels were later revived for use with talic (pp. 94–95) and Copperplate (pp. 102–103) scripts.

PATTERN BOOK

Designs for Versals were chosen by the patron from pattern books such as this one from the 12th century. This page shows a final working pattern, in which the intertwining stems have been accurately worked out.

Gothic Capitals

GOTHIC CAPITALS USE the same ductus as the minuscules (pp. 52-53, 56-57) and are written with the same "slanted" pen. However, the capitals have a wider, rounder aspect than the rigidly formal minuscules, and the two forms contrast strikingly when used together. The number of calligraphic flourishes in each Gothic Capital make it an unsuitable script for writing a whole word or a full page of text. For this, Lombardic Capitals provide a less flamboyant alternative (pp. 64-65).

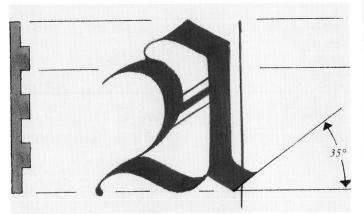

Letter height

The letter height of the Gothic Capital is approximately seven pen widths, two higher than the minuscule height.

Hairlines

The inner-letter space is reduced by the use of hairlines, drawn with the corner of the nib. There are usually one or two vertical hairlines, and a single diagonal hairline on either side of a thicker diagonal stroke.

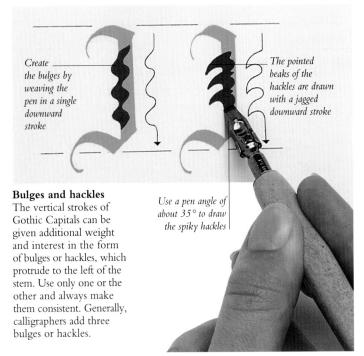

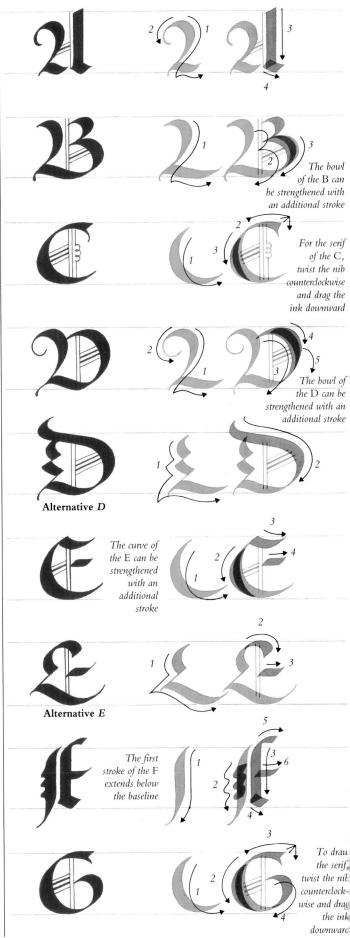

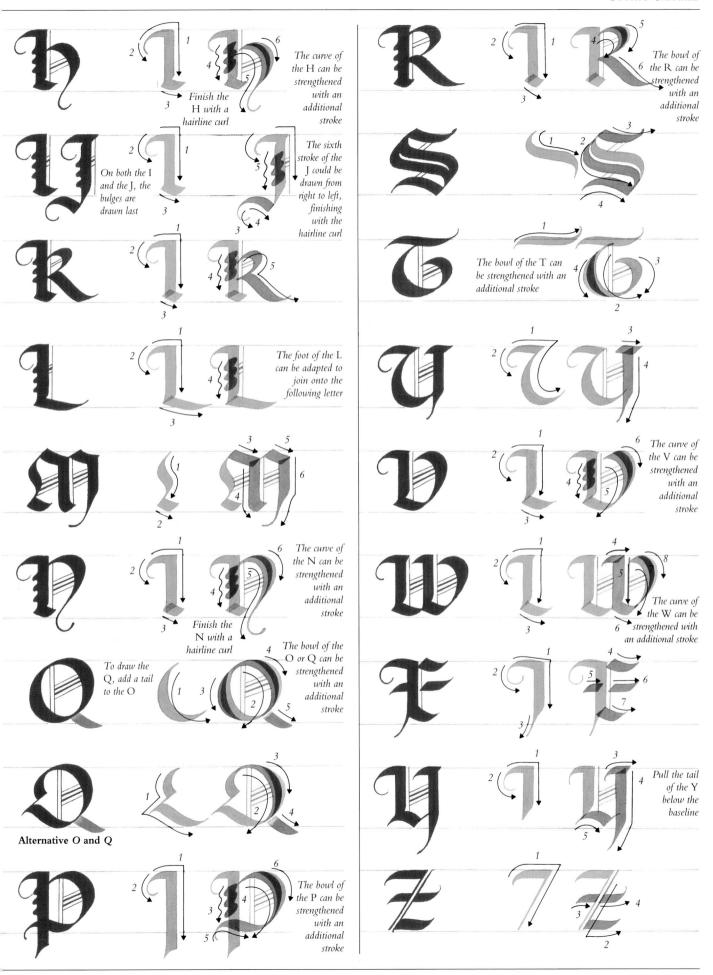

Lombardic Capitals

Aby curved stems and distinctive monoline serifs. Unlike Gothic Capitals (pp. 58–59), Lombardic letters worked well in sequence and so were used for whole words and phrases. They were successful both in penned form as display capitals and carved form for monumental work. The script was increasingly prevalent by the mid-11th century, and finally ousted by the Humanist Capital in the 16th century (pp. 98–99). However, it enjoyed a resurgence, particularly as a monumental letter, during the 19th-century Gothic revival in England, under the influence of the architect and designer A.W.N. Pugin.

The letter M can alternatively adhere to a baseline cross stroke, making the right-hand stroke a mirror image of the left-hand one (pp. 64–65).

There is a reluctance among some authorities to use the adjective "Lombardic" in relation to this script, because the letters have little specifically to do with the northern Italian region of Lombardy. However, over the centuries, the term has been widely used and accepted by calligraphers, typographers, and letterers, and has come to represent the particular combination of Imperial and Uncial elements that make up this distinctive hand of capital letters.

A simplified Imperial

Lombardic Capitals can be seen as simplified, pen-drawn versions of the Roman Imperial Capital. The multiple strokes of the Imperial (*pp. 110–119*) are reduced to a minimum, producing a letter that is relatively easy to execute (*pp. 64–65*). The Lombardic script usually includes Uncial forms of *A*, *D*, *E*, *M*, and *T* (*pp. 24–25*).

Dots are used on the letter N to give the strokes extra weight INCIPITEZE
CHIERE CHIERE
CHIERE
CHIERE
CHIERE
CHIERE
CHIERE
CHIERE
CHIERE
CHIERE
CHIERE
CHIERE
CHIERE
CHIERE
CHIERE
CHIERE
CHIERE
CHIERE
CHIERE
CHIERE
CHIERE
CHIERE
CHIERE
CHIERE
CHIERE
CHIERE
CHIERE
CHIERE
CHIERE
CHIERE
CHIERE
CHIERE
CHIERE
CHIERE
CHIERE
CHIERE
CHIERE
CHIERE
CHIERE
CHIERE
CHIERE
CHIERE
CHIERE
CHIERE
CHIERE
CHIERE
CHIERE
CHIERE
CHIERE
CHIERE
CHIERE
CHIERE
CHIERE
CHIERE
CHIERE
CHIERE
CHIERE
CHIERE
CHIERE
CHIERE
CHIERE
CHIERE
CHIERE
CHIERE
CHIERE
CHIERE
CHIERE
CHIERE
CHIERE
CHIERE
CHIERE
CHIERE
CHIERE
CHIERE
CHIERE
CHIERE
CHIERE
CHIERE
CHIERE
CHIERE
CHIERE
CHIERE
CHIERE
CHIERE
CHIERE
CHIERE
CHIERE
CHIERE
CHIERE
CHIERE
CHIERE
CHIERE
CHIERE
CHIERE
CHIERE
CHIERE
CHIERE
CHIERE
CHIERE
CHIERE
CHIERE
CHIERE
CHIERE
CHIERE
CHIERE
CHIERE
CHIERE
CHIERE
CHIERE
CHIERE
CHIERE
CHIERE
CHIERE
CHIERE
CHIERE
CHIERE
CHIERE
CHIERE
CHIERE
CHIERE
CHIERE
CHIERE
CHIERE
CHIERE
CHIERE
CHIERE
CHIERE
CHIERE
CHIERE
CHIERE
CHIERE
CHIERE
CHIERE
CHIERE
CHIERE
CHIERE
CHIERE
CHIERE
CHIERE
CHIERE
CHIERE
CHIERE
CHIERE
CHIERE
CHIERE
CHIERE
CHIERE
CHIERE
CHIERE
CHIERE
CHIERE
CHIERE
CHIERE
CHIERE
CHIERE
CHIERE
CHIERE
CHIERE
CHIERE
CHIERE
CHIERE
CHIERE
CHIERE
CHIERE
CHIERE
CHIERE
CHIERE
CHIERE
CHIERE
CHIERE
CHIERE
CHIERE
CHIERE
CHIERE
CHIERE
CHIERE
CHIERE
CHIERE
CHIERE
CHIERE
CHIERE
CHIERE
CHIERE
CHIERE
CHIERE
CHIERE
CHIERE
CHIERE
CHIERE
CHIERE
CHIERE
CHIERE
CHIERE
CHIERE
CHIERE
CHIERE
CHIERE
CHIERE
CHIERE
CHIERE
CHIERE
CHIERE
CHIERE
CHIERE
CHIERE
CHIERE
CHIERE
CHIERE
CHIERE
CHIERE
CHIERE
CHIERE
CHIERE
CHIERE
CHIERE
CHIERE
CHIERE
CHIERE
CHIERE
CHIERE
CHIERE
CHIERE
CHIERE
CHIERE
CHIERE
CHIERE
CHIERE
CHIERE
CHIERE
CHIERE
CHIERE
CHIERE
CHIERE
CHIERE
CHIERE
CHIERE
CHIERE
CHIERE
CHIERE
CHIERE
CHIERE
CHIERE
CHIERE
CHIERE
CHIERE
CHIERE
CHIERE
CHIERE
CHIERE
CHIERE
CHIERE
CHIERE
CHIERE
CHIERE
CHIERE
CHIERE
CHIERE
CHIERE
CHIERE
CHIERE
CHIERE
CHIERE
CHIERE
CHIERE
CHIERE
CHIERE
CHIERE
CHIERE
CHIERE
CHIERE
CHIERE
CHIERE
CHIERE
CHIERE
CHIERE
CHIERE
CHIERE
CHIERE
CHIERE
CHIERE
CHIERE
CHIERE
CHIERE
CHIERE
CHIERE
CHIERE
CHIERE
CHIERE
CHIERE
CHIERE
CHIER

The text is written in a very fine Early Gothic script (pp. 46–47)

THE WINCHESTER BIBLE

The Vision of Ezekiel, from the Winchester
Bible (pp. 46–47), includes a series of meticulously crafted
Lombardic Capitals. In common with other works from the
mid-12th century, the scribe has shown little concern about
breaking words at the end of a line: for instance, "INCIPIT
EZECHIEL" reads "INCIPIT:EZE/CHIEL." In the illuminated
initial, Ezekiel is depicted dreaming by the Chobar River. The
four interlocking wheels are symbolic of the four Evangelists.

anno inquarco inquinta mensis cum eem inmedio capauo um iyata suutum chobár apera sunt celi erusti ussiones dei Inquinta mensis ipse est annus quincus transmigrationis regis ioachim factum est uerbum dni adezechiel silu buzi sacerdorem-interra chaldeoum secus sumen

In this early example of a historiated Versal (pp. 58–59), the Virgin is shown in the form of a capital letter I These display letters read: "IN NM DNI NRI IHU PS INCPT LIB SACRAMTR." This is an abbreviation of: "IN NOMINE DOMINI NOSTRI JESU CHRISTI. INCIPIT LIBER SACRA MATRIS"

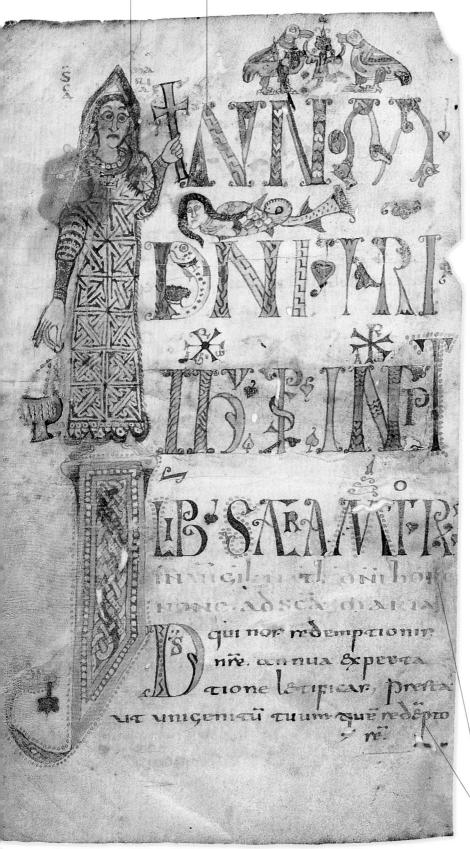

THE GELLONE SACRAMENTARY
In the title letters of this eighth-century text for Christmas Eve Mass, produced in northern France, we can discern the crude beginnings of Lombardic Capitals. The scribe has used Imperial Capitals as his models, drawing the outline of each letter in a single stroke with a narrow pen nib. In the first three lines, letters feature internal decoration. The words of the title have been considerably abbreviated. On the second line the abbreviation of "DOMINI" as "DNI" has been indicated with a mermaid instead of the traditional horizontal stroke.

Built-up letters

Unlike most other capital scripts included in this book, the Lombardic letter is not the product of a natural movement of the hand. While each basic component of the Gothic Capital, for instance, is made from a single stroke (pp. 60–61), a Lombardic component is built up from several composite strokes. The sides of the stems curve inward, usually drawn with the pen held horizontally. The monoline serifs are also the product of the horizontal pen; they are generally slightly concave and are not bracketed to the main stem as they are in the Roman Imperial Capital.

Embellishments

The Lombardic Capital forms the basis for many Versals (pp. 58–59), and the amount of embellishment and decoration is limited only by the scribe's imagination (p. 64). However, the stone-cut Lombardic letterform is often modified as a result of the nature of the surface – for instance, the fine serifs are either thickened or omitted altogether.

The Lombardic has been used extensively on other surfaces: textiles, metals, glass, and ceramics.

Below the title capitals, the chapter opening has been written in rubricated Uncial letters (pp. 24–25)

Below the chapter opening, the text script has been penned in a Half Uncial hand (pp. 38—39), recognizable by its upright aspect

Lombardic Capitals

There is no historical precedent for a full set of Lombardic Capitals and those shown here have been compiled from a variety of sources. Unlike Gothic Capitals (pp. 60–61), they are used for writing complete words and phrases and so consistency is of great importance. Concentrate on making the weight of stroke, the level of compression or expansion, and the serif construction exactly the same in each letter you draw.

Waisted stems

Waisted stems can be created by overlapping two broad, curved vertical strokes and then adding the hairline horizontals at the top and bottom (*above left*). A more precise method is to draw the whole outline with a narrow nib and then fill it in with ink (*above center*).

Use a narrow pen nib to add the decorative blobs at the end of the serifs

Rounded letters

Define the form of rounded letters by drawing either the outer or inner circle first. The latter often proves more practical (see letter *O*, *opposite*).

Expanded and compressed letters

To regulate the chosen level of expansion or compression, use the spaces enclosed within characters as guides. Compressed letters have shorter serifs than expanded letters. Bows can be fully rounded or pointed.

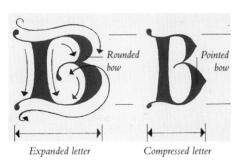

Display capitals

Since the 12th century, the Lombardic Capital has often been heavily elaborated when used as a display capital. Decoration can range from simple additional caselines to complex illustrations that are gilded and in color.

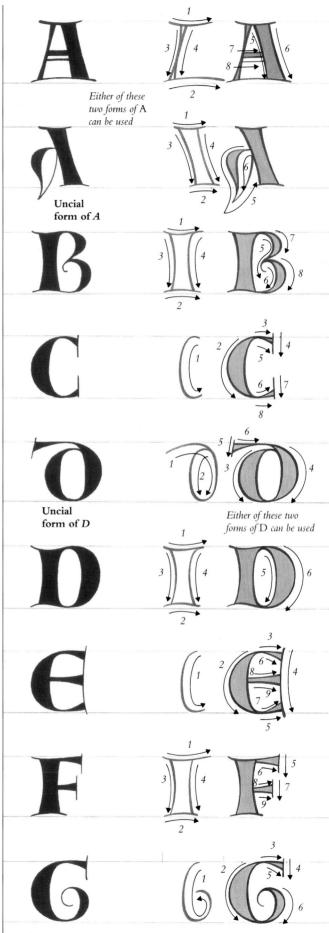

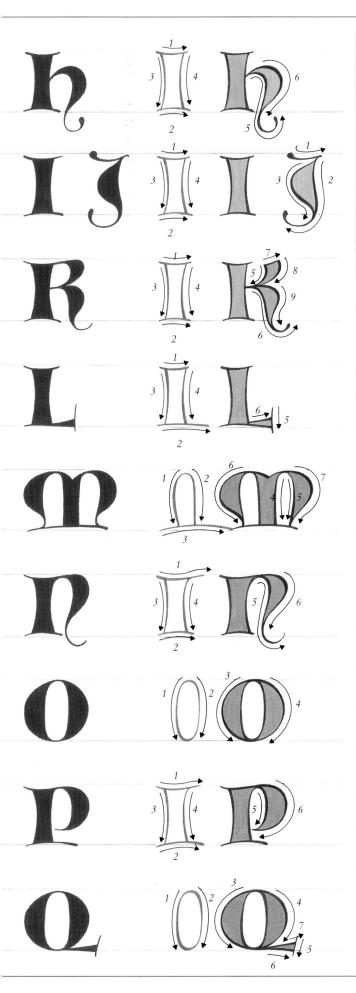

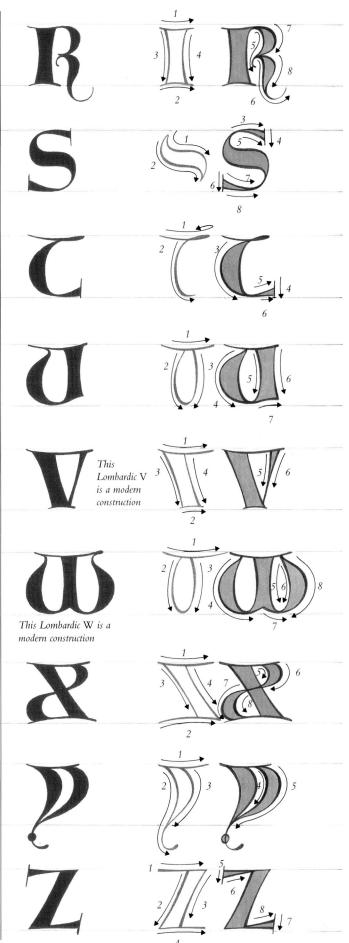

Bastard Secretary

HISTORICALLY, THE MORE FORMAL a manuscript hand has become, the greater the need has been for a functional cursive script to complement it. Just as the Insular Majuscule spawned the Insular Minuscule in the eighth century (pp. 28–37), so the prestige Texturas of the 13th century (pp. 50–57) gave rise to parallel hands for the less prestigious work of the day. A series of complementary cursive scripts evolved both regionally and nationally, quickly developing into fully fledged hands in their own right. They are classified under the generic title of "bastard" (bastarda) scripts, the term denoting a mixed cursive and Textura parentage.

Bastard Secretary *w*The *w* reaches ascender height
and is identical in both
minuscule and capital form.

The cursive script (pp. 34–35) had probably been rediscovered for documentary use in England toward the end of the 12th century. Although speed was the most important consideration, the script was also designed to impress, as the loops and linking letters testify. The French form of cursive, called Secretary or Chancery, was introduced into England and Germany at the end of the 14th century. When Textura features were incorporated, it became known as Bastard Secretary in English, Bâtarde in French (pp. 70–71).

The illuminated border and Versal are characteristic of 15th-century English manuscript work

The downward flick from the ascenders is known as an "elephant's trunk"

The feet of the minims turn upward

The horizontal stroke over the ampersand denotes the abbreviation of a word

MEDITATIONS ON THE LIFE OF CHRIST This manuscript page shows the translation into Middle English by Nicholas Lowe of a popular 13th-century Latin work attributed to St. Bonaventura. One of 49 versions of the text known to exist, it dates from about 1450. The script includes the Anglo-Saxon thorn sign, a character that resembles a y and represents a "th" sound (pp. 68-69). This sign remained in use until the 16th century.

> The Anglo-Saxon thorn sign has been used throughout the text

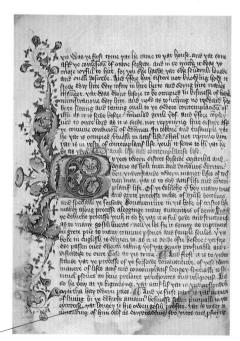

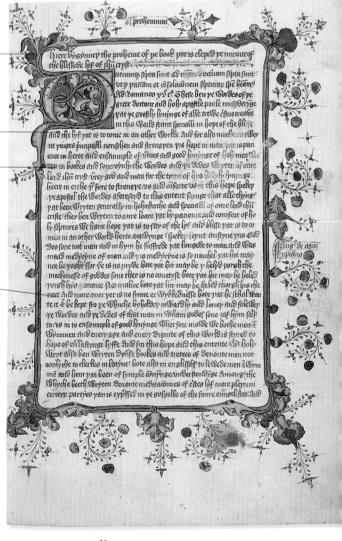

Kane medieval manuscript

Dating from about 1430, this earlier translation of St. Bonaventura's *Meditations on the Life of Christ* is also the work of Nicholas Lowe. In this version, the scribe has made use of both the Anglo-Saxon thorn sign and the modern *th* for writing the word "the." Notice also the serifs at the feet of the minims, which are turned upward and not broken as they are in the Bastard Secretary of the Adam and Eve text (*opposite*).

France of the to Barn sterny low spo for Sunge Sold wo might Spe or elles & They dans of the for this for mere god broth & the And thanne ferde Adam queters in henen and in of the his Brethe Bles it bo for me or for the I note And for one to Lam: my low some if I may be some a Dap for the fuce of 100 and for the fight of Do amgeles to that be map forgeto to be topo the Buth the once loss god gete so that happelin he lede the in paradys for Thy for the cause of me y art putte oute they of Thame ferde Asam Due fireke nomore fo. left oure tors god fendo his malifon oppon os Sor myght at bothat I myght mine Goodso mmp fleffle pat 16 to fapro. Tolk mpalit tt bo p I shild flow mone often flofflo Sut apfe go The mid sethe Shep St for to line and ne ftynt See nouled to feele They Sent and foglit but per fonde noght ale the Anode in parados Penetheleco friche the formden as neet and befrees eten Than ne serve domn make the forote m the fight of one lorde god. p made ds. and forthinke Se m greto forthingping & Sapes 31 thapely one low god. forzene ve and orderine Se Celier St to life Thanne ferde Eue to Dann my los fey, me The forther kyring 18 02 0 for Bo thinkse for thenk left impely Se take Sypon & that Se may not fulfille and once praires be not hejde and god turne the face foo ds. 3if the fulfille not that we have boliete to hanne ferde Some to Que those may fuffe to many 31f those Buth & those Tooft nonfit I fay the fo many Too no " Suit French and German features

There are certain features that help identify a bastard script by its nationality. The French form, for instance, is most distinctive for the calligraphic feast made of the *f* and long form of *s* (*pp.* 70–71). Early German cursive scripts were characterized by bold, expanded minims and tall ascenders and descenders. When they were contaminated with Textura features at the end of the 15th century, the Fraktur and Schwabacher hands emerged, featuring "broken" letterforms (*pp.* 74–75).

English characteristics

In English models, it is the letter *w* that attracts the most attention — the same impressive, looped form is used for both minuscules and capitals (*opposite*). Another English feature is the long, downward terminating flick from ascenders, sometimes called an "elephant's trunk."

Generally, the English Bastard Secretary tends to be staid and prosaic, lacking the subtle shifts of pen angle that characterize its French counterpart. As a result, it was highly practical, and so had a long life as a document hand. It was used well into the 18th century.

Adam and Eve

This text of the story of Adam and Eve was written in English in about 1415. A fine upright aspect to the letters suggests that they were written with an oblique-cut nib. In the best English Bastard script traditions, the w is well pronounced and the "elephant's trunks" are boldly drawn.

The text includes a set of capital letters written with the same ductus as the lowercase text (pp. 78–79)

The impressive height and looping form of the Bastard ecretary w make it the most striking letter in this page of text

DETAIL FROM ADAM AND EVE In this valuable detail, a split in the quill allows us to see very clearly both sides of each stroke. Notice particularly the letter f: this is constructed with a single stroke, the pen beginning at the vertical, then turning to about 30° at midstem before returning to the vertical for the descender (pp.~68-69).

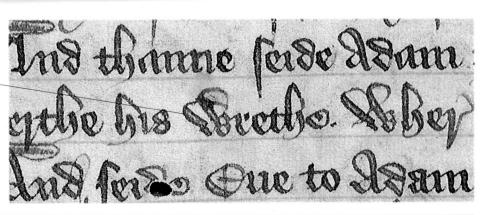

Bastard Secretary

As a functional, cursive script, the Bastard Secretary is written with as few pen lifts as possible, with letters linked wherever practical. Consequently, the hand can be penned far more quickly than the formal Gothic scripts, such as the Textura Quadrata (pp. 52–53). Ascenders are complemented by strong, downward diagonal strokes known as "elephant's trunks," drawn to the right of the stem at an angle of about 45°. These echo the downward diagonal strokes of the minim feet.

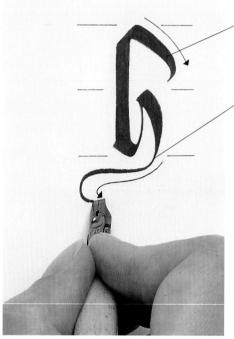

The angle of the "elephant's trunks" should be consistent throughout the text

The tail of the h is usually dragged to the left of the letter, almost at a parallel to the baseline

Key letter

The *h* is a useful letter with which to start practicing the Bastard Secretary. It includes both the "elephant's trunk" that sweeps from the head of the ascender almost to the headline and the characteristic downward pull of the pen at the foot of the stem.

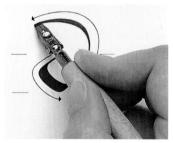

Drawing an upward loop

With its sweeping hairline loop, the *d* is one of the most distinctive letters in the hand. After drawing the bowl, create a large arc by pushing the pen upward in one sweeping movement.

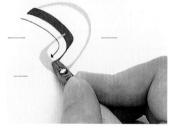

Adding a downward diagonal

Without lifting the pen, make a strong downward diagonal stroke, curving it to the left to join the bowl at its midway point. This stroke will echo the shape of the loop.

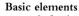

The pen angle for the hand is about 40–45° and a square-cut nib is generally used. Minim height is four pen widths, with the ascender equal to a further four widths.

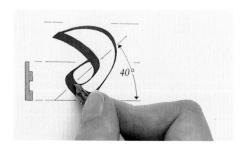

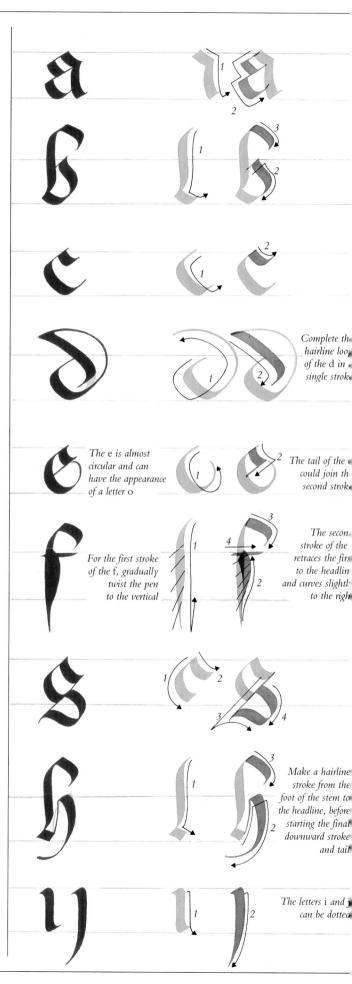

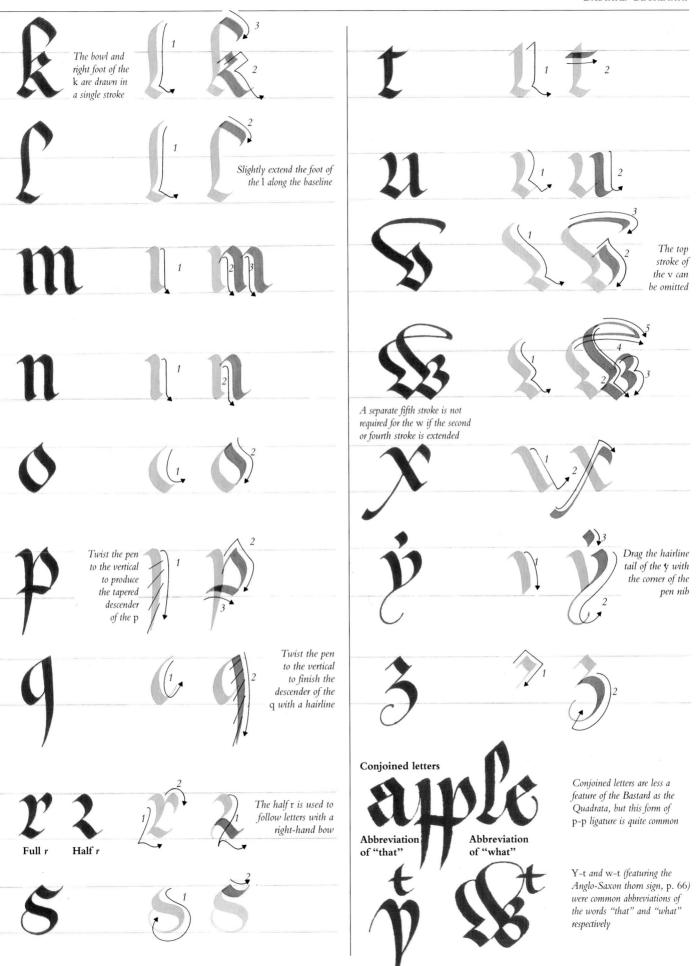

Bâtarde

The Batarde (Lettre Bourguignonne) is the French equivalent of the English Bastard Secretary (pp. 66–67). It was developed at the end of the 13th century and used until the mid-16th century, evolving from a lowly cursive bastard hand into a formal, prestige script in its own right. Bâtarde achieved its most sophisticated appearance in the mid-15th century, an era when the popularity of the printed book was increasing among a whole new section of society. In this deluxe form, it was the hand favored by Burgundian court circles, hence its alternative name.

This baseline cross stroke can be extended when the letter begins a word

BATARDE P
In constructing the Bâtarde p, a series of pellifts and angle changes is required (pp. 72–73).

By THE MID-15TH century, book illustration in France was moving away from medieval stylization (pp. 54–55), becoming less intricate and more naturalistic. The Bâtarde hand used for manuscript books was shedding its own Gothic ancestry – letters were lighter, seeming to dance on the page. This effect was achieved partly by making several changes of pen angle during the construction of each letter. In returning to the major key after each change, the scribe could create a rhythmic harmony across a page of text. This is particularly noticeable in the Froissart Chronicle (opposite). However, in other Bâtarde scripts, such as that in the Book of Hours (right), the harmony of the text is achieved instead by the maintenance of one constant overall angle.

> The split ascenders are one of several Gothic Textura characteristics that have survived in this bastard script

BOOK OF HOURS

This page is from a small prayer book written for the wealthy Poligny family in about 1470. The script's Gothic origins are clear: ascenders are split, descenders modest, and minim strokes terminated with feet reminiscent of the Quadrata (pp. 50–51). The overall textural effect is closer to the dense authority of the Gothic Textura scripts than to the light harmony of a true Bâtarde, such as that achieved in the Froissart Chronicle (opposite).

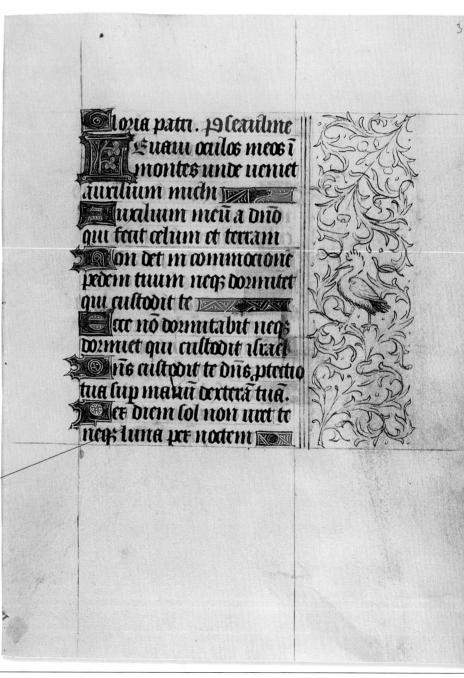

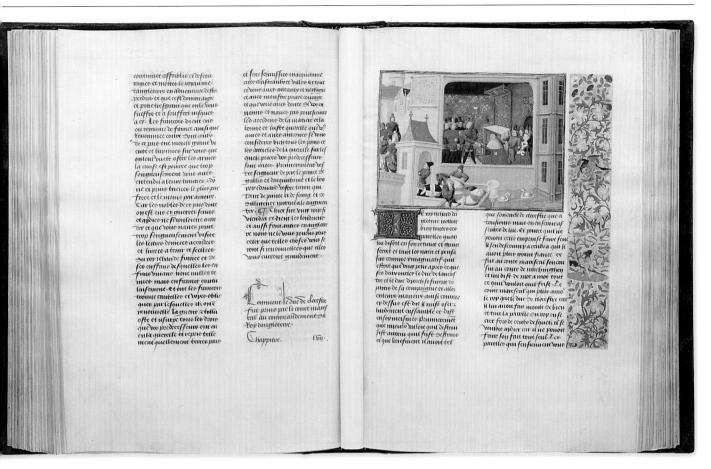

The Froissart Chronicle
This is a copy of the 14th-century chronicle
of Jean Froissart. A delightful book, it has
a modern appearance, owing partly to the
elationship of text to margins and partly to the
restraint shown in the decoration. The feet of
the minims end without elaboration and the
script is generally more cursive than that
used to write the Book of Hours (opposite).

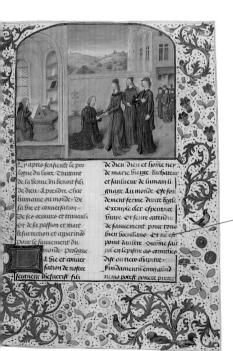

DETAIL FROM THE FROISSART CHRONICLE
The initial C is decorated with a Cadel
(pp.~80-81). The horns on the letter g are
similar to those on the g of another Gothic
script, the Fraktur (pp.~76-77). Both the
half r and full r forms are used in the text.

The forward lean of the letter f is one of the most distinctive characteristics of the Bâtarde

VITA CHRISTI PAGE

This page from *La Vengeance de la Mort Ihesa* includes the rubricated prologue to the main text, which opens with a Versal. The book dates from 1479 and was written by David Aubert of Ghent, scribe to Philip the Good, Duke of Burgundy. In the illustration, we see the scribe presenting the book to his patron.

Vita Christi

The scribe of the Vita Christi page from La Vengeance de la Mort Ihesa (left) had arguably lesser skills than his two contemporaries featured here. He does not achieve the harmony of the Froissart Chronicle or Book of Hours, his pen angles are inconsistent, and he is unable to return to any constant pen angle.

Common features

In some examples of Bâtarde, the f and long form of s lean forward at an angle. By keeping the angles of these two letters absolutely constant, the scribe can create a counterpoint to the main harmony. This textual effect – known as "hot spots" – is a common feature of Bâtarde.

Other frequent characteristics of *Lettre Bourguignonne* are the overlapping strokes reminiscent of Fraktur (*pp.* 74–75), and the delicate hairlines used to join strokes; these seem to add a further sense of movement to a page of text.

Bâtarde

O ACHIEVE THE most successful Bâtarde letters, the use of a $oldsymbol{1}$ quill is recommended. A sharply cut oblique nib is required to produce the exquisitely fine halrline strokes. The clubbed f and long s are frequently written more boldly than other letters and have a forward slant (the two letters have the same basic form, with a crossbar added for the f). This produces "hot spots" within the written text and makes for a distinctive textural pattern.

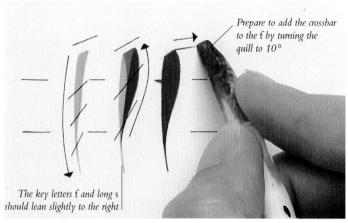

Drawing the f and long s The many changes of pen angle

required to draw the Bâtarde f and long s are typical of this sophisticated hand. Begin about half a minim above the headline and gradually

turn the pen from 30° to the vertical as you pull the pen downward, finishing with a hairline. Retrace the first stroke, looping outward to the right to create a thickened stroke, and return to the original angle of 30°.

The curved hairline stroke at the top of the letter q can be continuous with the descender

Descenders

The descenders of letters p and q are made by turning the nib counterclockwise from the horizontal to the vertical, finishing with a hairline. The descenders may alternatively slant to the left, echoing the forward lean of the f (above) and long s.

The height of the Bâtarde minim is about four pen widths

Flat feet occur on all leading minims in the script, such as the stem of the t and the first leg of the n. In a more cursive version of Bâtarde, the minims may terminate with a flick at the end of the downward stroke, as on the second leg of the n.

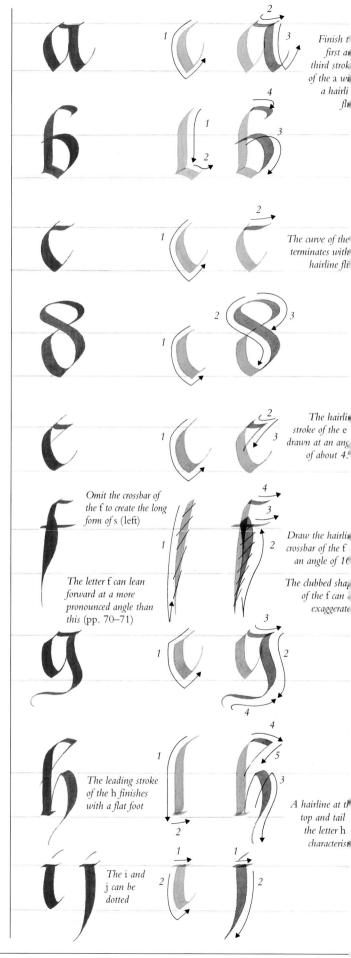

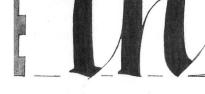

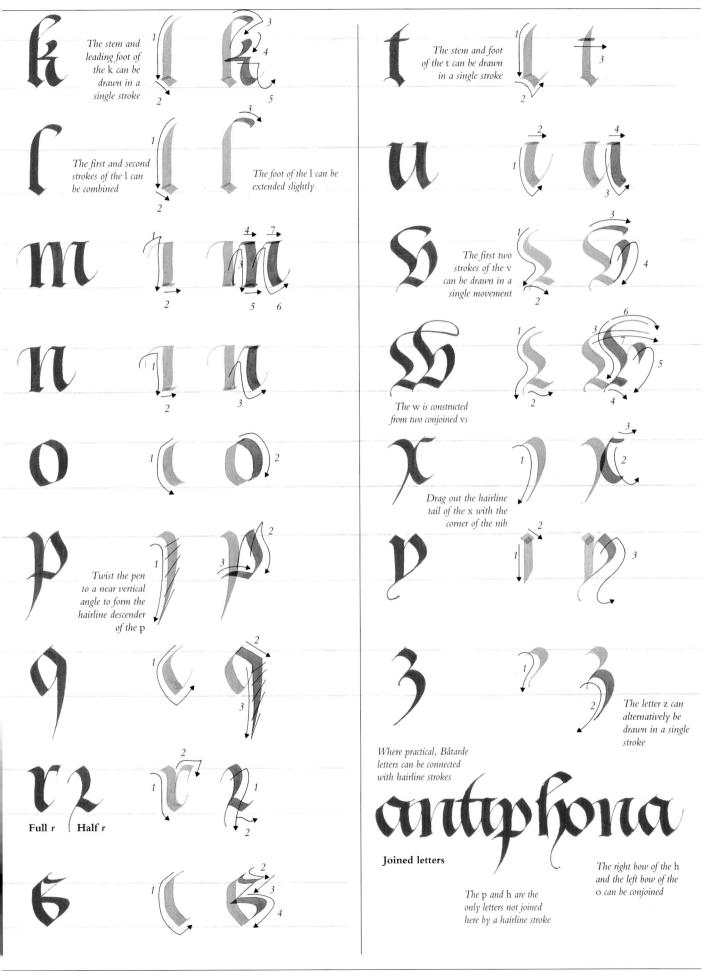

Fraktur & Schwabacher

Fraktur (German Letter) is a marriage between German cursive scripts and Textura Quadrata (pp. 50–51). Manuscript examples of the hand date from about 1400 and it first appeared as a typeface about a century later. Early type versions of Fraktur, and its more cursive, vernacular cousin, Schwabacher, remained close to their pen-written origins. They were designed by the leading German calligraphers of the day, including Johann Neudörffer the Elder. The two scripts continued to influence calligraphy and type design until the mid-20th century, and had a formative influence on the work of eminent practitioner Rudolf Koch (opposite).

The Fraktur a is always a single-story letter with an enclosed bowl

THE DIFFERENCES between Fraktur and Schwabacher are difficult to define precisely. Both feature the swollen body and pointed tail of the Bâtarde f and long s (pp. 70-71), as well as curved strokes on the bows of letters a, b, c, d, e, g, h, o, p, and q. Diamond strokes reminiscent of Textura letters are a distinctive feature of the hand, but there is a tendency for terminal strokes to be curved. All letters have a rigidly upright aspect.

Generally, the Schwabacher has a broader, more cursive form than the Fraktur, and does not have the forked ascenders and excessive elaboration of that hand. Some of the most striking versions of Schwabacher were penned, centuries after the script first appeared, by the calligrapher and designer Rudolf Koch (opposite).

WORKSHEET
This portion of a
worksheet (above) is
possibly the oldest
surviving example
of Fraktur-related
lettering. It was
written in about 1400

by Johannes vom Hagen, who refers to the hand as "Nottala Fracturarum" ("broken notes"). It is from this term that the name "Fraktur" is believed to have been derived.

The tail of this p, and that of other letters on the bottom line of text, may have been added by hand after the book was printed

The illustrations and Versals were added after the the text had been completed

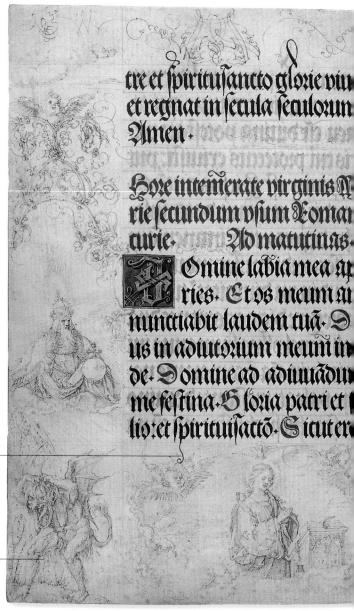

Matthäus Evangelium In this German text of the Gospel of St. Matthew from 1921, Rudolf Koch combines the features of Fraktur and Textura Quadrata to the ultimate degree - the lines of text appear to have been knitted. Koch classified this style as a version of Schwabacher, and explained: "The page should seem to be stacked with finished rows of lines...especially the space between words must not be broader than that between lines." The Versals have been treated in an equally robust manner, resulting in two beautifully designed pages of text.

In Koch's text, the interlinear space has virtually disappeared, allowing just sufficient white for the eye to scan along the lines horizontally

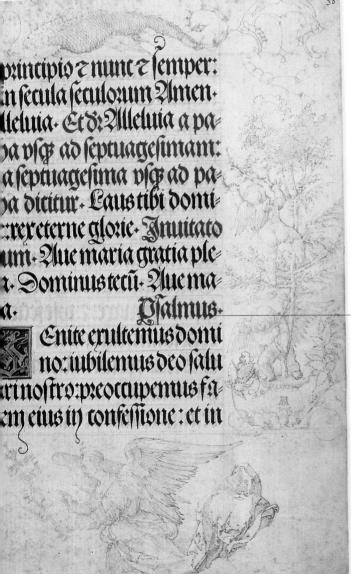

Lande oder zwearfuße habelfun ewigeneur geworfen. Und sowar raßes aus und wirfs von air Esift einawurg zum Leven eingehelt beim

DETAIL FROM MATTHÄUS EVANGELIUM The controlled freedom of Koch's letterforms is shown in this detail from Matthäus Evangelium (above). Radical in its time, such work gave new meaning to the term "Black Letter" (pp. 50–51).

The straight, compressed aspect of the hand betrays its Textura origins: even the letter f has an upright form

Prayer book These pages from the prayer book of Emperor Maximilian were published by Schönsperger of Nüremberg in 1514. The Fraktur type was designed by Johann Neudörffer the Elder, father of three generations of calligraphers. The border decoration is equally outstanding, being the work of Albrecht Dürer.

German Letter

By the early 16th century, a further form of Fraktur and Schwabacher had developed that has since come to typify German scripts. It featured "broken" letters created by the overlapping of strokes (pp. 76–77). Used only in German-speaking areas, this broken letter is frequently referred to as a "German Letter." The rejection of Italian scripts
Fraktur and Schwabacher enjoyed longer lives than any other bastard

Fraktur and Schwabacher enjoyed longer lives than any other bastard script in Europe; in the early 20th century, half the books printed in Germany still featured Fraktur-based typefaces. This longevity was a direct result of the German rejection of Italic and Humanist scripts (pp. 90–101). There were two important factors in this rejection: first, the Reformation caused Protestants in northern Germany to reject Italian hands as a political gesture; second, it was widely believed that a Humanist script did not suit German text.

Fraktur

The upright, compressed letters of Fraktur are closer in appearance to the Gothic Textura scripts (pp. 50–57) than either the Bastard Secretary (pp. 68–69) or the Bâtarde (pp. 72–73). The hairline spikes, such as those on letters b, g, h, and q, are a distinctive feature of Fraktur and do not tend to occur on the rounder Schwabacher letters. The pen angle of about 40° is altered only for drawing the pointed descenders.

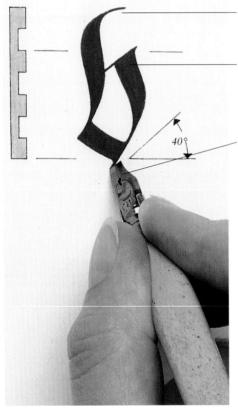

The ascender can be drawn with a single rounded stroke or with a split serif

The minim height is about five pen widths, with two more for ascenders and descenders

The pen nib should be square-cut for drawing Fraktur letters

Rounded strokes

Despite the Fraktur letter's upright aspect, many strokes are actually rounded. Here, the ascender of the letter b has been drawn with a curve to echo the rounded stroke of the bowl. Whether you choose straight or rounded letters or split or pointed ascenders, it is important to be as consistent as possible throughout the text.

The crossbar is a common feature of the letter g in both Fraktur

The tail of the g can finish with a short hairline, a blob, or a backward sweep; alternatively, it can be looped (see g, right) Alternatively, the hairline can be drawn as a continuation of the first stroke (see g, opposite)

The spike stroke overlaps the bottom of the rounded stroke of the bowl

Fraktur descenders are restrained, except on the bottom line of a page of text, where additional flourishes can occur

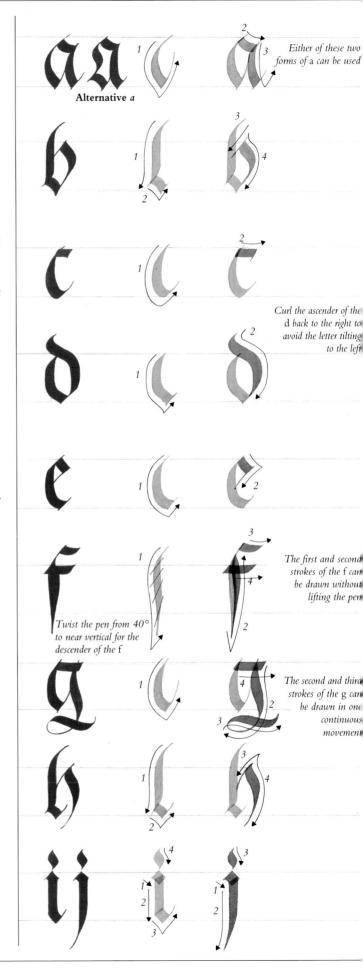

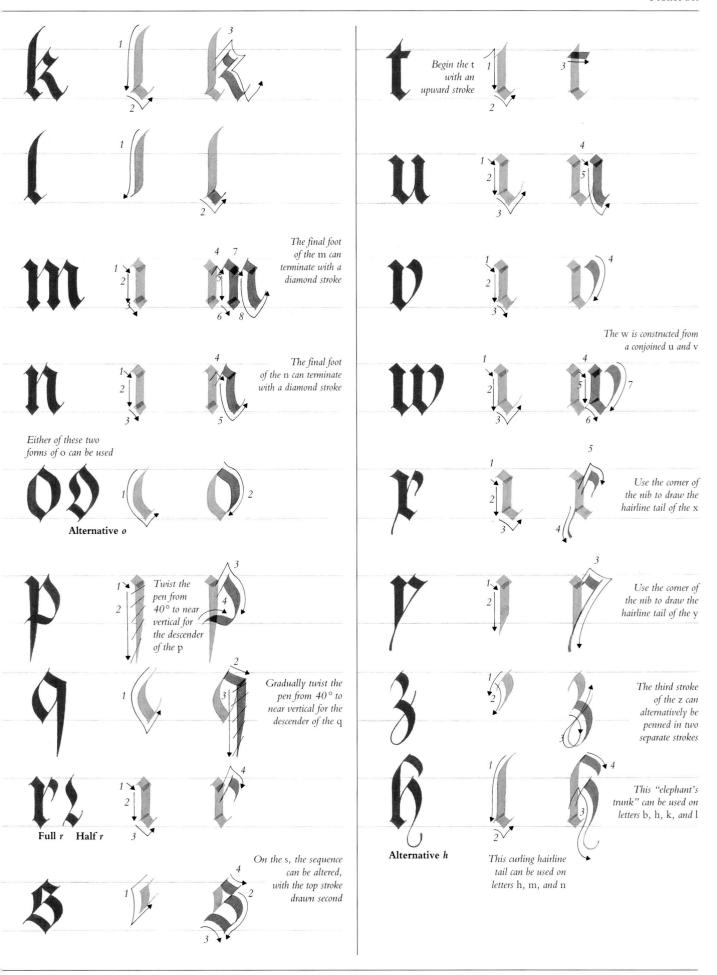

Bastard Capitals

 $B^{\rm ASTARD}$ Capitals have the same ductus as the minuscules that they accompany (pp. 68–77), and are penned with the same nib. In most instances, they tend to be wide, expanded letters. The thick stem strokes are often supported by a thin vertical slash to the right, and the addition of a diamond stroke in the center of the counter is also common. Like the bastard minuscule hands, the capitals were subject to a range of individual and regional variation. Because of this diversity, the alphabet shown here should be regarded only as a general guide.

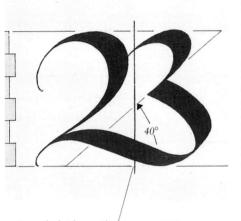

Basic elements

The pen angle of the Bastard Capital is about 40° or the same as the minuscule that it accompanies. The letter height is about six pen widths. The characteristically wide letters, such as the B, are a direct product of downward and horizontal arced sweeping strokes.

Draw the hairlines with the corner of the nib

Connecting hairlines

On letters H, M, and N, hairline strokes are often used to connect two main downstrokes. This hairline should spring from the right

edge of the baseline serif.

Limit the number of diamond-shaped spurs to two or three

"Elephant's trunks" The "elephant's trunk" so characteristic of the Bastard Secretary (pp. 68-69) also occurs on capital letters H, K, L, and X. Draw the diagonal trunk with the full width of the nib, finishing

with a short hairline.

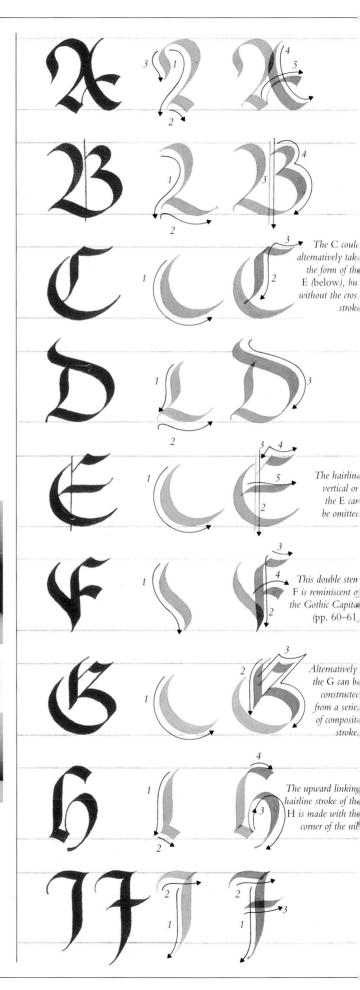

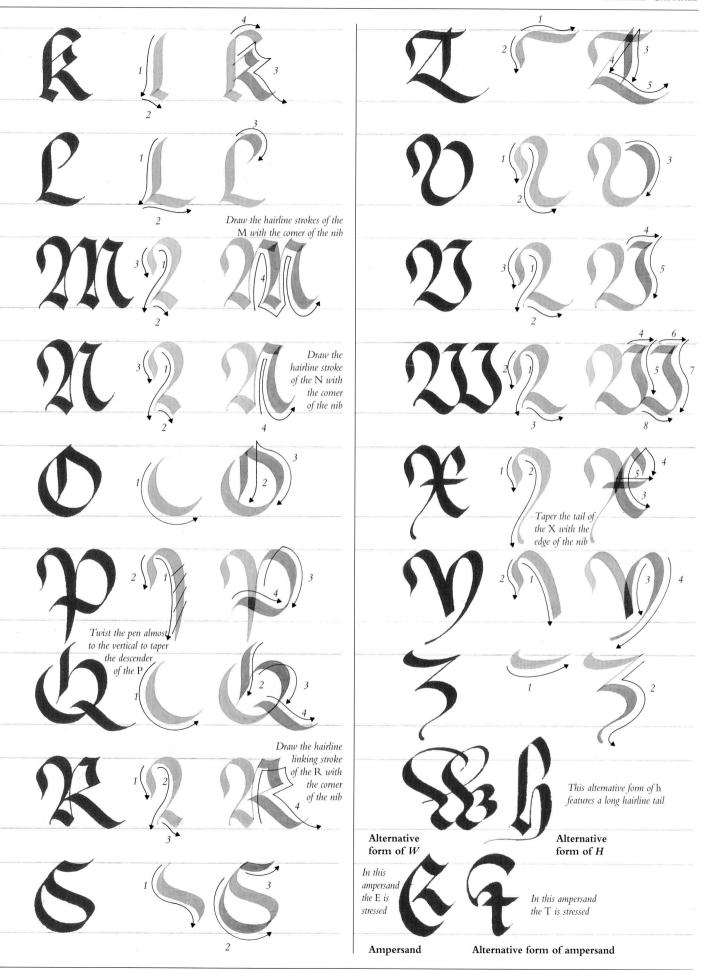

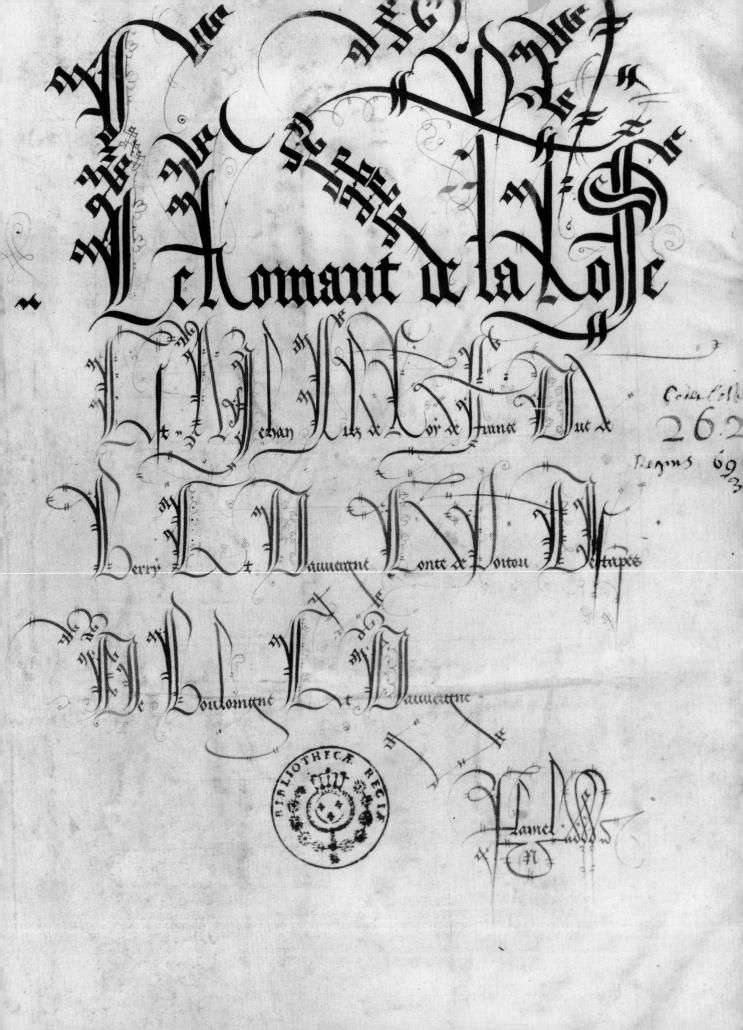

Cadels

The invention of the Cadel (Cadeaux) in the early 15th century is attributed to Jean Flamel, librarian to the prominent patron of the arts, the Duc de Berry. Flamel used these large, patterned capitals to inscribe the duke's name in the front of each manuscript. By the mid-15th century, Cadels were widely used in northern Europe as single Versals ($pp.\ 58-59$), mainly in vernacular text written in the various bastard scripts ($pp.\ 66-79$). During the 16th century, they appeared in Italic text in increasingly elaborate forms.

FLAMEL'S CADELS
This page from a manuscript
belonging to the Duc de Berry
was written by Jean Flamel in
about 1409. Although the basic
structure of the Cadels is relatively
simple, the fact that so many have
been used on the same page creates
an impressive overall effect.

ENGRAVED ALPHABET
This alphabet of capitals was engraved by Thomas Weston in 1682. Although the main structure of the letters follows that of Bastard Capitals (pp. 78–79), the basic forms have been embellished with typical Cadel scrolls and interlaces.

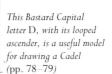

CADELS, CAPITALS, AND MINUSCULES These letters were penned in the second half of the 15th century, possibly by the English scribe Ricardus Franciscus. One basic element of the Cadel contained in the letter A is the left foot, which has been constructed from three strokes linked by a series of shorter strokes. This linking system is the key to more complex letters, such as the H (above).

Cadels were generally used with Bastard scripts: here, the minuscules resemble a German cursive hand (pp. 74–75)

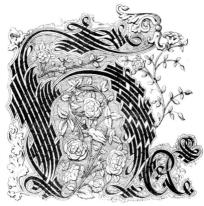

Cadel H

Despite the apparent complexity of this 16th-century Cadel, the main structure of the letter is easily pennable (*pp. 82–83*). The fine internal decoration can be drawn with a flexible steel nib.

BY THE END OF the 16th century, the Cadel was frequently appearing as a Versal in printed form, and the advent of copperplate engraving led to more fanciful elaboration than was achievable with a broad-edged pen. This paralleled the development of the various Italic and Copperplate hands (pp. 94–107), with which the Cadel was often incorporated.

Interlace patterning

The Cadel differs from other capitals used as Versals in that it is composed of interlacing strokes rather than built-up strokes (pp. 58-59). It is drawn with a constant pen angle — this produces thick and thin strokes that create a pattern with a continuously changing direction of line. In this way, substance is added to an otherwise skeletal letter.

Interlaced strokes can also be used to embellish the ascenders on the top line of a page of text or the descenders on the bottom line.

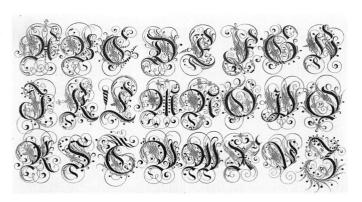

Cadels

THE GREAT VARIETY of existing Cadel models makes it very difficult to A assemble a complete alphabet. These examples have been selected to represent a few general principles. Although Cadels can look very daunting to accomplish, in practice they are often a great deal easier than you may think and, when used as Versals, they can look very impressive. The golden rule is to begin at the core of the letter and work outward.

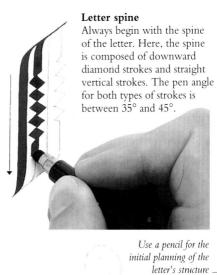

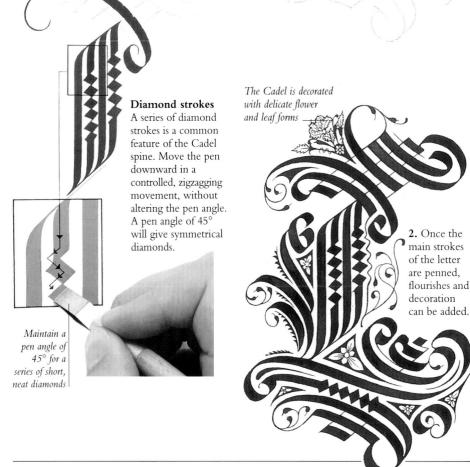

Cataneo's Cadels

1. Establish the basic structure

of the Cadel in

pencil before

retracing the strokes in pen. These letters B and C are based on the initials of Bernardino Cataneo, writing master at the University of Siena, Italy, between 1544 and 1560. In their original form, they were used with text in Rotunda (pp. 86-87) and Italic (pp. 96-97).

added last 2. Build up the skeletal form with loops at the top of the bowl and spurs to the left of the stem. Scrolls can be added as a final flourish.

The decorative

flourishes are

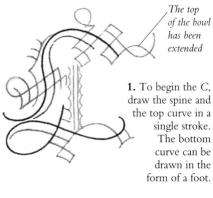

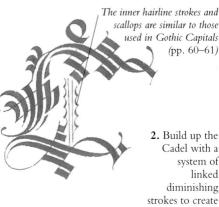

2. Build up the Cadel with a system of linked diminishing strokes to create "boxes" (opposite).

This pattern

three "boxes"

involves a series of

four small "boxes,"

followed by a line of

Drawing a Cadel A

This apparently complex A can be built up quite quickly in four stages. Diamonds have been drawn into the legs of the A, so keep a constant pen angle to ensure an even distribution of thick and thin strokes.

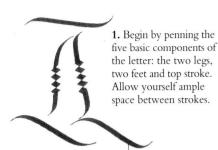

Straight horizontal strokes are best avoided, so use curved diagonals for the feet of the A

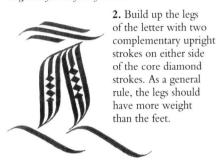

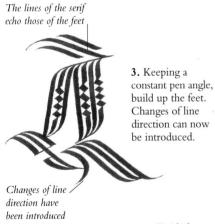

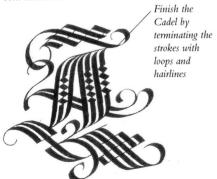

4. Now add the crossbar, breaking the strokes as they cross the lines of the legs. Finally, add the decorative loops and flourishes.

Cadel ornamentation

In order to build up the weight of a main stroke or to create a change in line direction, various types of ornamentation can be used. The patterns shown below have all been created with the pen at a constant angle. Each involves a series of short strokes that move at 90° to each other in a series of thin and thick "boxes." This simple device can be adapted to form increasingly complex patterns.

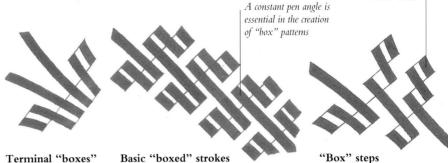

Terminal "boxes"

In this pattern, the use of "boxes" allows strokes to be terminated in different directions.

The basic principle of the "boxed" stroke is that when the pen moves sideways, a thin line is produced, and when it moves upward or downward, a thick line is produced.

"Box" steps

In a principle similar to the basic "boxed" stroke (above left), this pattern involves the "boxes" moving sideways in steps. This works best on curved strokes and requires careful planning.

terminal stroke or provide an infill.

The semicircular loops interlock without actually touching

Mirror images

This patterning is loosely based on a decorated descender from the 16th-century "Alphabet" of Mary of Burgundy. The two halves of the ornamentation suggest a mirror image. This decoration would work equally well from a top line of an ascender.

1. Begin by folding a sheet of lightweight layout paper in half - the fold will represent the center line of the image. Fold the paper again at a right angle to the original fold - this will represent the arm. Unfold the paper and work out the sequence, loops, and interlaces of half the pattern.

Small terminal loops should be drawn

complete; this is easier than trying

to construct half a loop

The balance of thick and thin strokes in the left arm will be the exact reverse of those in the right arm

Rotunda

The Gothic influence on western European scripts between the tenth and 13th centuries was largely resisted in one major country — Italy. The clarity of classical inscriptions, still evident throughout the land, the continued use of a wide, rounded hand called the Beneventan, and the retention of the Caroline Minuscule, were all factors in the emergence of a formal script that differed from its Gothic contemporaries in its round, open aspect. It was known as Rotunda.

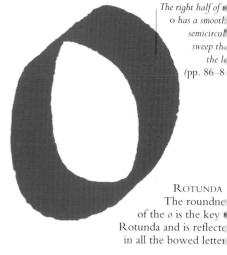

By the 12th century, the prestige Rotunda script had developed into an extremely formal and upright version of the Caroline Minuscule (pp. 38–39), with slightly shorter ascenders and descenders than its parent script. The hand also embodied elements of the Beneventan, most notably in the rounded strokes on many letters. In contrast, straight strokes were square-cut and rigidly upright.

A legible hand

In general, the Rotunda was bolder than the Caroline Minuscule, but the rounded strokes and modest ascenders and descenders created a clear, legible script that was used for handwritten work long after the introduction of printing. The simplicity of the letterforms made the script equally popular as a model for typefaces, thriving in that form until as late as the 18th century.

The many curved strokes, such as this on the letter 0, helped continue the Italian tradition of open, rounded scripts

The square baseline foot of the letter f is a distinctive characteristic of the Rotunda.

BOOK OF HOURS
This small Book of Hours, produced in
Bruges in about 1480, shows the evenness and
regularity of the Rotunda. The script differs
from that used for the Verona Antiphoner
(opposite) in one significant respect – the
upturned feet of the minims. Here, they are a
continuation of the minim strokes, which results
in slightly more cursive letters than was usual.

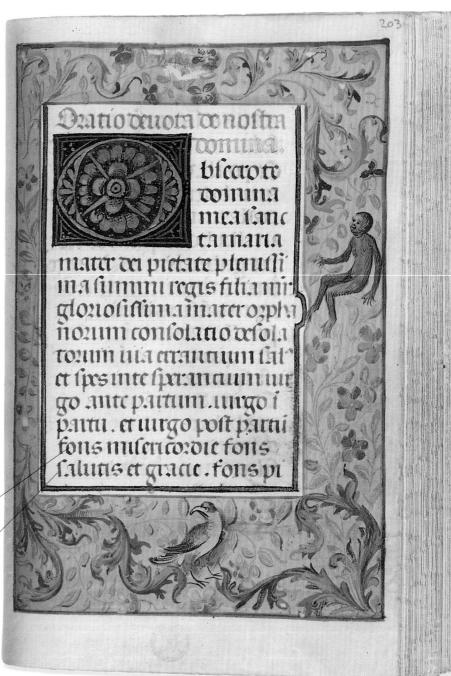

Large-scale letters

As a manuscript hand, the Rotunda was written in a full range of sizes, from very small to very large, and was the chosen script for some of the largest known manuscript books in the world. When written on a large scale, the letters can have a rigid formality and the hairline strokes often seem disproportionately light.

Rotunda Capitals

Accompanying capitals are written with the same pen as the minuscules (pp. 88–89). A double stroke can be used for the stem, with a clear gutter between strokes. In some historical instances, the Rotunda Capital developed into a Versal. In others, Gothic or Lombardic Versals were used with Rotunda text script.

A common feature of all Rotunda letters, both minuscule and capital, is the sharpness of the cut of the nib, which gives clear, precise strokes and fine hairlines. In larger versions, the pen should be clearly lifted after the completion of each stroke, while in smaller versions, many strokes can be drawn in one continuous movement.

These large-scale Rotunda letters lack any cursive features: note the angularity with which the ascenders and straight minim strokes have been drawn

> Compare the unusual broken forms of the strokes on capitals A, C, and E with the more common form (pp. 88-89)

THE VERONA ANTIPHONER

This Antiphoner (book of chants and anthems) was written in about 1500 for the monasteries of SS Nazro nd Calio in Verona, Italy. This type of book was often written in a large format to enable several choristers to ead it at the same time. The Rotunda letters have been drawn with considerable precision, with idiosyncrasies rising only in the unusual broken form of the capitals.

> This Caroline form of d features an upright stem and curved bowl.

ROTUNDA AS A TYPEFACE

The type used in this dictionary was possibly from the founts of the Venice-based German printer Erhard Ratdolt (pp. 90-91), who had punches cut for a Rotunda type in 1486. This detail shows two different forms of d: the uncial form and the upright Caroline form - both can be seen in the middle of the sixth line.

Emphitheosis sm Azo.i sum. C.de iure em phi, z fm Bof, in sum, rubzi, de loca, z cons duc, s, dd sit emphitheof, dz g emphitheo sis grece è meliozatio latie. Ab initio ei tm sterilia phúc pou pcedebát: vt is quecipet re i melioze staru deduceret: 2 sterile fertiles redderet.postea tu pmissus e o reb fertilib z fructuolissimis emphitheoticari posse:vt C.ve sure emphilifin on. Et de emphithe osis velempbitheotic otractus ille qui in

Rotunda

 ${f R}^{\rm OTUNDA~IS~AN}$ upright, open letter, which works well on both a large and small scale. The characteristic straight stem strokes, such as those on letters b,f, and h, are constructed with the pen held at about 30°. The square foot is then added in one of two ways. The simplest method is to use the corner of the nib to outline the foot, before filling it in with ink. Alternatively, the "dual ductus" technique can be used, which involves turning the pen from 30° to the horizontal in one short movement. Although the latter may seem more complex, it is probably preferable when drawing large Rotunda letters.

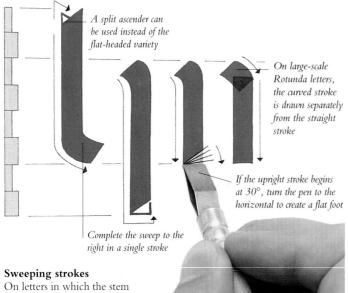

On letters in which the stem stroke ends in a right sweep, such as *l* (*above*), the sweep is usually completed in a single stroke. On larger letters, two separate strokes are used (see *b*, *l*, and *t*, *right*).

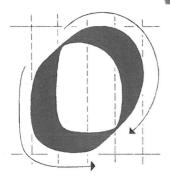

Key letter

The o is the key letter of the Rotunda. The bowls of b, d, g, p, and q closely follow its shape, and its open aspect is also echoed in the ε and ε . The first stroke is only slightly curved, closely following a vertical before sweeping vigorously to the right. The second stroke is much more semicircular than the first.

Terminating flicks

As an alternative to the sweeping stroke, letters m, n, and u can terminate with a flick. These are severe and rather mechanical; the stroke is simply executed with a pen angle of 30° and without any directional turn of the pen.

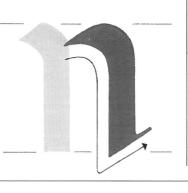

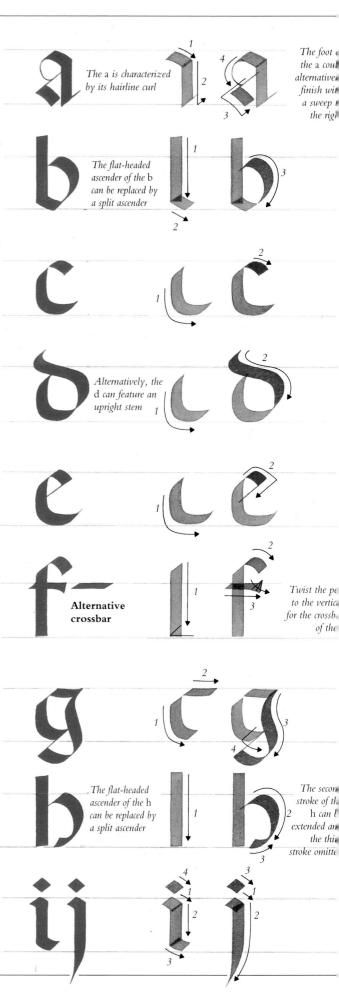

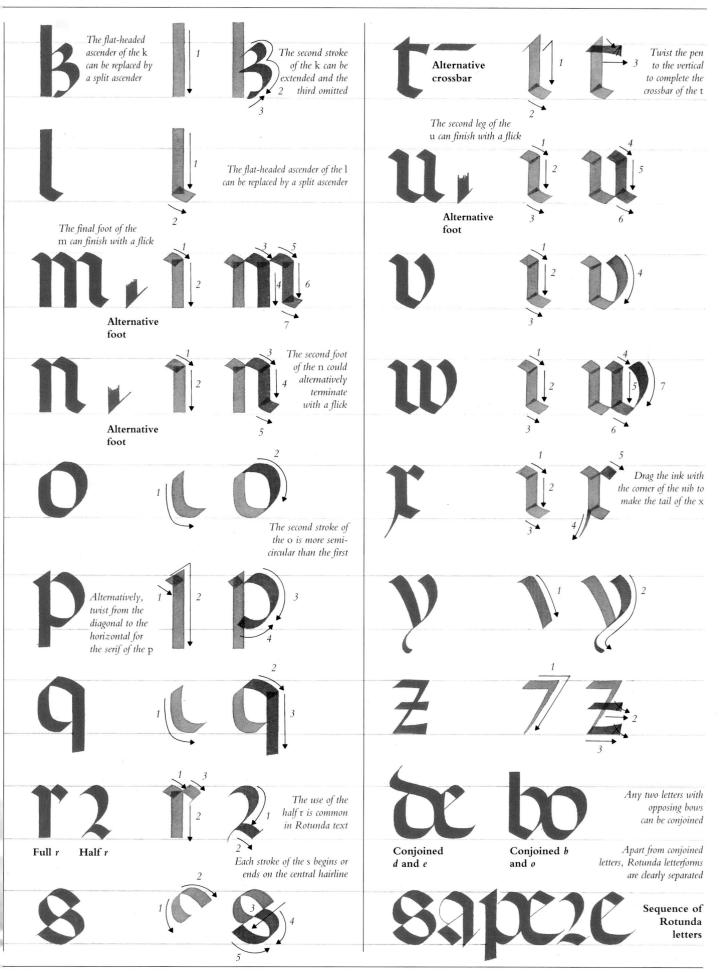

Rotunda Capitals

The structure of the Rotunda Capital is less clearly defined than the minuscule (pp.~86-87). Both single and double stem capitals can be used; historically, they were often combined with Lombardic Capitals (pp.~64-65). The double stem capitals shown here have been taken from a number of sources and should be regarded only as guide for individual interpretations. As with the Rotunda minuscules, a "double ductus" applies, with all curved strokes and some upright strokes drawn with the pen at 30° , and the remaining strokes drawn with the pen at the horizontal.

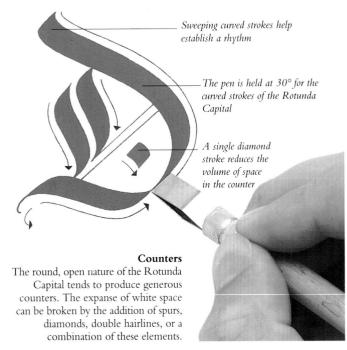

The feet are outlined and filled in with the corner of the nib

Alternative form of M

In this form of *M*, the double stroke is in the center of the letter and a large sweeping stroke has been incorporated. The volume of space in the counter has been reduced by the double hairline.

Square feet

If the pen is at 30° at the top of the stem, the angle should be maintained for the whole stroke, finishing at the baseline. To create the square foot, use the corner of the nib to trace along the baseline and up to join the right side of the stem. Fill in this triangle of white space with ink.

The gap between the two stem strokes should be about half a pen width

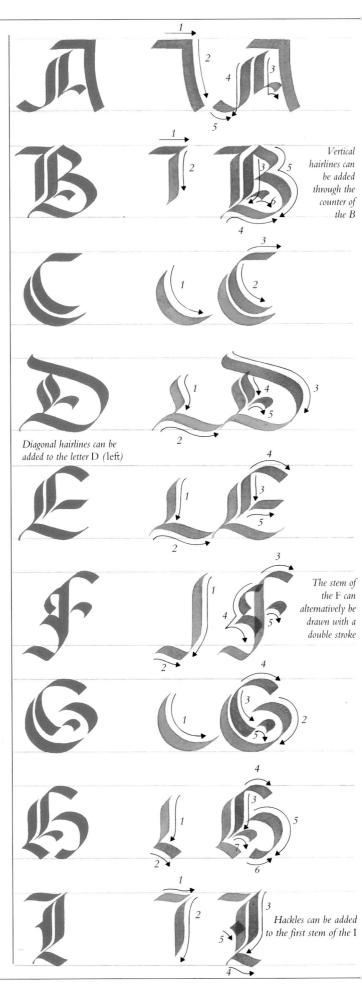

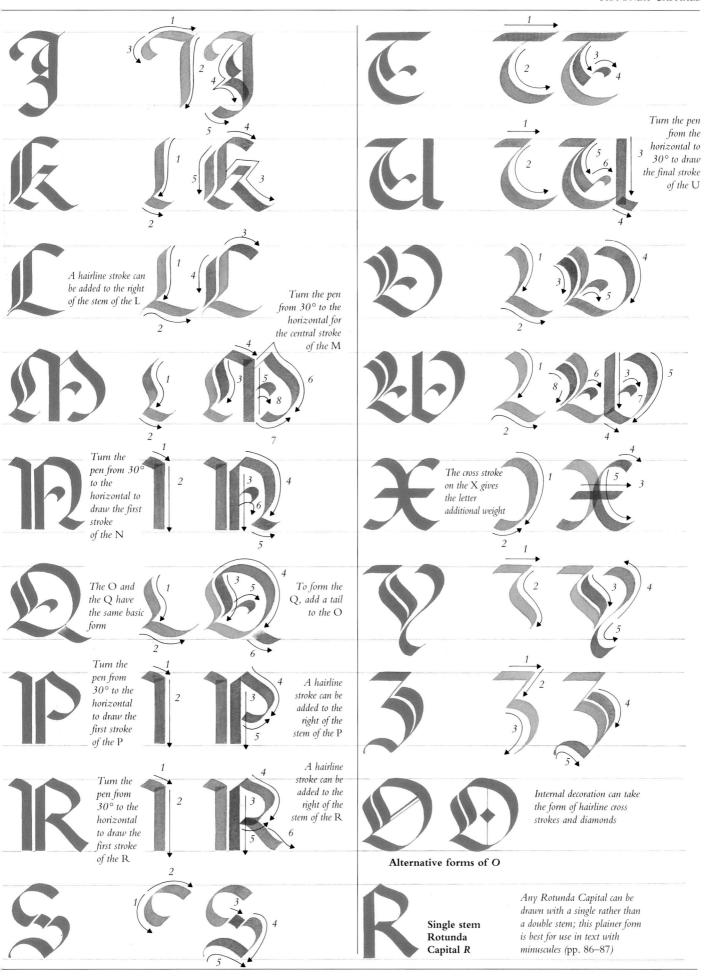

Humanist Minuscule

THE HUMANIST MINUSCULE (*Littera Antiqua*) and the Roman Imperial Capital (*pp. 108–109*) are the two historical scripts most influential in our modern society. Between them, they give us the basic constructions of our capital and lowercase letters, both in handwritten and typewritten form. In the Humanist Minuscule, the darker overtones of the Gothic scripts gave way

to the lighter style of the Renaissance letter. It would be difficult to envisage a script better suited to the intellectual ideals of the age.

The Humanist Minuscule was essentially a rediscovery of the Caroline Minuscule (pp. 38–39). As a clear, unambiguous hand, free from affectation, the Caroline was considered by 14th-century scholars, including the Italian poet Petrarch, to be in harmony with the ideals of the Renaissance.

Although the Humanist Minuscule was to have a profound and formative influence on modern Latin-based writing, acceptance of it was initially slow. The widespread popularity of the script came only after manuscript books were superseded by printed works, and it was adapted as a model for text typefaces, notably by Nicholas Jenson of Venice after 1470 (pp. 38–39). It gradually replaced the Rotunda in Italy (pp. 84–85) and the Gothic scripts of Britain and southern Europe as the principal model for typefaces.

BOOK OF HOURS
This Book of Hours was written in Bologna in about 1500 for Giovanni II Bentivoglio.
Arguably, the sumptuous decoration and bright colors of the Versals detract from the dignity of the text script itself. The flat serifs at the heads of the ascenders are the natural product of a horizontally held pen (pp. 92–93).

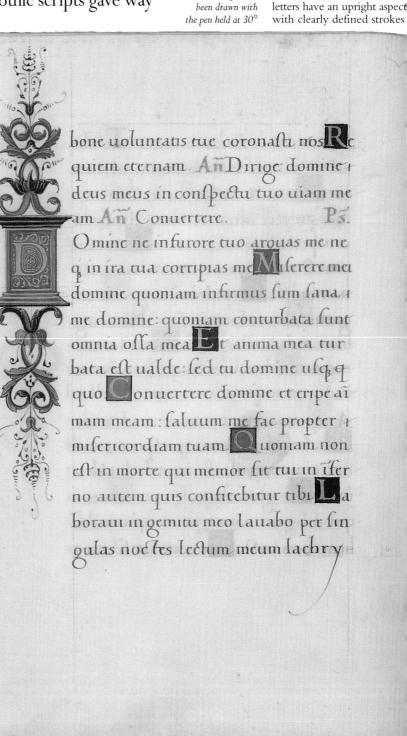

The serifs have

HUMANIST MINUSCULE *M* All Humanist Minuscule

Note the scrupulous consistency with which these small ampersands have been drawn throughout the text

The book has been

The Versals are based on Roman and not Lombardic letterforms (pp. 58–59)

handwritten on vellum

ST. PAUL'S EPISTLE Written in about 1500, this text combines Italic and Humanist Minuscule hands to dramatic effect. Despite the diminutive size of the letters, reproduced here approximately the same size as they are written, each character remains distinct and clearly legible. At a glance, the manuscript may be mistaken for a printed book.

In this margin annotation, the early use of Arabic numerals is evident

PRINTED TEXT Fifteenth-century text type was closely modeled on the handwritten letters of the period. The similarities between this typeface (below), printed after 1486, and the handwritten Humanist Minuscule of St. Paul's Epistle (above) are very clear.

The same serif formation has been used for both capitals and minuscules.

plani. P. i.g. c. zo. de To torro y lauro filia dec. 12. J. T. p. n. pel'a fie. Torriga que e na. -12. plan. na. pff. P. 2. c. 97. ce e de urlo marmo spal' retal g' ad alias naras. l'. 3. c. 12. apud 193 plani.

Gene 2.Mat.19

Mar in Lad Co

rinthins 6

Secenaus in fide effe sextendion in his vita

adials, Execto Marig. Lucis. Mario, Ently

> he had adopted the Caroline Minuscule as a model for his hand. These Italic letters were probably cut by the goldsmith Francesco Griffo in 1501

THE HANDWRITING

The script developed by Francesco Petrarch

was probably the first

Humanist Minuscule.

This annotation by

the poet to his copy

of Suctonius's Lives of Caesars, was made in

about 1370 and clearly

demonstrates the

degree to which

OF PETRARCH

ex eis quæ manifeste apparent concludamus, as na nobis alibi demonstratis, atque ab ipso adeò naquæça anima is pars humorem ad se loco alissius naturats, permutat. Est autem unicuiça par elicet est, non secudum humorum quæ ipsi insunt lidorum corporum substantiam, a quibus etiam alteratio contingit. Verum siquidem hoc ita

Cöcludit cö tra Aristot, testes semen generare ex coq; nutriri Ad Ephelios

F. pifto.beati Pauli

about fed nutrit & fourt cam ficult

Christus ecclesiam : quia membra fo

mus corporiseius de carne eius & de

offibus eius. Propter ho relinquet ho

mo patrem & mattem fuam dad

herebit vxori fuz: & etunt duo i cat

ne vna. Sacramentum boc magnum

ell. Ego autem dico in christo 861

ecclefia. Verutamen & vos finouli

vnulquila vxorem fuam ficut leip

fum diligat : vxor autem timeat viru

os er parentes quomodo muicem viusi instituit deimde servos er dominos, si siluparentes honorent, parentes illos

ad wacundia non prouocent Serus [b

rech fint dominis, domini bemone illes

tractent Postremo in universum I

phefins ad militiam fides hortatur vi

ell. Honora patrem tuum & matrems

tuam: quod est mandatum primum

Hii obedite parentibus vris

in domino. Hoc enimiusta

Cap Seq. Apostolus, primum fili

in promissione vi benefit tibi & fis lo genus Super teeram . Et vos patres no lite ad iracundiam prouocare filios ve ftros fed educate illos in disciplina et correptione domini. Serui obedite do minis carnalibus cum timore & tremo re in simplicitate cordis vestri sicut ch No non ad oculum feruientes quafi ho minibus placentes: fed vt ferui christi facientes voluntatem dei : ex animo cui bona voluntate semmentes sicut domi no & non hominibus fcientes quonia vnulquilqs quodcungs fecerit honum hor recipiet a domino, fine fernus fine liber. Et vos domini eadem facite illis remittentes minas : fcientes quia ceillo rum & vester dominus est in celis et lemi 15 adies personarum acceptio non est apud deu De caterofratres confortamini in do mino & inpotentia virtutiseius. In duite vos armaturam dei vt polítics stare adversus insidias diaboli quo mam non est nobis colluctatio aduer fus carnem & fanguinem, fed aduer

Lenting, addie.
2. ad Col. 5.

Advanio 12.2.
1. Perrin ad Col. 5.

A small letter

Like the Caroline Minuscule, the Humanist Minuscule was an elegant hand that worked most successfully on a small scale. This is evident in the diminutive letters of the Epistles text (above). In Italy, the Rotunda (pp. 84–85) continued to be used for large-scale book work.

Versals and capitals

Versals, so popular with Gothic scribes, were also used with the Humanist Minuscule, but these were increasingly modeled on Roman forms (pp. 108–109). The use of capitals for sentence openings was now universal. Also derived from Roman forms, the Humanist Capitals were drawn with the same ductus as the minuscules and were the same height as the minuscule ascender (pp. 98–99). A rigid adherence to ascender and descender lines, along with clear line separation, helps give an ordered aspect to a page of text.

Humanist Minuscule

The Humanist Minuscule is a direct descendent of the Caroline Minuscule (pp. 40–41). Letters are clearly defined, separate, and open; very close in form to modern letters, particularly those used as typefaces. There is no exaggeration of ascenders and descenders in the script and interlinear spacing is clear and regular. Humanist Minuscule can be written with a square-cut "slanted" or an oblique-cut "straight" pen. The letters shown here have been written with a "straight" pen. In both cases, the letters are upright and usually small in scale, with a minim height of about five pen widths.

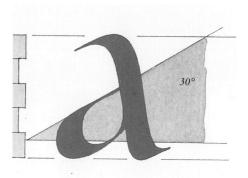

"Slanted" pen

The "slanted" pen Humanist Minuscule is based on the early hand of Poggio and relates quite closely to the Caroline Minuscule. It is written with a pen angle of 30–40°. The *a* is a double-story letter; this distinguishes it from the Italic *a*, which is a single-story letter (*pp.* 96–97).

During the latter part of the 15th century, there was an increasing tendency to write the Humanist Minuscule with a "straight" pen. The pen angle for this is shallow (5–15°) and a greater contrast between thick and thin strokes can be produced.

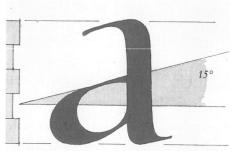

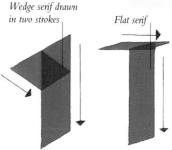

Serif types

The script features two types of serifs: wedge-shaped and flat. The wedge serif is created either in a single stroke or in two separate strokes (*above*). The flat serif is created with a single horizontal stroke. When using a "straight" pen, the flat serif can also be used to terminate upright minims and descenders (see letters *f*, *h*, *k*, *m*, *n*, *p*, *q*, *r*, *opposite*).

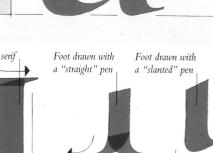

Minim feet

When using a "slanted" pen, the tendency is to create a turned foot, produced by terminating the minim stroke with a flick to the right. When using a "straight" pen, this flicking movement is more difficult. Instead, use the flat serif, or finish the stroke with a slight movement to the right along the baseline and then add a separate serif to the left.

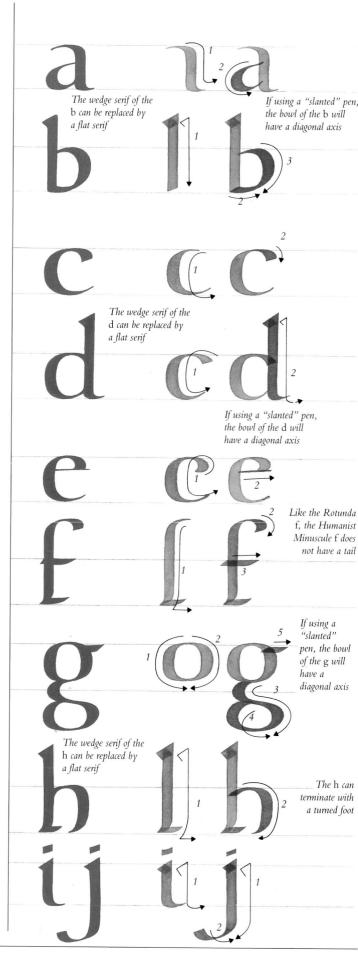

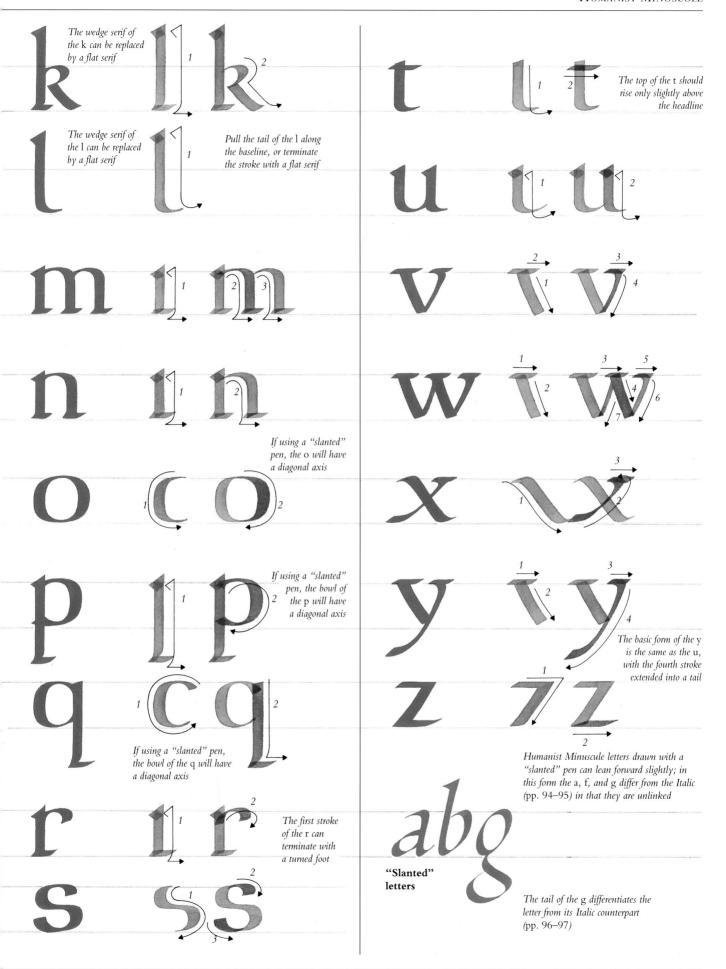

Italic

In ITS BASIC FORM, Italic script (Chancery Cursive, Cancellaresca Corsiva, Littera di Brevi) is a cursive offspring of the Humanist Minuscule (pp. 90–91). Over time, it became a distinctive hand in its own right, spawning, in turn, the Copperplate (pp. 102–103). The script was invented in 1420 by Niccolo Niccoli, an Italian scholar who found the Humanist Minuscule too slow to execute. By 1440, his new, less labor-intensive script had been adopted as the official hand of the Papal Chancery.

ITALIC *A*The Italic *a*, with its fully formed bowl, is the earliest ancestor of our modern lowercase letter *a*.

Letters generally join at the midway point between the baseline and the headline

THE FOUR BASIC characteristics of Italic that were established by Niccoli tend to occur naturally when the Humanist Minuscule is written rapidly and with the minimum number of pen lifts: there is a tendency for the hand to lean to the right; circles become more oval; many letters can be written in a single stroke; and letters are joined to each other with a connecting stroke.

Changing the a

The character altered most significantly by Niccoli was the *a*, which he transformed from a tall two-story letter (*p. 92*) into a single-story letter of minim height (*above right*). His *q* also tended to follow this new form, resembling an *a* with a tail.

The terminals of Italic ascenders and descenders were drawn in one of two forms: the formata (semiformal), in which they were horizontal or wedge-shaped and left-facing, or the corsiva, in which they were rounded and right-facing (pp. 96–97).

TREATISE ON HAWKING
This page from a work by the Italian scholar
Francesco Moro was penned in about 1560-70
and consists mainly of alphabets and texts in
different hands. At the top, in gold, are two lines
of Cadels (pp. 80-81). Beneath the blue border
are the Italics, fully separated and generously
spaced. The minuscule hand is a formata,
identifiable by the wedge-shaped ascender serifs.
Four lines of Textura Quadrata (pp. 50-51)
follow and, below the green border, there are
several lines of Humanist Minuscule (pp. 90-91).

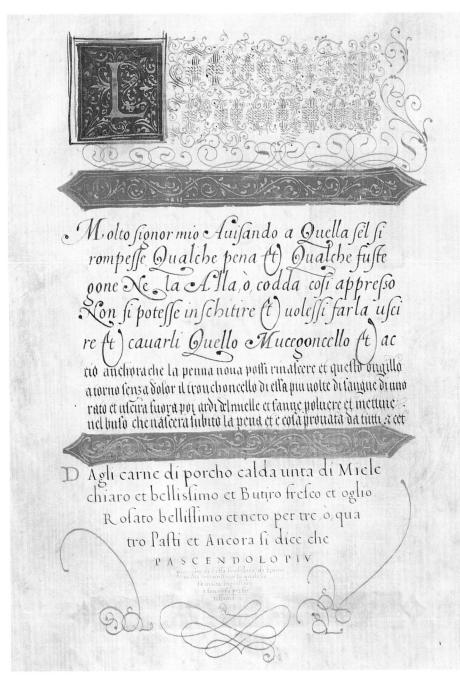

FVRIVS IN QUARTO AN NALIressatur pede pessimucro mucrone: uiro uir. Hinc Virgilius
Here pede pessi densus uiro uir. Homeri est. Hunc secutus
stius poeta in libro secundo belli hystrici ait. Non nist mini
que centum: atq; ora si etiam to tidem uocesq; liquate. Hin
Virgilius ait. Non mini silingue centum sint oraq; centum:
merica descriptio est equi sugientis in hec uerba.

The long ascenders and descenders have presented a problem for the scribe where they clash in the interlinear space

In this Italic text, the calligrapher has included both formata and corsiva ascenders; this 1 is the corsiva type

PRINTING TYPE CATALOGUE
This design from 1990 is by the
Norwegian calligrapher Christopher
Haanes. He has achieved harmony
between the capitals and minuscules
by reducing the size of the capitals
to just above minim height.

SATURNALIA
This fine Italic script was written by Ambrosius
Theodosius Macrobius in 1465. Each letter is
clearly defined, reminiscent both of the Humanist
Minuscule (pp. 90–91) and the earlier Caroline
Minuscule (pp. 38–39). The capitals are small and
restrained compared with those by Moro (opposite).

The influence of type

The changing demands brought about by the developing printing industry of the 15th century had an important influence on the Italic script. In 1501, the Venetian printer Aldus Manutius commissioned goldsmith Francesco Griffo to design a small Italic type (pp. 90–91) in which most of the characters were clearly separated. From that point, calligraphers began to follow the example of type by separating their penned letters. This led to a loss of some of the Italic's cursive quality and the script quickly reached its full maturity as a carefully crafted text hand. But by the 1550s, the complaint from scribes was that it had become too slow to write. From then, its decline was rapid, eventually being used only for text in parenthesis and for annotation.

Johnston's o

For the modern calligrapher, Italic script remains a constant source of inspiration. However, much new Italic can be traced back not to the 15th century but to the influence of the early 20th-century calligrapher Edward Johnston. The script was subtly modified by his introduction of two pulled strokes for the *o* and related letters, in place of the original single stroke (*pp. 42–43*).

The relative crudity of Morris's capital letters is probably due to his use of a pointed pen nib rather than the more suitable broad-edged nib

Although clearly an Italic script, Morris's letters are noticeably upright compared with a classic Italic such as Francesco Moro's (opposite)

William Morris Although Edward Johnston is generally regarded as the father of modern calligraphy (pp. 42–43), William Morris had been exploring the methods of medieval scribes two decades before him. This illuminated work of 1874 is an attempt to realize the vision of the Arts and Crafts movement by achieving communion between craftsman and tool (pp. 42-43). But since a pointed nib rather than a broad-edged pen has been used to draw the capitals, the attempt is only partially successful.

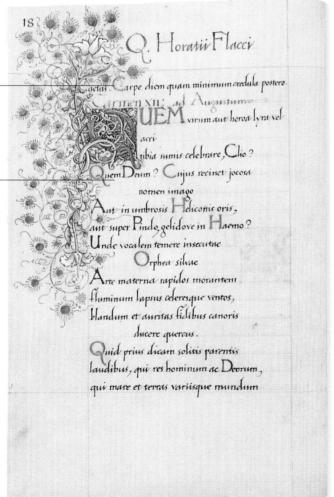

Italic

The Italic hand is written with a square-cut "slanted" pen, held at an angle of between 35 and 45°. Letters should be written with the minimum number of pen lifts — most can be written with a single stroke. The two traditional examples shown here are formata and corsiva. Formata letters are distinguished by the wedge serif to the left of the stem, corsiva by the swashes to the right of the stem. Ideally, the two different types should not be mixed. The o is the key letter of the script; it establishes the basic ductus of the hand, the curve of other letters, and the letter width (below).

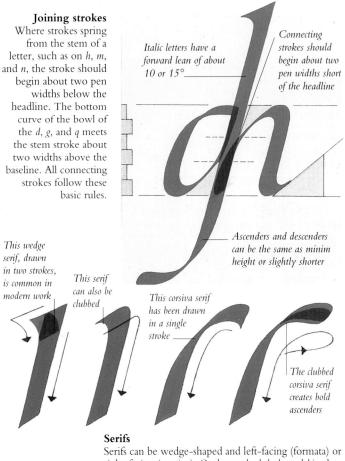

Step-by-step o

Serifs can be wedge-shaped and left-facing (formata) or right-facing (corsiva). On letters *b*, *d*, *h*, *k*, and *l* in the alphabet (*right*), both formata and corsiva types are shown.

1. To create the o in a single stroke, use an angle of 40° . Begin just below the headline and push the pen upward to the headline, before curving down to the left.

2. Maintaining the 40° pen angle, curve the stroke downward toward the baseline, before moving along the baseline and beginning to curve upward.

3. Push the pen toward the headline in an arc, meeting the top curve just below the headline. Alternatively, draw the letter in two strokes (*opposite*).

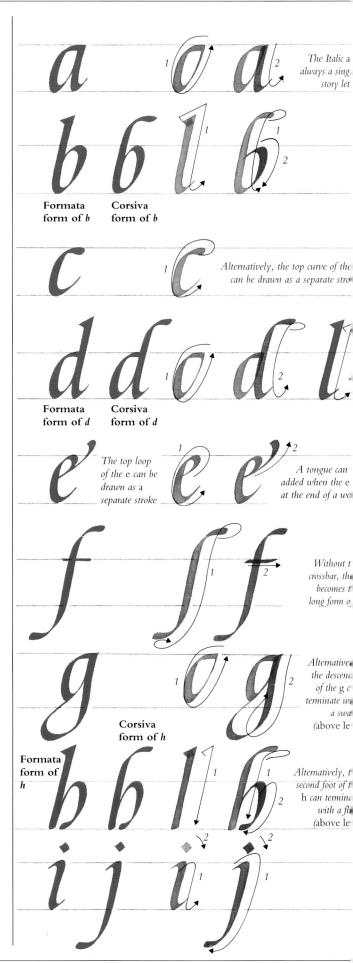

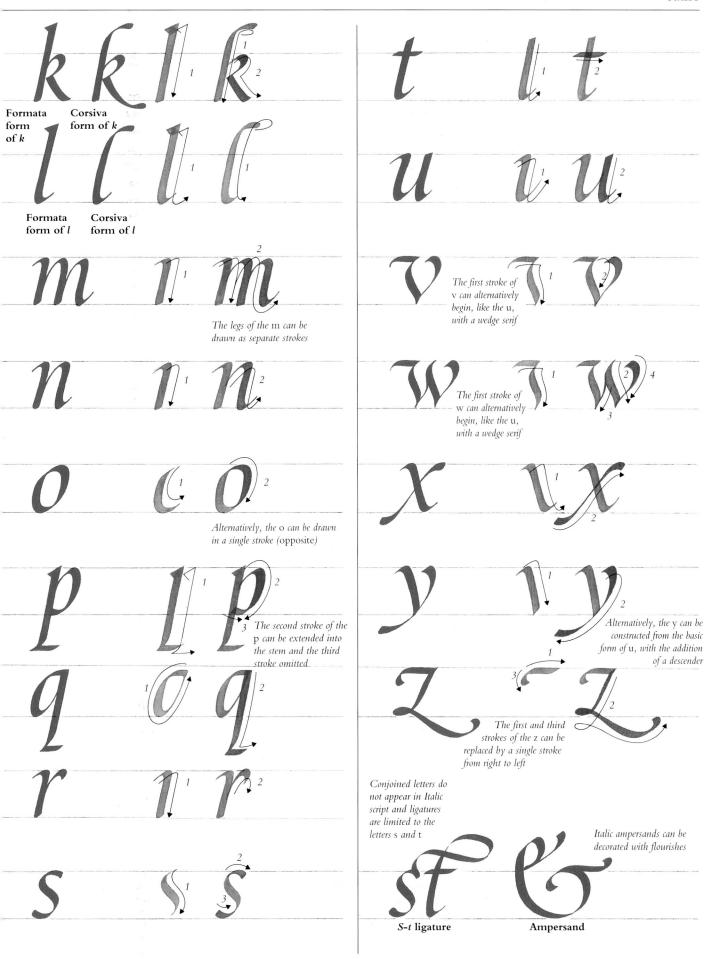

Humanist & Italic Capitals

Humanist Capitals are closely modeled on Roman Imperial Capitals (pp. 110–119) and can be used with the Caroline Minuscule (pp. 40–41) and Foundational Hand (pp. 44–45), as well as with Humanist Minuscules (pp. 92–93). A pen angle of 30° is most likely to produce letters with a similar stroke weight to the stone-cut Roman originals. Italic Capitals are based on the Humanist letterforms but have a distinctive forward lean. There are various possible serif formations (below), and any of these can be used on either type of capital.

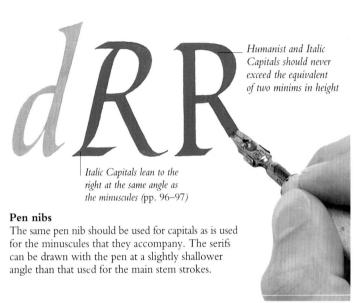

Arm serifs

Draw the arms of E and F and the top curves of C, G, and S in a single stroke and, if desired, build up the two serifs with the corner of the nib.

Alternative serifs

Alternatively, the top left serif can simply be the beginning of the stem stroke and the right serif can be created with a slight flick to the left.

Basic foot serif

Create the basic foot serif by extending the stem to the left and finishing with a baseline stroke.

Bracketed serif

Alternatively, finish the stem stroke with a sweep to the right and add the left serif separately.

Inner fillet

A third option is to draw the basic foot serif (*left*) and add the inner fillet with a short curve.

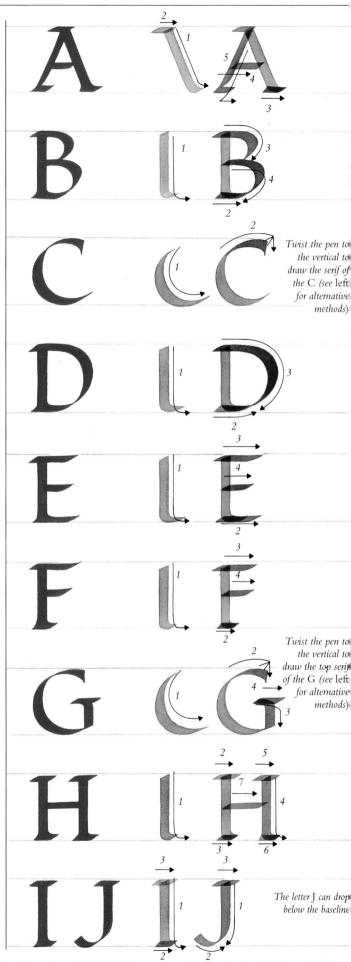

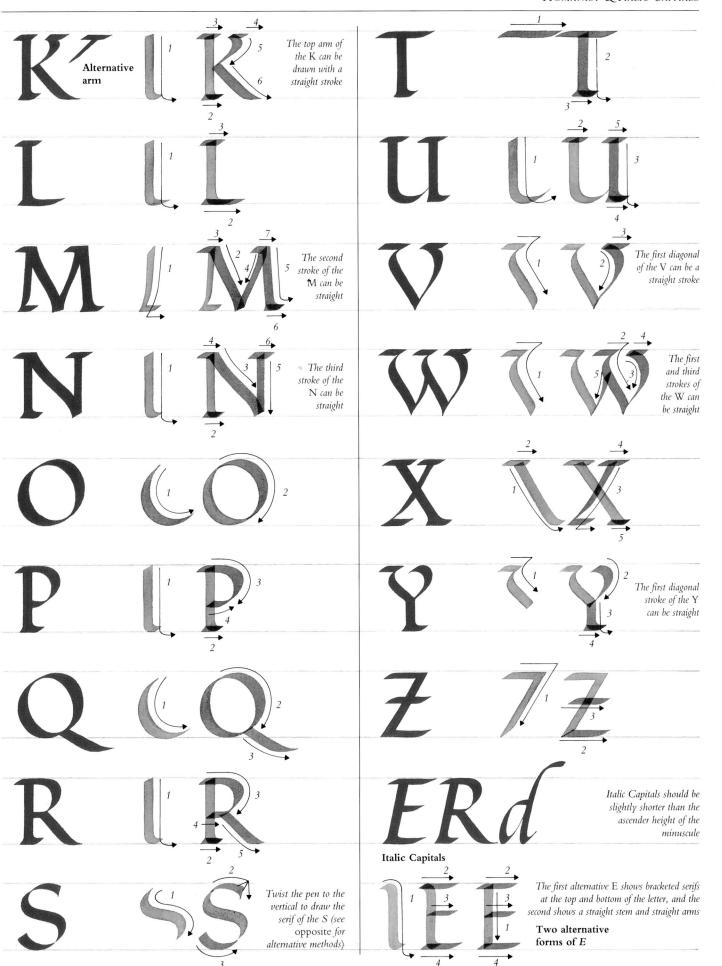

Italic Swash Capitals

SWASH CAPITAL IS A flamboyant letter that traditionally served A similar function in Italic text to that of the colored Versal in Gothic text (pp. 58-59). It should never be used to write a complete word, but can be combined with standard Italic Capitals (pp. 98–99). The Swash Capital's characteristic showiness is created by the extension of stem strokes above or below the capital line and the extension of bowls and horizontal strokes to the left of the stem. These extended strokes terminate with a swash or, instead, can be looped like Copperplate Capitals (pp. 106–107).

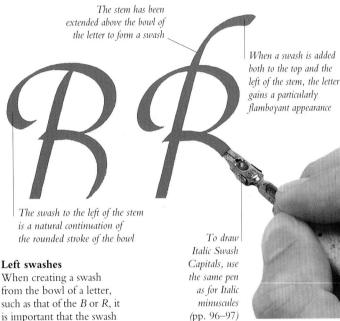

When creating a swash from the bowl of a letter, such as that of the B or R, it is important that the swash is a natural extension of the bowl stroke, with the pen pulled in a sweeping movement. The letters in the alphabet (right) show the swashes added as separate strokes.

Top swashes

The stem can be extended upward and pulled to the right in the manner of a corsiva ascender on the Italic minuscule (pp. 96-97).

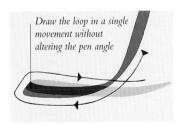

Looped terminals

This clubbed, looped terminal can be used as an alternative to the swash in finishing the stem stroke. It works particularly well on a single stem letter such as an I or P. Create the loop by crossing back over the stem and pulling the stroke out to the right.

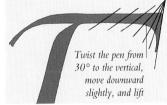

Formal arm serifs

This formal type of serif provides an elegant contrast to the flourishes. In construction, it closely imitates the brush-drawn Imperial Capital serif (pp. 110-119). On reaching the end of the arm, begin to twist the pen from 30° to the vertical.

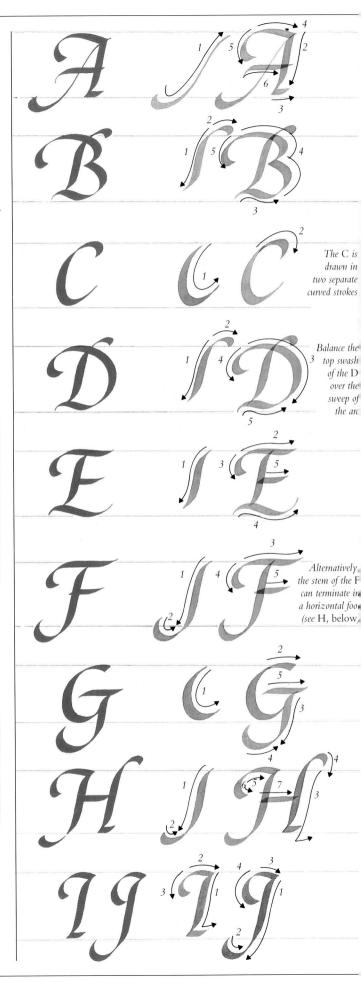

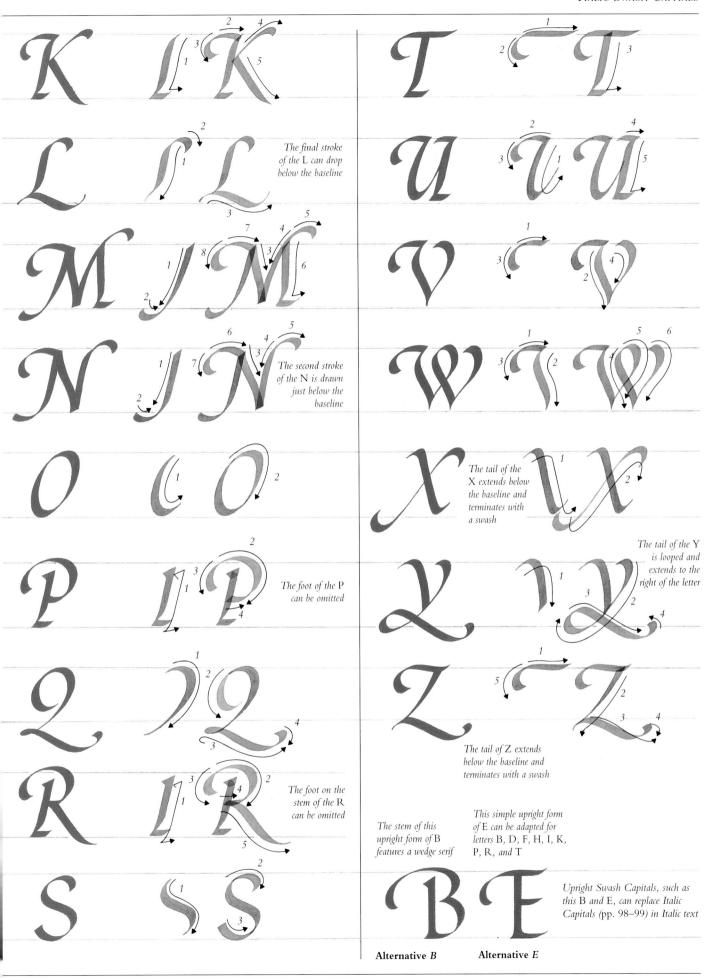

Copperplate

A LTHOUGH THE ITALIC script began life as a quickly penned, cursive version of the Humanist Minuscule, by the beginning of the 16th century it had become a formal script in its own right with a correspondingly slower ductus (pp. 94–95). In 1574, an instruction manual for Italic script was printed from text that had been engraved on sheets of copper with a pointed tool known as a burin. The hand developed for this new engraving method, combined with the narrower pen and slanted writing angle that scribes had begun to favor, led to the emergence of a new handwritten script: Copperplate.

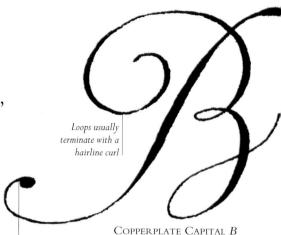

The stem of the Copperplate Capital usually terminates with a blob

COPPERPLATE CAPITAL B
Although written to the same stroke thickness as the minims, Copperplate Capitals tend to be relatively large (pp. 106–107). The degree of expansion or contraction should closely echo that of the minim.

The principal innovation of the Copperplate was that, for the first time, all the letters in a word were linked, making it a fast and practical hand to write. By the mid-18th century, it was the established script of commerce, replacing the various bastard hands that had previously been used for much business and vernacular work in Europe (pp. 66–79).

Throughout the 17th and 18th centuries, Copperplate writing also acquired the status of an art form suitable for gentlefolk, who used the impressive script for both private and business correspondence. Eventually, Copperplate replaced the Humanist hands — including the Italic itself — altogether.

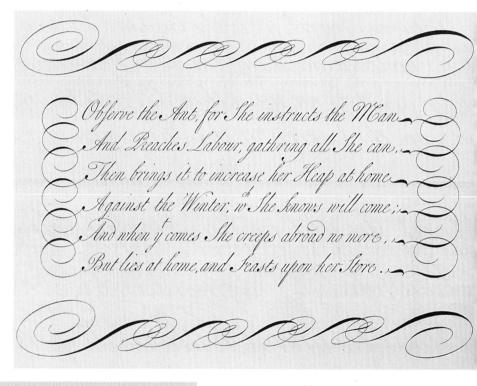

On, on, with feweful voolence, it came, The raying tempest, with its voice of thunder,
The whorlivind breath and eye of land flame,
Rending the up filed grande works a funder,
brushing the fresh trees, and making tame
The fierest animals with and and wonder;
On, on it came, and at the midnight hour
Had reached its height - the youth of its power.

THE UNIVERSAL PENMAN

This version of an instructional text by Samuel Vaux is from The Universal Penman, a celebrated volume of engraved work by the calligrapher and engraver George Bickham. Published in 1743, the book epitomized the elegant writing manuals of the 18th century. The engraved letters, written with very few lifts of the tool, closely follow

pen-drawn Copperplate letterforms.

Walpurgis Night

This handwritten text of a poem by the artist Richard Dadd dates from about 1840. The letters closely follow the approved "school" hand of the period: the minims are small, ascenders are relatively large and unlooped, and the hand is written at a very steep angle of nearly 40°.

Good Sense and Good-Nature are never separated, tho the ignorant World has thought otherwise; Good-Nature, by which I mean Beneficence and Candor; is the flroduct of right Reafon, which of necessity will give allowance to the Failings of others, by considering that there is nothing perfect in Mankind.

"HE UNIVERSAL PENMAN" his engraving of an instructional ext by W. Kippax is also from George Bickham's *Universal* Penman. Notice the looped and nlooped forms of ascenders sed; on the third line, the word which" includes both types.

1) III Compare Virus

"COMMAND OF HAND"

In order to maintain their status as teachers, the 18th-century writing masters often produced a series of virtuoso calligraphic performances that were each known as "striking" or "command of hand," in which increasingly complex baroque flourishes were produced without the removal of pen from paper. This ornate work is one such example.

The strokes cross each other at the most acute angle possible

The loops, drawn to varying sizes, would have been carefully planned in advance

COPPERPLATE WORKSHOP
In letterpress printing, the raised surface of the type is inked and impressed onto paper. In copperplate (intaglio) printing, this process is reversed. Ink is applied to the inscribed surface and wiped from the face of the plate. Dampened paper is then pressed onto the plate, picking up the ink from the recesses. In this engraving, we can see the paper being forced onto the plate, while, in the background, printed sheets are drying on the racks.

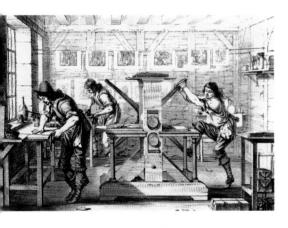

The calligrapher has broken with Copperplate convention by looping the letter d

DAVID HARRIS
In the past, the production
of Copperplate script from
type was a very limiting
process – joins did not fully
connect and ascenders and
descenders were atrophied.

This 1984 design for a Copperplate typeface shows smoothly linked letters that are very close in form to the engraved script. designed by David Flavis

currently in course of development

and production by Fonts

Copperplate in education

The adoption of Copperplate script, occurred remarkably rapidly, a phenomenon due partly to the role in education of the writing master. In the past, writing skills had been taught by university academics, but by the late 17th century, increasing literacy and the demands of business created the need for a teacher who taught writing exclusively. Examples of writing masters' work were reproduced by copperplate engraving, and schoolbook manuals began to supersede the elegant writing manuals – such as *The Universal Penman* — that previously had been widely favored.

Technical skill

By the 19th century, Copperplate was the standard school hand in Europe and the United States, and students were judged as much on writing technique as the content of their work. This emphasis on technical skill lasted well into the 20th century, when the Copperplate pen was usurped by the ballpoint pen, typewriter, and word processor.

Copperplate

This elegant script is probably the most cursive of all hands. Most letters can be written in one stroke and there are few pen lifts between letters. Minims can be slightly compressed and the characteristic loops of the ascenders and descenders can be drawn either open or enclosed. The best effects are often achieved by using compressed minims with enclosed loops. The fine lines of the burin engraving ($pp.\ 102-103$) are difficult to replicate with a steel nib but, with practice, impressive results can be achieved.

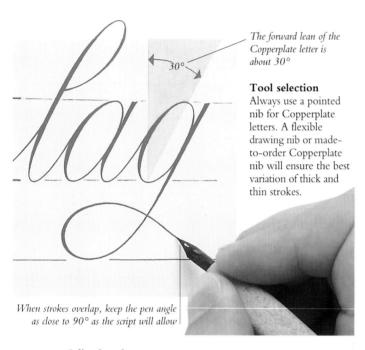

Adjusting the pressure

The pressure is adjusted twice on the average minim stroke. Begin with a gentle pressure to produce a fine line, increase it to thicken the stroke at the center of the minim, then relax it again at the bottom of the stroke.

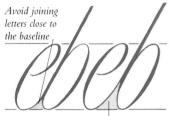

Try to leave a neat triangle of space between each letter

Internal spaces

Once you have decided whether to use compressed or expanded minims, make sure each counter contains the same amount of space. The interletter space should be approximately half the internal space.

Linking letters
Link letters wherever possible,
ensuring that the link is as high up
the stem as is practicable. Do not
join letters near their base.

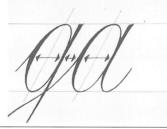

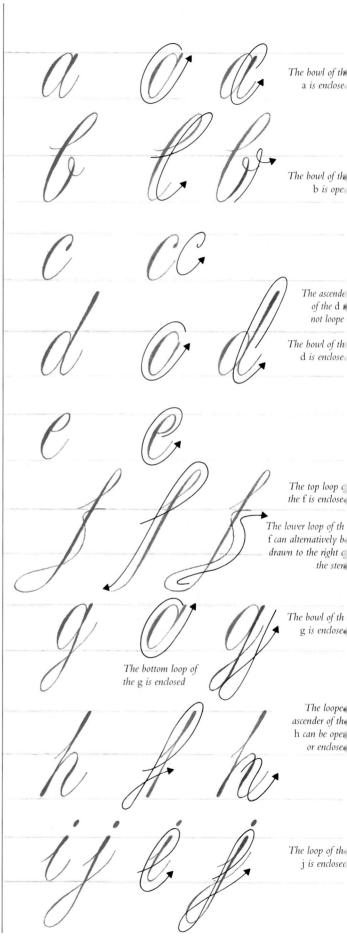

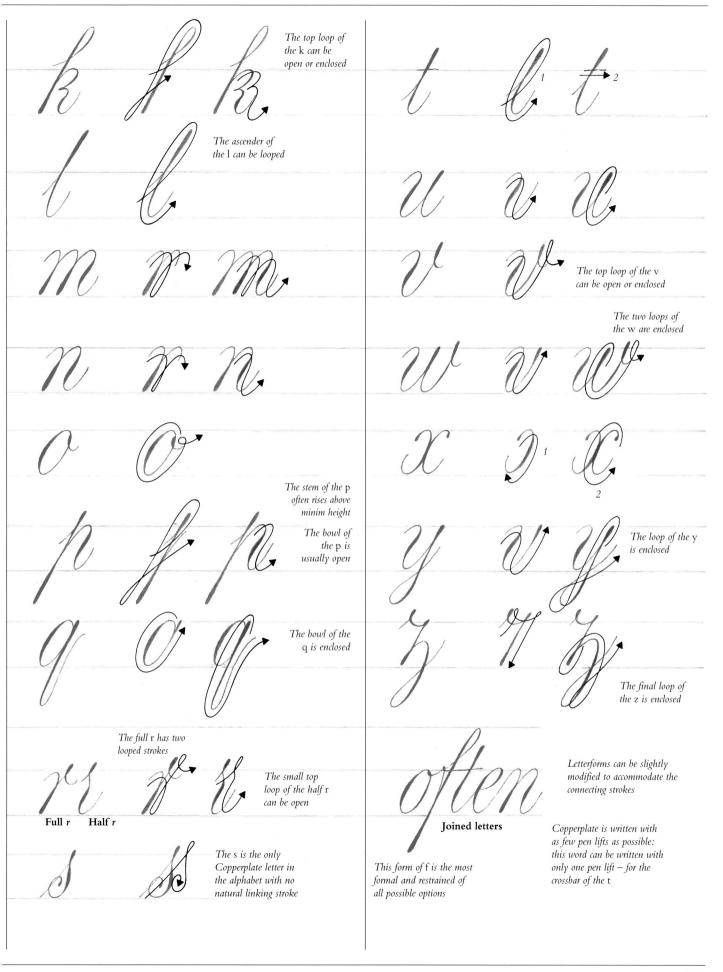

Copperplate Capitals

AMONG THE MORE useful practical advice offered in the Copperplate manuals of the 19th century (pp. 102–103) is this tip from writing masters James Lewis and Joseph Carstairs: "The writing hand should be lightly supported by the tip of the little finger and the forearm free to move in a circular movement." This can very helpfully be applied to the drawing of Copperplate Capitals, a script in which the precise control of pressure on the pen is central to the execution of each letter.

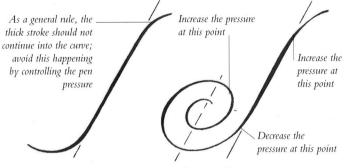

Incorrect S

This *S* shows how the letter will look if the pressure on the pen is not meticulously controlled. The stroke should only increase in weight when following the angle of the italic slope.

Correct S

To draw the *S* correctly, begin the stroke with light pressure, increasing it when reaching the italic slope angle. Decrease the pressure when moving away from the italic slope angle.

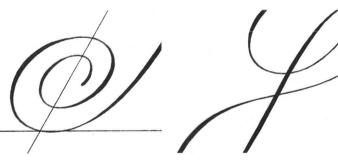

Loops

Loops should balance over the upright axis and, when used spirally, should diminish proportionately, rather like a snail's shell.

Crossing strokes

As a rule, thin strokes can cross both thick strokes and other thin strokes. However, thick strokes should never be crossed with other thick strokes.

Capitals and minuscules

Never use Copperplate Capitals to write a whole word. Where several capitals have to be used, such as for initials, plan the letters very carefully. When used to begin a word (pp. 104–105), the features of the Copperplate Capital can be adapted to complement the minuscules.

Here, the tail of the L has been elongated and lowered to complement the minuscule letters When terminating a stroke, finish with a hairline or apply pressure on the pen to leave a blob

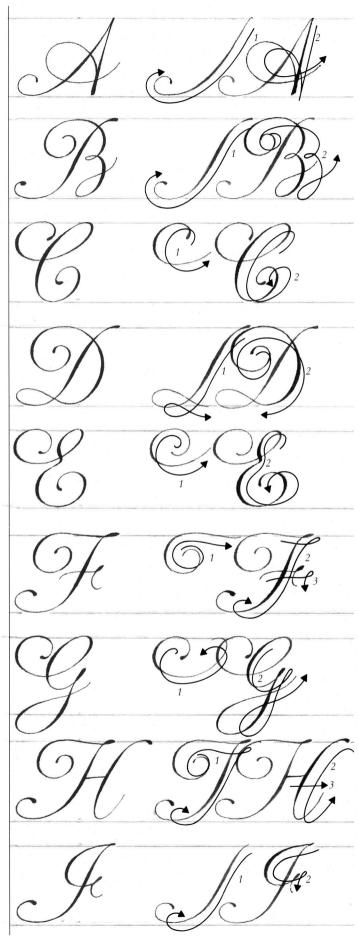

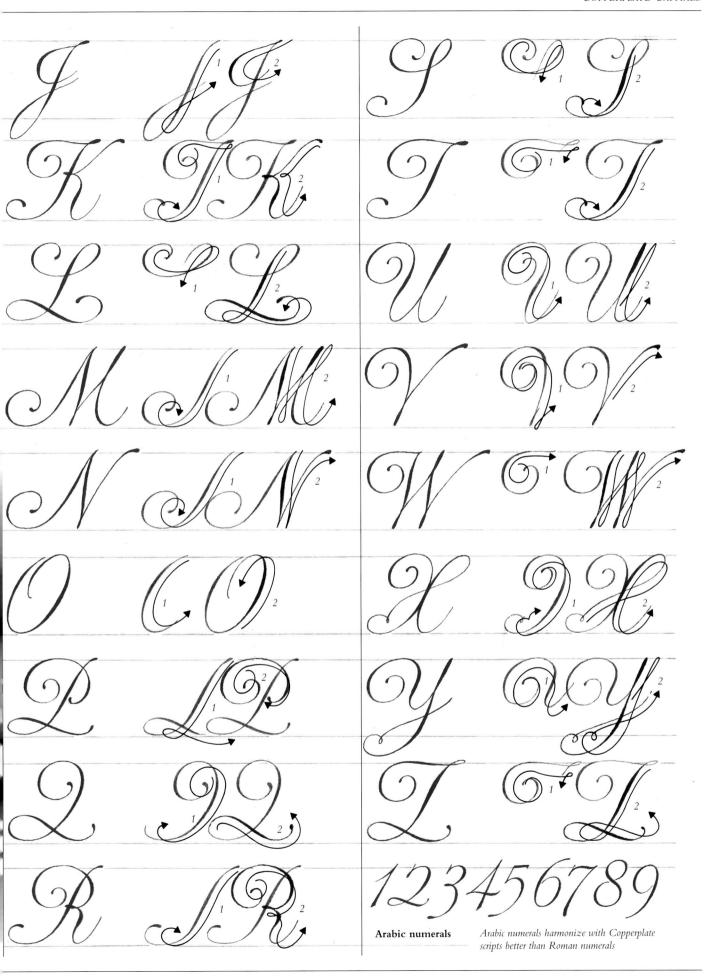

Imperial Capitals

The Imperial Capital (Capitalis Monumentalis) was the letter used on the monuments of Ancient Rome to proclaim the might of the Roman Empire, and is indisputably the most stately of all scripts. The earliest examples of a mature Imperial letter date from the first century BC, and some of the finest models are inscribed on the base of the Trajan Column in Rome (opposite). These stone-cut letters were carved directly on top of brush-drawn forms (pp. 110–111), their proportions dictated by the natural movement of the hand.

Capital Letters with serifs had been written by the Greeks from the fourth century BC. However, it was only when the Romans developed a springy, broad-edged brush from the hairs of the red sable that it became technically possible to draw serifs and other letter parts quickly and with precision. When used within the natural compass of the hand, this tool proved crucial in determining the shape of the Imperial Capital itself.

A key function

In a society with a high degree of literacy but without the benefit of the printed word, Roman scribes and signwriters performed key functions. Although what remains of their work is fragmentary, we do know, from one small painted section of an election poster in Pompeii, that — by simplifying some strokes — the Imperial Capital was adapted from the prestige letters of state for use in everyday documentation.

The Imperial Capital has become the most enduring of all scripts. More than 2,000 years after it was first used, its form remains virtually unchanged, as the capital letters in the type print of this book testify. The frequency of the occurrence of Q in Latin text provides a distinct design advantage, with the tail gracefully descending below the baseline

The regulation of space between letters, words, and lines was of primary concern to the Roman scribe

The proportions of Dürer's letter A are based on a subdivided square, with the serifs based on compass-drawn circles

DÜRER'S CLASSICAL A
The analysis and rediscovery of antique letters was a matter of great industry for Renaissance scholars and artists. This Imperial Capital, drawn by Albrecht Dürer in 1525, demonstrates the widespread belief that the key to understanding classical letters lay in geometric dissection.

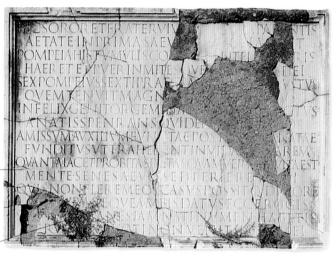

DETAIL FROM THE VIA APPIA MONUMENT In this inscription on the Via Appia Monument, the interlinear space is equal to about half the height of a letter. Were the spacing any tighter, as it is on the Arch of Constantine (opposite), the ease of horizontal scan would be reduced and the letters would become jumbled.

Compare the interletter spaces of the eleventh line with those of the twelfth to see how the spaces have been compressed to accommodate the allocation of text

Via Appia Monument

The beautiful proportions of the letters on this monument in the Via Appia, Rome, compare very favorably with those on the base of the Trajan Column (opposite). Such a large amount of text would have required considerable advance planning. The initial allocation of words to each line may have been calculated on a wax tablet or slate, before working rules were drawn to letter height on the marble. Once the position of the letters was marked in chalk between the rules, the letters were painted with a brush. Only then were the words actually carved into the stone.

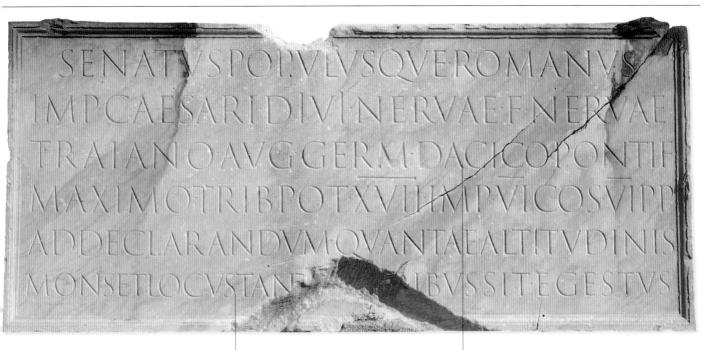

The Trajan Column

This inscription on the base of the Trajan Column in Rome, cut in AD 112-3, is 9 feet 2.74 meters) wide and 3 feet 9 inches (1.15 neters) high. The inscription, commemorating the battles of Trajan against Germany and Dacia, begins with the phrase "SENATVS POPVLVS QVEROMANVS" ("The Senate and People of Rome"). The letters were originally colored red so that they would stand out from the background. Words are separated by a medial interpoint and the horizontal stroke over certain letters indicates their use as numerals.

The words "SENATVS POPVLVS QVEROMANVS" have been abbreviated to "S.P.Q.R." and relegated to the second line The letters on the top line are $4^{1/2}$ inches (11.5 centimeters) high, reducing to $3^{3/2}$ inches (9.6 centimeters) on the bottom line — probably indicating the relative importance of the words

The letter A, like the N and M, has a pointed apex, a form of Imperial Capital more difficult to construct than the common serifed or flatheaded letter (p. 113)

THE ARCH OF CONSTANTINE

This monument dates from AD 315, some 200 years after the Trajan Column (above). In some ways, it marks the degeneration of Rome, since many of the statues and reliefs on the column have been scavenged from earlier work. The letters are square-cut in shallow relief. Originally, the grooves would have housed bronze letters – the circular fixing holes can

still be seen inside each letter.

Since the Renaissance, Imperial Capital letters have been studied, analyzed, improved, and recreated by countless scholars and calligraphers. However, it is only through the pioneering work of a modern scholar, the late Father E.M. Catich, that we can now fully understand the ductus of the hand. His analysis of Roman letter construction was demonstrated on 19 letters of the alphabet in his definitive work, *The Origin of the Serif*, published in 1968. These methods are interpreted for all 26 letters in the following pages (*pp. 110–119*).

Spontaneous letters

The great strength and beauty of the Imperial Capital lies in the fact that the letters can be written with spontaneity, the tool and hand determining the form, and one letter part relating naturally to the next. In much modern work, excessive preplanning can have the effect of making the letters appear labored. However, the methods explained in the following pages will enable the modern scribe to work in the same way as his or her Roman forebears and produce spontaneous letters for our own time.

Imperial Capitals: Brush Strokes

IN ORDER TO RECREATE authentic Imperial Capitals, it is essential to use a broad-edged brush. This should be made from sable or synthetic hairs, which are fine enough to create a sharp clean edge when wet. Imperial Capitals are constructed either from "pulled" or "manipulated" strokes, or from a combination of both. In both types of stroke, the angle between the brush and the work surface is equally as important as the angle of the brush edge on the letter. When drawing letters with a brush, differences in stroke thickness are created by many factors, including changes in rhythm and tempo, and the increase or decrease of pressure on the tool. This sensitivity is generally most apparent on "manipulated" strokes (opposite).

The basic "pulled" strokeThe "pulled" stroke is used in the majority of Imperial Capital letter strokes. The basic "pulled" stroke is the vertical stem stroke. For this, the hand moves only slightly, with the index finger drawn toward the palm of the hand, causing the brush to be pulled downward.

A movement of about two inches (five or six centimeters) can be achieved with the hand resting on a mahlstick

Brush movement for "pulled" strokes With the hand resting directly on the work surface, the movemen of the brush will be very small for a "pulled" stroke - about one inch (two or three centimeters). With the right hand resting on a mahlstick, the movement car be increased 4. On letters B, D, E,

A mahlstick is useful for

keeping the hand clear of

the writing surface

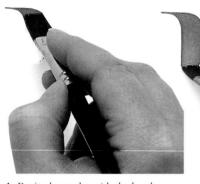

1. Begin the stroke with the brush at a fairly flat angle to the surface. Gently edge the brush to the right and begin the downward sweep of the stroke.

3. Continue pulling the brush downward, slightly reducing the pressure as you reach the center of the stem; this will give the stroke a slight waist. Increase the pressure again and, at the bottom of the stem, begin to lift the brush while moving to the right.

This is an

and N

alternative left

serif for A, M,

Adjust the brush angle to 30° for the addition of a thicker stroke to the right

and L, the vertical stem

stroke is continued into the bottom horizontal

arm. In these instances.

the angle of the brush

should be about 30°.

edge on the letter

Other "pulled" strokes

The brush is held in a similar way on curved strokes as on vertical strokes, but instead of drawing the brush toward the palm of the hand, the hand moves in a semicircular movement to the right or left. To make this movement smooth and easy, the angle of the brush edge on the letter should be about 15°

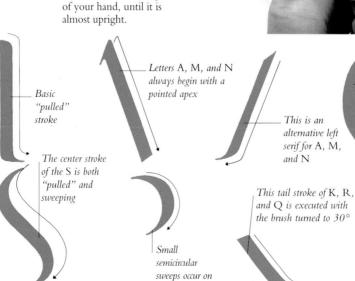

B, P, and R

2. As you move downward into the stem, gradually pull the brush toward the palm

The index finger

on the ferrule of the brush

should be positioned

This sweeping stroke is used Opposing on C, G, O, sweep for and Q letters D, O, and Q

> Letters M, N, V, and W have a diagonal stroke that turns upward at the baseline

The "manipulated" stroke

To draw "manipulated" strokes, you need to be able to twirl the brush through 180°. To make this possible, hold the brush between thumb and index finger with an angle of about 90° between the brush and the work surface.

"Manipulated" strokes are used to create the four main types of serifs in Imperial Capitals: the top left serifs and arms of letters T and Z (above right); the top serifs that terminate the arms of letters C, E, F, G, S, and T (right); the bottom serifs and arms of C, E, L, and Z (below); and the bottom left serif of the S (below right). Although the top strokes of C, S, and G are curved, the principle remains the same as for the straight top arms of the E and F. For the bottom arms of E, L, and Z, the brush is positioned so that the angle of the edge on the letter is about 150°. The strokes of the top serifs are known as "forward" and those of the bottom serifs as "reverse." The bottom serif of the S is unique in that the brush begins rather than ends at the serif tip.

Top left serif on T and Z

1. Begin the top left serif on the T and Z by bringing the brush downward in a short stroke.

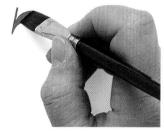

2. Twirl the brush to 30° to create the left serif, slightly increasing the pressure as the brush twirls.

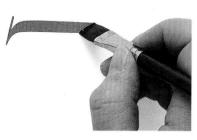

3. Without adjusting the angle of the brush edge on the letter, move the brush horizontally to create the arm.

Top right serif on C, E, F, G, S, and T

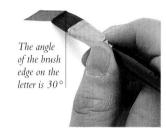

1. To create the top right serif of *C*, *E*, *F*, *G*, *S*, and *T*, hold the brush in an upright position and begin the horizontal stroke with the brush edge on the letter at 30°.

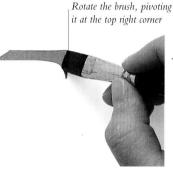

2. Continue moving the brush horizontally, maintaining the angle of 30° until the brush approaches the end of the arm. At this point, begin to rotate the brush on its right corner.

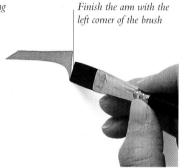

3. Continue to rotate the brush on its left corner until the edge is 90° to the arm. Finally, move it downward slightly and "edge off," gently lifting the brush from the surface.

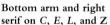

1. To create the bottom arm and right serif on *C*, *E*, *L*, and *Z*, begin with the angle of the brush edge on the letter at about 150°, and move to the right.

2. On reaching the end of the stroke, twirl the brush to the vertical, then move upward and edge off, finishing on the left corner of the brush.

1. The bottom serif of the *S* is the only bottom serif on the left side of a letter. Begin at the tip of the serif, moving the brush downward.

2. Twirl the brush to 30° and curve to the right and upward. Work carefully, for the first part of the stroke will be obscured by your hand.

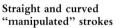

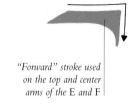

"Reverse" stroke used on the bottom arm of E, L, and Z

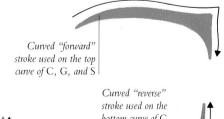

Curved "reverse" stroke used on the bottom curve of C

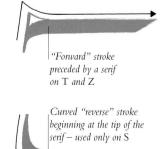

Imperial Capitals: Construction

T HE 26 CHARACTERS constructed in the following pages are based on the 19 letters included in the inscription on the base of the Trajan Column in Rome ($pp.\ 108-109$). The two Greek-derived letters, Y and Z, are based on other Roman sources, and the remaining three letters, J, U, and W, are modern characters, which, as such, are open to individual interpretation. In principle, the letters adhere to the ductus described by Father E.M. Catich in his book $The\ Origin\ of\ the\ Serif$. Each letter is individually demonstrated by stroke sequence and brush angle. The pressure on the brush and the speed at which the strokes are drawn will vary from the brush of one calligrapher to another, and the rhythm that suits you best will be acquired with practice.

Color coding

The first stroke - the

White lines

30° to the vertical

indicate a change of brush angle, in this instance from

Each letter has been constructed from a series of color-coded strokes: pink indicates the first stroke, purple the second, green the third, and yellow the fourth. The frequently changing brush angles are represented by a series of white lines across the stroke.

Letter weight

It is generally assumed that the weight – the relationship between stem width and stem height – of the Trajan letter is 10:1. A balance of 11:1 is generally considered acceptable, although the actual letter weight is about 9.5:1.

The H is created from two Is joined with a crossbar

The fillet between the serif and stem of an Imperial Capital can be slightly fuller than this

Letter proportions

When writing a series of Imperial Capitals, it is essential to know the relative width of one Imperial Capital to another. The width of a letter – including serifs – is measured in stem widths. The apparent discrepancy in weight between rounded and straight letters is optical; rounder letters appear lighter than straight ones. To our modern eyes, this can be displeasing and the effect is "corrected" by the addition of extra weight to the curved strokes. Arguably, the original weight differences give the Imperial inscriptions a more natural rhythm than that achieved in more formal modern work.

Numerals

Although Arabic numerals were not introduced into Europe until the 13th century, avoiding their use in favor of Roman numerals can be an encumbrance in modern calligraphy. Arabic numerals can be drawn using a similar ductus to the Imperial Capital letters and can be contained within the capital height. The θ is usually a narrow numeral, but if used singly, it can be made wider, resembling a letter O(p. 116).

1234567890

Stroke order for numerals

1 2 3 4 5 6 2 7 8 9 C

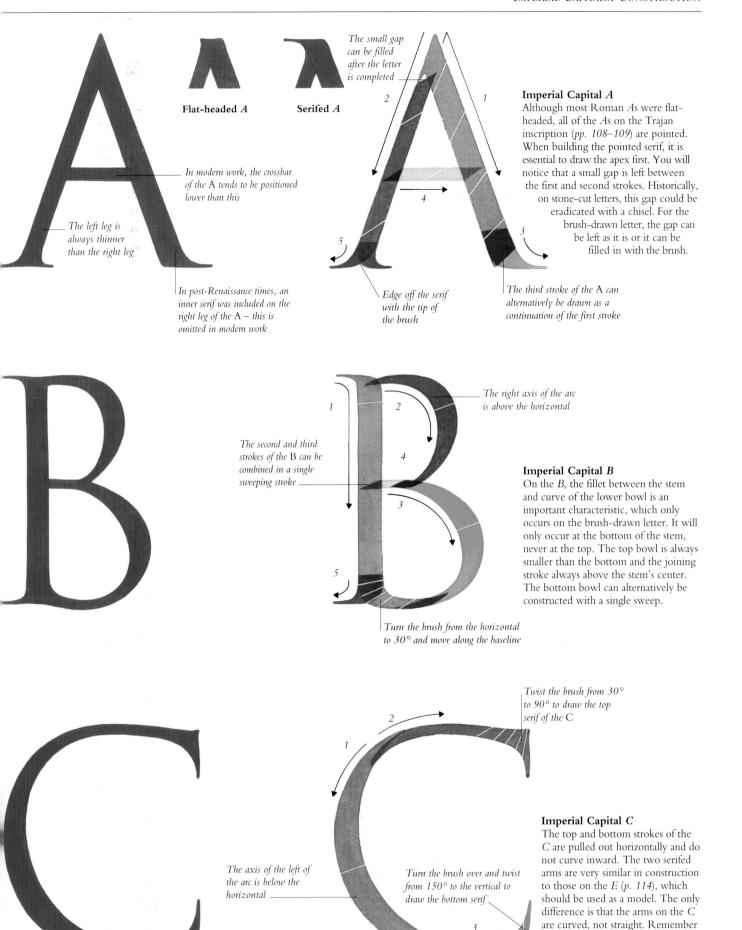

to turn the brush over to 150° for

the bottom stroke.

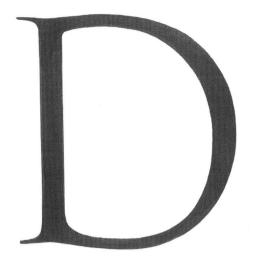

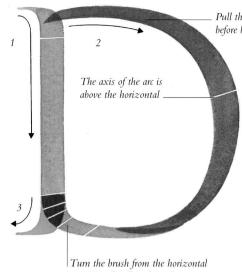

Pull the stroke to the right before beginning the arc

Imperial Capital D

As on the letter B(p, 113), the stem and rounded stroke of the D are connected with a fillet. This is always at the bottom of the letter - never at the top. The width of the letter presents a problem in connecting the baseline stroke to the bowl. In anticipating this, the Trajan scribe sloped the stem slightly to the right. In modern usage, the stem is upright.

to 30° and pull it along the baseline as far as possible

The F has the same construction as the E except for the omission of the foot

The top serif of the

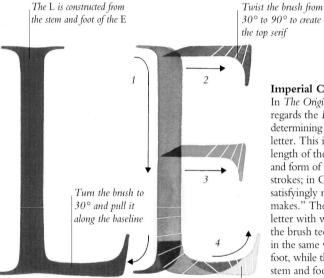

30° to 90° to create the top serif

> Imperial Capitals E, F, and L In The Origin of the Serif, Catich regards the E as the key letter in determining the form of the Imperial letter. This is due to the fact that the length of the top arm and the size and form of the serif are natural strokes; in Catich's words, "the most satisfyingly natural stroke the brush makes." Therefore the E is an ideal letter with which to start learning the brush technique. The F is created in the same way as E but without the

foot, while the L is made up of the

stem and foot of the E.

For the fourth stroke of the E, turn the brush over and twist from 150° to 90°

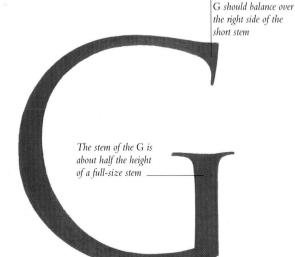

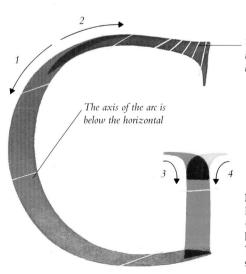

To create the top serif of the G, pull the stroke horizontally to the right before twisting from 30° to 90°

Imperial Capital G

For practical purposes, the G is the C(p. 113) combined with the upper half of the stem of the I(p. 115). The top serif is a manipulated stroke similar to the top arm of E (above).

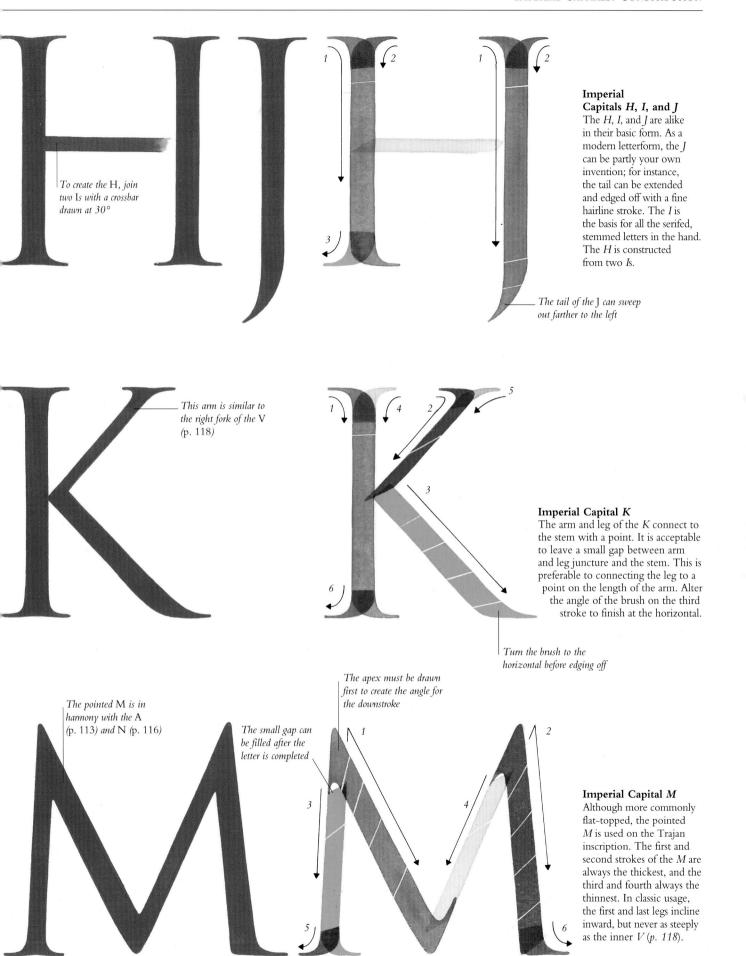

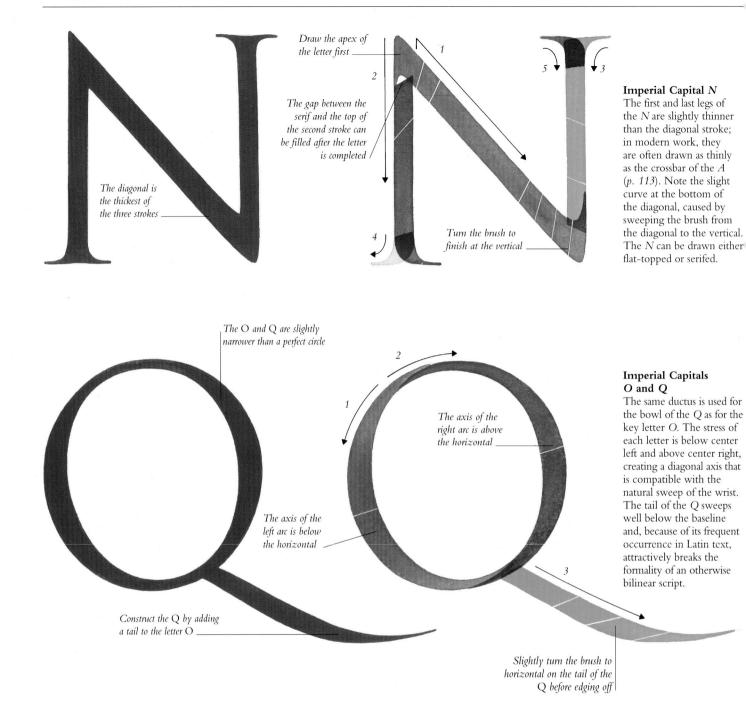

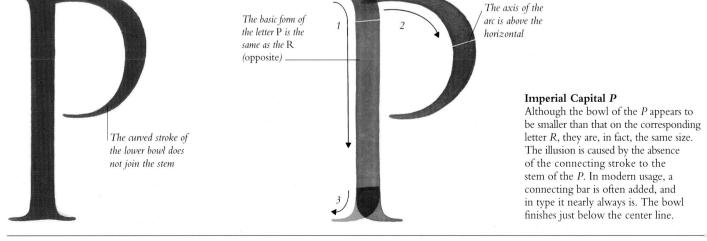

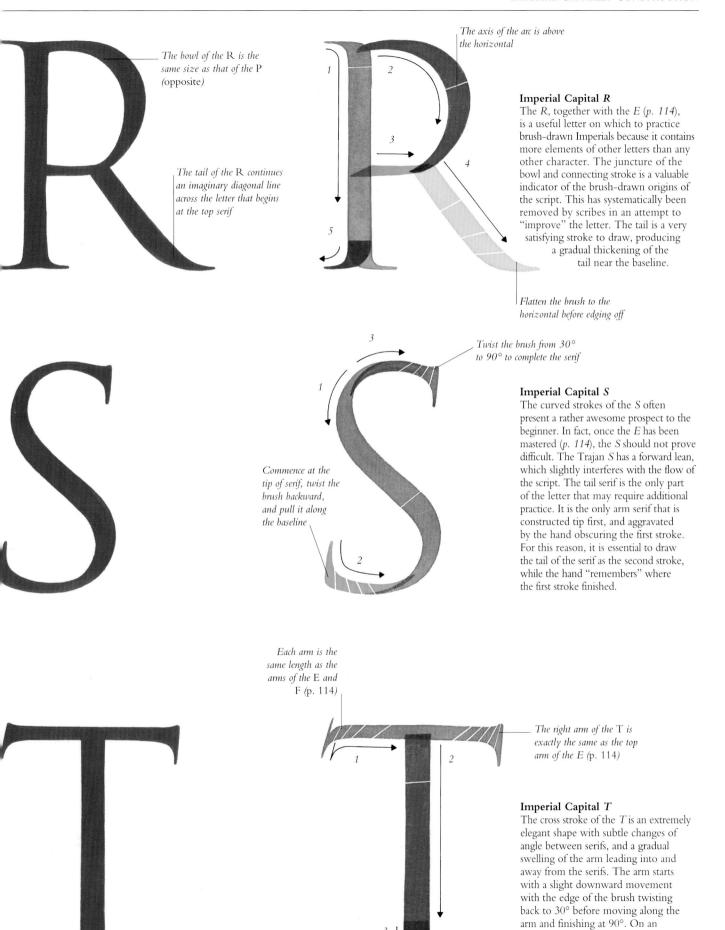

inscription, the initial juncture would be filled in by the chisel.

The bottom serif of the U can be omitted, with the curve sweeping up to meet the right vertical stroke

At the end of the second stroke, sweep the brush to the right and edge off with a fine stroke

Imperial Capital U In Latin, the character V was used to represent both U and V sounds. In medieval scripts, the V often took the form of a U; by about the 14th century the two letters were differentiated and used separately. It is a matter of personal opinion as to what extent the Imperial Capital script should be adapted to languages other than Latin.

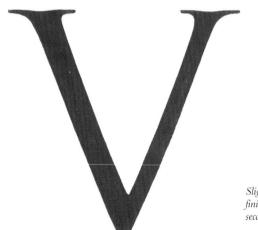

Slightly twist the brush to finish at the angle of the second stroke

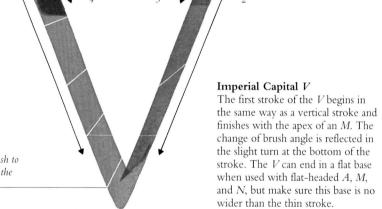

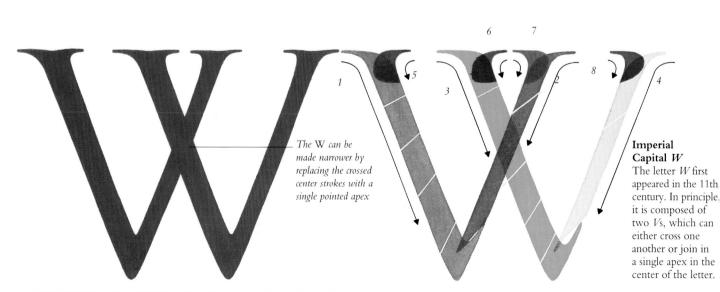

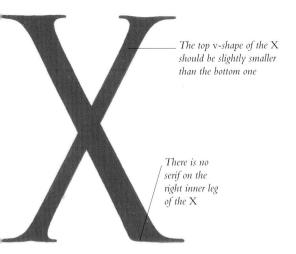

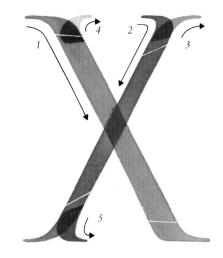

Imperial Capital X

The letter X appears with relative frequency in Latin inscriptions, used as a numeral to represent 10. The slope is more inclined than that of the A and ideally, the top v-shape should be smaller than the bottom one to make the letter optically correct – balanced and not top-heavy. There is no serif on the right inner leg.

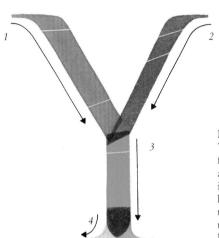

Imperial Capital Y

The letter *Y* was used by the Romans for words of Greek derivation, and it appears only occasionally in Latin inscriptions. This construction is based on a Greek inscription of the letter Upsilon. It is also correct to include an inner serif, as on the letter *X* (*above*).

Twist the brush to 30° and move horizontally to create the top stroke of the Z

The second stroke is thicker than most diagonal strokes in the script

Turn the brush over and twist from 150° to 90° to draw the bottom stroke

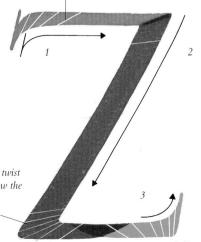

Imperial Capital Z

The Z is an interesting construction, which combines the top arm of the T and the bottom arm of the E, separated by an awkward diagonal stroke – awkward in the sense that a stroke moving to the left is naturally thin (see A, p. 113). However, a thin stroke would make the letter appear inordinately light, and so the brush is held near to the horizontal to create a thick diagonal.

Script Reference Chart																
1	Imperial Capitals	A	В	C	D	E	F	G	H	Ι		K	L	M	N	0
Roman & Late Roman Scripts	Rustic	λ	B	C	0	f	f	G	\mathcal{H}	1		K	1	M	N	0
	Uncial	A	B	c	9	e	r	C_{j}	h	1		k	1	m	N	0
	Square Capitals	A	B	C	D	E	F	G	H	I		K	1	M	N	O
	Half Uncial	α	b	c	d	e	F	9	b	1		k	l	m	N	0
Insular & National Scripts	Insular Majuscule	α	6	C	0	c	r	3	h	1	J	K	2	m	н	0
	Insular Minuscule	a	в	c	9	e	F	3	h	1		k	1	m	n	0
CAROLINE & EARLY GOTHIC SCRIPTS	Caroline Minuscule	a	Ь	c	d	e	f	g	h	ı		k	l	m	n	0
	Early Gothic	a	b	c	đ	e	f	g	h	1		k	1	m	n	ø
	Textura Quadrata	a	b	c	ð	ľ	f	g	h	ĺ	Í	k	ĺ	m	n	0
	Textura Prescisus	a	b	c	b	ľ	f	g	h	Í	j	k	1	m	11	0
	Gothic Capitals	21	23		29	£	F	6	b	1	1	k	1	99	17	9
	Lombardic Capitals	A	B	\mathbf{C}	\mathbf{o}	\mathbf{e}	F	G	n	İ		K	L	m	Ŋ	0
	Bastard Secretary	a	ß	e	9	e	f	8	B	í	Í	k	ľ	m	n	0
	Bastard Capitals	æ	23	C	5	E	F	G	B	7	7	R	L	201	27	0
	Bâtarde	a	6	t	8	C	F	g	6	ī	j	A	ſ	m	n	0
	Fraktur	\mathfrak{a}	6	Ć	8	e	F	g	b	i	j	k	ſ	m	n	0
	Rotunda	a	b	c	8	e	f	g	b	i	j	B	l	m	n	0
Italian & Humanist Scripts	Rotunda Capitals	用	B	C	D	E	£	6	B	1	3	K	C	B	IR	Ø
SCRIPTS	Humanist Minuscule	a	b	c	d	e	f	g	h	i	j	k	1	m	n	0
	Italic	a	b	c	d	e	f	g	6	i	j	k	1	m	n	0
	Humanist Capitals	A	В	C	D	Ε	F	G	H.	Į.	J	K	L	M	N	0
Post- Renaissan	Copperplate	a	в	c	d	e	R	g	h	i	j	k	C	m	n	O
SCRIPTS	Copperplate Capitals	A	\mathcal{B}	8	D	E	F	0	H	9	J	K	L	\mathcal{M}	N	0

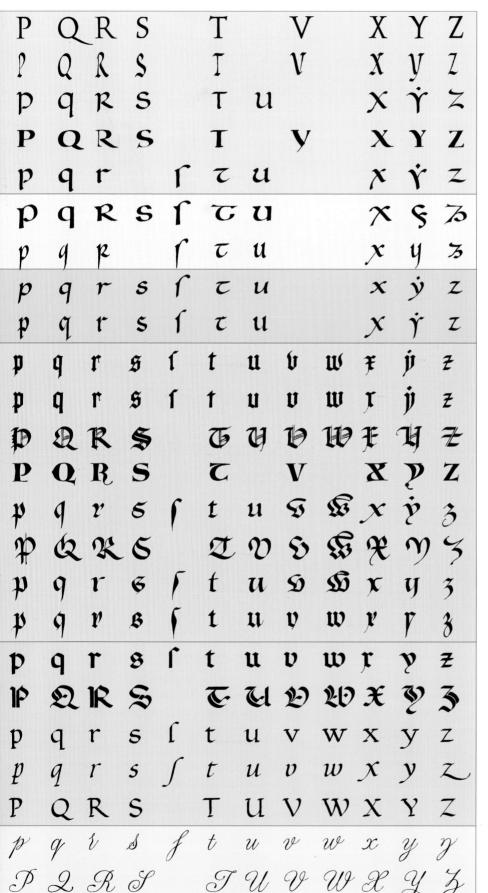

NOTES ON SCRIPTS

Prestige Roman hand used in brush-drawn and carved forms; the letterforms are the basis of many modern capitals

First-century script used in manuscript, signwritten, and carved forms; later used only for chapter headings

Latin version of the Greek Uncial with rudimentary ascenders and descenders; used by the early Christian Church

Late Roman capitals reserved for non-Christian deluxe manuscripts; a time-consuming letter to pen

A more cursive form of Uncial incorporating ascenders and descenders; the letterforms are the basis of minuscule letters

Combines Uncial and Half Uncial elements; developed by Irish-Northumbrian Celtic monks

Cursive form of the Insular Majuscule used for documentary work; continued to be used in Ireland into the 20th century

Reformed Half Uncial; established hand of the Frankish Empire; the model for 15th-century Humanist Minuscule

Compressed version of the Caroline Minuscule used in the 12th century; presaged later Gothic scripts

Fully compressed Gothic letter from the early 13th century; characterized by diamond terminals of minims

Twin script of the Quadrata; characterized by flat feet on minims; used for prestige manuscript work

Accompanying capitals for Textura minuscules

A built-up, prestige display and Versal capital; usually used in conjunction with Quadrata or Prescisus scripts

A cursive Gothic script used only for vernacular and documentary work

Capital letters used with bastard minuscules, including those in the Bâtarde and Fraktur hands

French version of the Bastard Secretary

German, late bastard script with many Textura features; with Schwabacher, it remained in use until the mid-20th century

Italian hand; contemporary with Gothic scripts; rounder and more open than other northern European hands

Accompanying capitals for Rotunda minuscules

Renaissance hand influenced by the Caroline Minuscule; the letterforms are the basis for much modern printing type

Cursive form of the Humanist Minuscule; used in modern type for text in parenthesis and annotation

Accompanying capitals for Humanist and Italic minuscules; pen-drawn derivatives of Imperial Capitals

Extreme form of cursive script with most letters linked; derived from Italic and influenced by copperplate engraving

Accompanying capitals for Copperplate minuscules

Glossary

Ampersand The character & denoting the word "and."

Anthropomorphic decoration A style of letter decoration that incorporates imagery of human forms.

Apex The pointed tip of a letter, as in A.

Arch The portion of a lowercase letter formed by a curved stroke springing from the stem, as in h and n.

Arm A horizontal stroke touching the letter at only one end, as in E and F.

Ascender The upper stem of a lowercase letter, as in b, d, and k.

Ascender line A writing line to which the upper stems of letters rise.

Axis In Roman Imperial Capitals, this is the imaginary line that passes through the thickest points of a letter. Also known as the "stress" of the letter.

Baseline The writing line on which the main body of the letter sits.

Bastard script A Gothic script of mixed Textura and cursive elements.

Bilinear The term used to describe a script that is written between, and adhering to, two imaginary writing lines.

Black Letter See Textura.

Bookhand The generic term for scripts used in books before the age of printing. Bookhands include Uncial and Caroline Minuscule.

Bowl The curved stroke attached to the letter stem that creates an enclosed space (counter), as in letters b, d, and g. Also known as "bow."

Bracketed serif A type of serif that forms a fillet with the stroke of a letter.

Built-up letters Letters that are outlined and filled, or constructed one section at a time.

Burin A pointed tool used in copperplate engraving.

Cadel An ornate Gothic capital letter constructed from a series of interlacing pen strokes written with the minimum number of pen lifts.

Capital height The height of a majuscule (capital) letter.

Capital letter See majuscule.

Capital line The writing line to which uppercase letters rise. The capital line is often slightly lower than the ascender line.

Capsa A container for storing scrolls.

Compressed letter A style of lettering in which the characters and interletter spaces are narrower than is usual.

Conjoined A term used to describe letters that are joined together.

Copperplate An extremely slanted script with distinctive flourishes that developed from letter

engraving on thin plates of copper.

Counter Any space within a letter, either fully or partially enclosed.

Crossbar The horizontal stroke on a letter, as in *t* and *H*. Also known as the "bar."

Cross stroke A horizontal mark essential to the letter, made either from left to right or right to left, such as on the letters *E*, *F*, and *T*.

Cursive A rapid form of writing, using elements such as linking and loops.

Deluxe A term used to describe the highest grade of manuscript writing.

Descender The lower stems of letters such as p, q, and f.

Descender line The line on which a letter's descender should rest.

Display capitals Decorated capitals used in the introductory word or words of a text but not singly as versals.

Downstroke A stroke that is directed downward.

Ductus The direction and order of the strokes used to construct a letter.

Ear A small stroke that projects from the top of the letter *g*.

Edge off A term used with reference to brush-drawn letters to describe the technique of removing the edge of the brush from the writing surface, with the left corner lifted last.

Edge on The technique of gradually placing the full edge of the brush onto the surface, with the right corner touching the surface first.

gh

Hairlines are drawn with the corner of the pen nib and often taper from a thicker stroke

"Elephant's trunk" A broad, sweeping stroke that hangs from the ascenders in certain bastard scripts, such as the English Bastard Secretary.

Expanded letter A style of lettering in which the characters and interletter spaces are wider than usual.

Filigree Elaborate decoration in the form of fine, curved lines.

Fillet The name given to the filled angle that is formed between a stroke and its serif.

Floriated Decorated with images of flowers.

Folio A leaf of a manuscript. Also refers to the page number.

Fret patterns Ornamental designs that can be used to form the border of a page or can be woven into the text. The simplest fret patterns are composed solely of straight lines.

Gilding The application of gold leaf to the writing surface.

Gothic scripts The generic term for hands written between about 1200 and 1500.

Gouache Watercolor mixed with a type of chalk to achieve an opaque effect.

Hairline A fine line used to link letters, terminate strokes, fill large counters, and decorate letters.

Half r A form of the letter r, the spine of which is provided by the previous letter.

Headline The line to which the uppermost point of a letter – excluding its ascenders or descenders – rises. Also known as the "waistline."

"Hierarchy of scripts" The name given to the code of practice whereby different scripts

Molto signormio Auisando a Quella sel si rompesse Qualche pena st) Qualche suste gone Ne La Alla, o, codda cosi appresso Non si potesse inschitire st) uolessi sarla usci re st) cauarli Quello Mucegoncello st) ac

Italic script is characterized by linked letters with a distinctive forward slant

appearing in the same manuscript adhere to a strict order of use: the most regal hand is used for the titles and important details, the next most formal script for the first sentence, and so on.

Historiated The term used to describe initial letters that are decorated with the human figures described in the text.

Cadels are ornate Gothic Capital letters that were originally used with bastard text scripts

Illumination Originally, the term referred only to gilded decoration, but it is now used to describe any form of text decoration.

Insular Originating from the Latin word for "island," this term is applied by paleographers to indicate a shared culture between Ireland and northern Britain, free from Continental influence.

Interlace A form of decoration in which lines weave in and out of each other.

Interletter space The space between characters.

Interlinear gloss Words written in the interlinear space of the main text to provide a commentary on the text or a translation of its contents.

Interlinear space The space between the baseline of one line of text and the headline of the line below it.

Italic A Humanist style of writing in which the oval-shaped, linked letters slant to the right.

Leading minim The name given to the first minim of a letter, as in m and n.

Letterform The shape of a letter.

Ligature The linking of letters by one or more strokes.

Where the bowls of letters are combined, the letters are referred to as "conjoined"

Link The stroke that connects the top and bottom of the minuscule *g*.

Loop The enclosed space in an ascender or descender, as in *g*.

Lowercase See minuscule.

Majuscule A bilinear script in which the letters are of equal height. A capital letter.

Manuscript A handwritten book or document predating the invention of printing. Can be abbreviated to "ms."

Minim A downstroke that is as tall as the body height of the script.

Minim height The height of a minuscule letter, excluding the ascender and descender. Also known as "x height" or "body height."

Minuscule Any noncapital letter. Minuscule scripts contain letters of uneven height because of the ascenders and descenders.

Movable type Individual letters made from metal that can be inked and printed in any order.

Paleography The study of the history of handwriting and documents.

Papyrus The earliest form of paper; made

A manuscript is a book or document written by hand

from the stem of the papyrus plant.

Parchment A writing surface made from mammalian skin, usually sheepskin or goatskin.

Quill A writing implement made from the tail or wing feather of a bird, such as turkey or goose.

Reed pen A writing tool made from a hollow-stemmed marsh plant.

Roman The Latin alphabet. The term is also used to describe any plain, upright letter.

Rubricated Originating from the Latin word *ruber* for "red," this describes letters in a heading or within a passage of text that are colored red.

Rune Any letter in the ancient Germanic alphabet. The characters contain no curved strokes and very few horizontal strokes.

Sable A very fine pointed brush, made from the tail hairs of the sable, a dark-furred mammal of northern Asia.

Serif A short, decorative stroke used to finish off the stroke of a letter. Many different types exist, including the bracketed serif and the wedge serif.

Skate The technique of gently pulling the wet ink from one stroke to create another stroke, often a hairline.

"Slanted" pen A pen with the nib cut at right angles to the shaft. Held at an angle, the position of the nib is "slanted" to the stem.

Spur A small projection off a main stroke.

Stem The main vertical stroke of a letter. It can be drawn at an angle for a slanted script, and can be the main diagonal stroke of the letter, as in N and Z.

Stipple To engrave, paint, or write in dots.

"Straight" pen A pen with the nib cut obliquely to the shaft, facilitating the drawing of an upright stem. When positioned horizontally, it will produce a greater contrast in thick and thin strokes, an effect known as "shading."

Stroke Any straight or curved line that has been penned or painted.

Tail A diagonal line that connects to the letter at one end, as in Q and γ .

Terminal A stroke that does not end with a serif.

Text script A script that is particularly suitable for pages of text, due to its clarity and lack of

decoration. Also known as "body text" or "text hand."

Textura From the Latin word for "woven," this is the name given to a style of Gothic script characterized by dense, compressed characters and minimal interlinear space.

Thorn sign The Anglo-Saxon sign resembling a γ that was used to represent the "th" sound.

Uncial A late Roman script with rudimentary ascenders. The name means "inch high."

Uppercase See majuscule.

Vellum A type of writing surface made from calfskin.

Versal A built-up ornamental capital letter used to open verses and paragraphs.

Decorative abbreviated strokes known as "serifs" can be drawn in a variety of different styles

Waistline See headline.

Weight The relationship of a letter's nib width to its height.

Word space The amount of space between words.

Zoomorphic decoration A style of decoration incorporating imagery of animal forms.

Bibliography

The Decorated Letter, J.J.G. Alexander/Thames and Hudson, London, 1978

The Winchester Bible, Clare Donovan/British Library, Winchester Cathedral, 1993

Manuscripts at Oxford – R.W. Hunt Memorial Exhibition, Edited by A.C. de la Mare and B.C. Barker-Benfield/Bodleian Library, Oxford, 1980

Eyewitness Guide to Writing, Karen Brookfield/Dorling Kindersley, British Library, London, 1993

The Golden Age of English Manuscript Painting 1200-1500, Richard Marks and Nigel Morgan/Book Club Associates, London, 1981

Anglo-Saxon Manuscripts, Michelle P. Brown/British Library, London, 1991

A Book of Scripts, Alfred Fairbank/Penguin Books, London, 1949

Writing, David Diringer/Thames and Hudson, London, 1962

Das Schreib-Büchlein von Rudolf Koch, Johannes Stauda Verlag Kassel, 1984

Thesauro de Scrittorio 1535, Ugo da Carpi, introduction by Esther Potter/ Nattali and Maurice, London, 1968

Writing and Illuminating and Lettering, Edward Johnston, originally published 1906, reprinted by A. & C. Black, London, 1983

English Handwriting 1400-1500, Jean F. Preston and Laetitia Yeandle/State University, New York, 1992

A Guide to Western Historical Scripts from Antiquity to 1600, Michelle P. Brown/British Library, 1990

The Book of Kells, Selected and introduced by Peter Brown/Thames and Hudson, $1980\,$

The Lindisfarne Gospels, Janet Backhouse/Phaidon, Oxford, 1981

The Universal Penman, Engraved by George Bickham, 1743/Dover Publications Inc., New York, 1954

The Art of Calligraphy, Western Europe and America, Joyce Irene Whalley/Bloomsbury Books, London, 1980

The Story of Writing, Donald Jackson/Studio Vista, 1981

Medieval Calligraphy, Its History and Technique, Marc Drogin/George Prior Associated Publishers Ltd., London, 1980

Calligraphy: The Art of Written Forms, Donald M. Anderson/Dover Publications Inc., New York, 1992

The Origin of the Serif, Edward M. Catich/Catich Gallery, St. Ambrose University, Iowa, 1968

Masters of the Italic Letter, Kathryn A. Atkins/Penguin Press, London, 1988

The Italic Calligraphy Handbook, Carolyn Knudsen/Stemmer House Publishers Inc., Maryland, 1985

Calligraphy, Inspiration, Innovation and Communication, David Harris/Anaya, London, 1991

Books of Hours and their Owners, John Hartham/Thames and Hudson, 1977

Lettering Old and New, Translated by Dr. W.E. Walz/Batsford, London, c.1930

Ornamental Alphabets and Initials, Alison Harding/Thames and Hudson, 1983

Celtic Knotwork, Iain Bain/Constable, London, 1986

Index

Adam and Eve. 67

Alcuin of York, 9, 38 Anglo-Saxon minuscules, history and development, 9 Arabic numerals, 107, 112 arch, letter anatomy, 6 Arch of Constantine, 109 Artificial Uncial: history and development, 24-5 practical, 26-7 Arts and Crafts movement, 42, 95 ascender: letter anatomy, 6 height, 7 ascender line, letter anatomy, 6 Aubert, David, 71 Augustine, St., 24

В

baseline, letter anatomy, 6 Bastard Capitals, practical, 78–9 bastard scripts, 10, 11 Bastard Secretary: history and development, 13, 66-7 practical, 68-9 Bâtarde, 7, 11 history and development, 13, 70-1 practical, 72-3 Bede, Venerable, 34 Beneventan Minuscule, history and development, 9, 12, 84 Bentivoglio, Giovanni II, 90 Bernard, St., 47 Berry, Duc de, 81 Bickham, George, 102-3 Black Letter see Textura Quadrata, Textura Prescisus Bobbio, 9 body height, letter anatomy, 6 Bonaventura, St., 66 Book of Durrow, 30 Book of Hours, 70, 84, 90 Book of Kells, 29-31 bow, letter anatomy, 6 bowl, letter anatomy, 6 bracketed serif, letter anatomy,

British calligraphic revival,

history and development, 12

Brown, Denis, 11, 31 brushes, 14

Cadeaux see Cadels Cadels, 59, 94 history and development, 81 practical, 82-3 Cambrensis, Giraldus, 31 Cancellaresca Corsiva see Italic capital letter, letter anatomy, 6 capital line, letter anatomy, 6 Capitalis Monumentalis see Imperial Capitals Capitalis Quadrata see Square Capitals Caroline Minuscule, 16, 35, 84, Early Gothic and, 46, 47 history and development, 9, 12, 38-9 practical, 7, 40-1 Carstairs, Joseph, 106 Catich, E.M., 109, 112 Chancery, 66 Chancery Cursive see Italic Charlemagne, Emperor, 9, 38 Chichester Cathedral, 51 Cîteaux, 47 Cockerell, Sidney, 43 Codex Amiatinus, 24, 25 Codex Vaticanus 3256, 20-1 Coefrid, Abbot, 24 Columba, St., 34 "Command of hand," 103 Copperplate, 10 history and development, 11, 13, 102-3 practical, 104-5 Copperplate Capitals, practical, 106-7 Corbie, 9 counter, letter anatomy, 6 cross stroke, letter anatomy, 6 crossbar, letter anatomy, 6 Cultural Decomposition, 31 Cursive Half Uncial, history and development, 12 curved stroke, letter anatomy, 6

D

Dadd, Richard, 102 descender, letter anatomy, 6 descender line, letter anatomy, 6 detachable nibs, 14, 15 development of Western script,

8-13 diamond, letter anatomy, 6 Dürer, Albrecht, 75, 108 Durham Gospels, 30

E

Eadfrith, Bishop, 30 ear, letter anatomy, 6 Early Gothic: history and development, 9, 12, 46-7practical, 48-9 Echternach Gospels, 30 English Bastard Secretary see Bastard Secretary English Caroline Minuscule, 42 Etruscan alphabet, 8 Exeter Book, 35

F

felt-tipped pens, 14

Flamel, Jean, 81 flourish, letter anatomy, 6 foot, letter anatomy, 6 Foundational Hand: history and development, 42 - 3practical, 44-5 fountain pens, 14 Fraktur, 67 history and development, 13, 74 - 5practical, 76-7 Franciscus, Ricardus, 81 Froissart, Jean, 71 Froissart Chronicle, 70-1

G

Gellone Sacramentary, 63 German calligraphic revival, history and development, 13 German Letter see Fraktur Gill, Eric, 43 Gothic Capitals, 10 history and development, 58-9 practical, 60-1 Gothic scripts, history and development, 9, 10 Grandval Bible, 38-9 Greek scripts, 8 Greek Uncial, history and development, 12 Griffo, Francesco, 91, 95

H

Haanes, Christopher, 95 hackle, letter anatomy, 6 Hagen, Johannes von, 74 hairline, letter anatomy, 6 hairline tail, letter anatomy, 6 Half Uncial: and the Caroline Minuscule. 38-39, 40 history and development, 8, 9, 12 Halliday, Peter, 17 handmade papers, 14, 47 Harris, David, 103 headline, letter anatomy, 6 Henry of Blois, Bishop, 46 Henry VIII, King of England, 51 hierarchy of scripts, 16 Historia Ecclesiastica, 35 horizontal foot, letter anatomy, 6 Humanist Capitals, 91 practical, 98-9 Humanist Minuscule, 50, 94 history and development, 11, 13, 90-1 practical, 92-3

Imperial Capitals, 7, 16, 90 brush strokes, 110-11 construction, 112-19 history and development, 8, 13, 108-9 In Proverbia Salamonis, 34 innerletter space, letter anatomy, 6 Insular Display Capitals, history and development, 13 Insular Majuscule: history and development, 12, 29 - 31practical, 32-3 Insular Minuscule: history and development, 9, 12, 34–5 practical, 36–7 insular scripts, 9 interlaced patterning, 81 interletter space, letter anatomy, 6 interlinear space, letter anatomy, Iona, 34 Irish scripts, 9 Italic: history and development, 13, 94 - 5

tottula

A lottula Timples

Jonk willighe behegtvelichert vlitlich touoring Alfei leutste ...

god here vinde here ver bidden iste vinde ermanen im dusser ...

vardighen strifft dat gr den be ghonden krich willen aff laten
the willen willen den gr an inhe hauen bebben nivt heren :b

wille vir of twene fesen de twissen unven graden vinde sprice

vit to bedeutstren ein middel moge rinden die schal grant at

emquadratus Somequadratus.

hm muoraum eraidhut me deus ulhac mer in tabala aone dilatalh anda linter a a crandroranonen meam

Rottila Rottila frattumeum

ebern un leutre geneichert Belleibleter beliegkelichert :

chieren touvound theuen beren vielle Mit fundemin frank

ich dat genbereiten der abaren naden sonn abe
fein moghen wilde der abaren naden sonn dahe
fein moghen wilde der abaren naden sonn dahen

igher fecten dur bot de gegebe gegert zu benanne

et deus som magnam insserterediam trans dem multitudiner intention traum dele inquitatem meam Anne de laua me ab instruction meam et pearatio meo munde me la juoniam insquitatem meam et pearation meum contra ne el semper Rubi soli pearatio et oram te sen uti inspicarie in semombus trus el vintas aum indicam tragalitatibus conceptus sum em em pearatis con un me

Erba mea aunbus percepe domine inti lige damoien meu Intmit von dianoms mer:

erra Arabahisa dar hine Arabairo

Homla noun

nlen lutteren grot mit vlitlike; behegelishen alle tid touerin hocheborne vortre here muke here wir biden indee hoshmeshtighen eddelichert vlitlichen in diffeme seghenebardigh breue dat gr wo mirt millen laten van dime lande dat gr an ghenemen hebben v heren ill. Dat wir mit insbest eddelichert midst dat dar vomme domen vindet dat dar vomme domen vindet dat dar vomme mit molbedathtem verhte vom to rade fuit ge worden vinde befunden mit molbedathtem verhte digthen mide vinder oldesten alle de serbe vonter lantbesten vindes sichten state und dat un midst and

Texter Botan Sag

nar hemucuut gaues et popi inges tent 3 principes conneneur inges tent 3 principes conneneur inges tent 3 principes conneneur

Torustess

In ratmanne unde gibt liveren der sicht in bedernverder Bekennen openbaielt in dussenne beine vor alle den de en sein leinen edder selen Datt ich ingher dusse beweis einer wome dutsene elderen bir und selft gibt hat. Went die elderen einen pie bo is Dit bestenne im dar de vorghenante icht van ih in mid sine elderen einen und vormelicht unde eldanne ib die matte elden vinde mehr van an ander weiten women alle gibt diede in alle eldane vinden bedernen Beite gheilte und weitlich auch de diene vorghenant ich wan ih gundt guden willen willen midten den Late e dine vorghenant ich wan ih gundt guden willen benden unde ome behulpen im eder war he on be gherende ist to linem gibt schiche Dat mille im gheine urzhen an un din oven millichlich vordinen Wor sie tat giebot an epine gibt ikken edit se edder an epine giveteen Des iv epines behautinste hebbe wir willer stad in gibt.

Rottula adauata

nom vrimitiken grimmer fal Seffe breff zeetera? Onfen bekegbeliken trinnen millen in reihten vlite tomorin lene bere ber vinde unfe egkentlike grunner vno onde den dufen to duffer ind sunderlike minnentlike vroorde vno ent fran ift ont dat my h

practical, 96–7 Italic Capitals, practical, 98–9 Italic Swash Capitals, practical, 100–1

Jarrow, 25, 29 Jenson, Nicholas, 38, 90 Jerome, St., 24, 31 Johnson, Edward, 11, 42–5, 95

K

Kane Medieval Manuscript, 66 Kippax, W., 103 Koch, Rudolf, 11, 74–5

L

Larisch, Rudolf von, 11 Late Caroline see Early Gothic Late Uncial, 25 left-handed calligraphy, 7 Lethaby, W.R., 42 letter height, letter anatomy, 7 letterpress printing, 103 Lettre Bourguignonne see Bâtarde Lewis, James, 106 ligature, letter anatomy, 6 Lindisfarne, 29-31, 34 Lindisfarne Gospels, 29-31 link, letter anatomy, 6 Littera Antiqua see Humanist Minuscule

Littera di Breva see Italic

Littera Uncialis see Uncial
Lombardic Capitals, 88
history and development,
13, 62–3
practical, 64–5
Lowe, Nicholas, 66
lower counter, letter anatomy, 6
lowercase letter, letter anatomy,
6
Luttrell Psalter, 55
Luxeuil, 9
Luxeuil Minuscule, history

M

and development, 12

Macrobius, Ambrosius Theodosius, 95 majuscule, letter anatomy, 6 manipulated strokes, 111 manuscript sources, 7 Manutius, Aldus, 95 Matthäus Evangelium, 75 Maximilian, Emperor, 75 Meditations on the Life of Christ, 66 Mercian prayer book, 34 Merovingian script, 9 Metz Pontifical, 50 minim height, letter anatomy, 6 Minuscules: letter anatomy, 6 development, 8 origin, 24 Moralia in Job. 47 Moro, Francesco, 94 Morris, William, 43, 95

N

Neudörffer, Johann the Elder, 74, 75 New Roman Cursive, history and development, 12 nibs, 14–15 Niccoli, Niccolo, 94

\bigcirc

Old English see Textura Quadrata Old Roman Cursive, history and development, 12 Orgemont, Guillaume d', 51 Ormesby Psalter, 55

P

papers, 14 handmade, 47 Papyrus, 17 parchment, 7, 14, 20 Patrick, St., 29 pattern books, 59 pen angle, letter anatomy, 6, 7 pen width, letter anatomy, 6 Petrarch, Francesco, 90, 91 Philip the Good, Duke of Burgundy, 71 Phoenician scripts, 8 Phoenix, 11 Pliny, 10 Pointed Minuscule, 34 Poligny family, 70 Prescisus see Textura Prescisus printing, 103 Proto-Gothic see Early Gothic Pugin, A.W.N., 62

O

Quadrata see Textura Quadrata quill pens, 7, 14–15

R

Ramsey Psalter, 42-3

Ratdolt, Erhard, 85 reed pen, 14 Rochester Priory, 46 Roman Imperial Capital, 7 history and development, 8 Roman scripts, history and development, 8 Romanizing Uncial of the Canterbury Style, 25 Rotunda: history and development, 11, 12,84-5practical, 86-7 Rotunda Capitals, practical, Runic Capitals, history and development, 13 Rustic Capitals, 8 history and development, 13, 16 - 17practical, 18-19

S

St. Ambrose, De Misteriis I, 46 St. Paul's Epistle, 91 St. Vaast Bible, 59 San Sebastiano, Rome, 20 Saturnalia, 95 Schwabacher, 50, 67 history and development, Sherbourne, Bishop, 51 "slanted" pens, 15 sources, 7 spring-loaded pens, 14 Square Capitals: history and development, 8, 13.20 - 1practical, 22-3 stem, letter anatomy, 6 "straight" pens, 15 stroke sequence, 7 swash, letter anatomy, 6

Т

Tara brooch, 30 Textura Prescisus, 10, 50 history and development, 55 Textura Quadrata, 10, 94
Early Gothic and, 46, 47
history and development, 12, 50–1
practical, 52–3
tongue, letter anatomy, 6
tools, 7, 14–15
Trajan Column, 8, 108–9, 112
Treatise on Hawking, 94
Trewhiddle, 35
turned foot, letter anatomy, 6

U

Uncials:
history and development, 8,
9, 12, 24–5
practical, 26–7
The Universal Penman, 102–3
uppercase letter, letter anatomy,
6

V

Vaast, St., 59

Vatican Basilicanus, 38
Vaux, Samuel, 102
vellum, 7, 14
La Vengeance de la Mort Ihesa,
71
Verona Antiphoner, 84–5
Versals, history and
development, 58–9
Vespasian Psalter, 25
Via Appia Monument, 108
Virgil, 16, 21
Visigothic Minuscule, history
and development, 9, 12

W

waistline, letter anatomy, 6
Walpurgis Night, 102
Waters, Sheila, 39
Wearmouth, 25, 29
wedge serif, letter anatomy, 6
Weston, Thomas, 81
whetstones, 15
Winchester Bible, 46, 62
Windmill Psalter, 10, 55

X

x-height, letter anatomy, 6 x-line, letter anatomy, 6

Acknowledgments

PICTURE CREDITS

Every effort has been made to trace the copyright holders and we apologize in advance for any unintentional omissions. We would be pleased to insert the appropriate acknowledgment in any subsequent edition of this publication.

Key: t: top b: bottom c: center r: right l: left

Abbreviations:

AA: Ancient Art and Architecture Collection BL: By Permission of the British Library, London BN: © Cliché Bibliothèque Nationale de France, Paris BO: The Bodleian Library, Oxford IK: Ikona, Rome

VA: By Courtesy of the Board of Trustees of the Victoria and Albert Museum, London

Jacket: Calligraphy by Carol Kemp back jacket: tl: Add 4213 f 73, BL; lc: Worksheet, Author's own copy; tr: Harl 2904 f36, BL; rc (detail): Reid MS 64 f. 33, VA; b: Historia Ecclesiastica Genis Anglorum, COTT T1b CII f 5v, BL

Pages 2-3

p2: Reid MS. 64 f. 33, VA p3: Metz Pontifical, early 14th century, MS. 298.f.138v/Fitzwilliam Museum, University of Cambridge

Pages 4-5

pp4-5: Add 42130 201v (detail), BL

Pages 6-7: Introduction

p6: *tl:* Beatus of Liebana, Spain, c.1220, Scriptorium in the Tower of the Monastery of Tavara, The Pierpont Morgan Library, New York, M.429, f.183

Pages 8-11: The Development of Western Script

p8: r: Terracotta Marker, inscribed with Oscan script, Italy, The Trustees of the British Museum, London; b (detail): Inscription on the Base of the Colonna Traiana, Monti, Rome/IK p9: t: Charlemagne with Alcuin, Mary Evans Picture Library; b: Msc. Patr. 5 f.1v, Staatsbibliothek Bamberg p10: t (detail): M 102, f.1v-2, The Pierpont Morgan Library, New York; b: Frontispiece of translation of Pliny's Natural History, 1473, Biblioteca Medicea Laurenziana, Florence p11: t: Ms.Lat 9474, BN; b: Phoenix, Denis Brown, 1993

Pages 16-17: Rustic Capitals

pp16–17: tr, l (detail), b (detail): VAT 3867 f.3v, Vergilius Romanus Ecloga 11 & 4, Biblioteca Apostolica Vaticana/IK; c: Ms. Bodl. 218, fol.62r, BO p17: bc: Peter Halliday, Quotation from Virgil: Eclogue VII, 43 x 31.5 cm, 1983, black ink on cream paper, translation by the scribe

Pages 20-21: Square Capitals

p20: *tc:* The Parchment Maker, Dover Publications Inc., New York; *c:* Inscription at San Sebastiano/IK **pp20–21:** *b (detail):* Pontificia Commissione de Archeologia Sacra/IK **p21:** *t:* Pontificia Commissione de Archeologia Sacra/IK

Pages 24-25: Uncial & Artificial Uncial

p24: *r*: MS E Museo 100 f7v/BO; *b*: Ceolfrid Bible, AA **p25:** *t*, *b* (*detail*): COTT VESP A1 30v–31, BL

Pages 28-31: Insular Majuscule

p28: The Book of Kells MS 58 fol. 40v, The Board of Trinity College, Dublin **p29:** *br (detail):* The Book of Kells MS 58 fol. 179v, The Board of Trinity

College, Dublin **p30:** *tl:* Tara Brooch, National Museum of Ireland, Dublin; *b, tr (detail):* Lindisfarne Gospels f29 COTT Nero DIV f29, BL **p31:** *t:* MS COTT Nero DIV f5v, BL; *b: Cultural Decomposition*, Denis Brown, 1993

Pages 34-35: Insular Minuscule

p34: tr: Lindisfarne Priory, photo: Andy Williams; cr (detail): Bedes Commentary on the Book of Proverbs, MS 819 folio 29/BO; bcr, bcl (detail), b (detail): Royal 2 Axx f17 Prayer-book, English Mercian, BL p35: t (detail), tcl, bcl (detail): Historia Ecclesiastica Genis Anglorum COTT T1B C11 f5v, BL; bcr: The Spirit of Men 11.71— end, Widsith, 11.1—13 fol 84b, Reproduced by Permission of the Dean and Chapter of Exeter

Pages 38-39: Caroline Minuscule

p38: *b:* Arch. S. Pietro D182 fol. 159v, Bascicicanus D182 f 159v/Foto Biblioteca Vaticana/IK **p39:** *tl:* Sally-Anne Reason; *tr: Cloud Conceptions from Above*, 1st verse, Sheila Waters; *b:* Moatiev Grandval Bible ADD/MS 10546 f 25 B-26, BL

Pages 42-43: Foundational Hand

p42: br, l (detail): Harl 2904 201v, BL **p43:** tl: Worksheet, Author's own copy; tr: Photograph of Edward Johnston, Holburne Museum and Crafts Study Centre, Bath; b: Edward Johnston's Winchester Formal Writing Sheet C.778, Holburne Museum and Crafts Study Centre, Bath

Pages 46-47: Early Gothic

p46: c: Winchester Bible, AA; br: CO7 6Bv1, BL **p47:** bl: Moralia in Job, Lib XVII–XXXV, MS 173, fo 41, Bibliothèque Municipale de Dijon; tr: The Paper Maker, Dover Publications Inc., New York

Pages 50-51: Textura Quadrata

p50: *b:* Metz Pontifical, Early 14th century, MS 298 f138v/Fitzwilliam Museum, University of Cambridge **p51:** *t, l (detail):* Chichester Cathedral, Henry VIII (Bishop Sherbourne asking Henry VIII to confirm the charter for Chichester Cathedral), Fotomas Index; *b:* MS Rawl liturg.e. 40 fol 40v/BO

Pages 54-55: Textura Prescisus

p54: Judgement of Solomon, The Pierpont Morgan Library, New York, M.102, f.1v-2 **p55:** *cl* (*detail*): Add 42130 201v, BL; *c:* MS Douce 366 fol 154r/BO

Pages 58-59: Gothic Capitals & Versals

p58: MS 2981, Sets of Capitals, Magdalene College, Cambridge p59: tl: MS 55 G vol3 F52V, Bible of St. Vaast, Bibliothèque Municipale d'Arras; r (detail): MS 2981, Sets of Capitals, Magdalene College, Cambridge; bl: MS.83-1972 flr, Fitzwilliam Museum, University of Cambridge

Pages 62-63: Lombardic Capitals

p62: *b (detail):* Winchester Bible, Ezekiel, 12th century, AA **p63:** Latin 12048 f 1v, BN

Pages 66-67: Bastard Secretary

p66: ar: Kane Medieval MS 21 folio 6r, Grenville Kane Collection of Medieval Manuscripts, Manuscripts Division, Department of Rare Books and Special Collections, Princeton University Libraries; bl: E Mus 35 f 98/BO **p67:** English Genesis, MS Bodley 596 f2r/BO

Pages 70-71: Bâtarde

p70: b: MS Douce 267 f.36r/BO p71: t, c (detail): Jean Froissart's Chronicle, 14th century, BL; bl: Roy 16 GIII f8, BL

Pages 74-75: Fraktur & Schwabacher

p74: d (detail): MS Lat 2° f384 v, Berlin, Staatsbibliothek zu Berlin – Preußischer Kulturbesitz – Handschriftenabteilung pp74–75: b: MS 64/35v & 36r, Bayerische Staatsbibliothek, München p75: t, r (detail): Rudolf Koch, Gospel of St. Matthew, 1921, Offenbach/Klingspor-Museum der Stadt Offenbach am Main

Pages 80-81: Cadels

p80: D54/107 fr380 Page de Garde, BN **p81:** *l:* MS Ashmolean 789 fol. 4v/BO; *tr:* Initial Letter, Speedball Textbook 1952, Ross F. George; *br:* An example of fine initials from a book by Thomas Weston in 1682, Speedball Textbook 1952, Ross F. George

Pages 84-85: Rotunda

p84: *b*: MS.L.4929-1866 f.27r Verona Antiphoner, mid-15th century, VA **p85:** *t*: L.2384-1910 f.203r Epistle Book, Italian Book of Hours, VA; *b*: Sheet of printed Rotunda, Author's own copy

Pages 90-91: Humanist Minuscule

p90: *b:* Reid MS 64 VA **p91:** *t:* MS L1721-1921 f96v-97r, VA; *c:* MS 186 fol 21r, The Rector and Fellows of Exeter College, Oxford; *b:* Petrarch's Annotation, Author's own copy

Pages 94-95: Italic

p94: *b:* MS L1485-1946 Francesco Moro: Alphabet Page, VA **p95:** *tl:* Skrift Katalog, Christopher Haanes, Oslo; *tr (detail):* MS L1769-1952 f.113r, VA; *b:* Lat Class E38, William Morris manuscript, BO

Pages 102-103: Copperplate

p102: c, b: The Universal Penman, Dover Publications Inc., New York p103: t, cr: The Universal Penman, Dover Publications Inc., New York; d: Copperplate workshop, Fotomas Index; b: Copperplate typeface design, David Harris

Pages 108-109: Imperial Capitals

p108: t: Lettering from On the Just Shaping of Letters, Albrecht Dürer, Dover Publications Inc., New York; b, c (detail): Appian Way: Inscription, De Luca, Rome/IK p109: t: Inscription on the Base of Colonna Traiana, Monti, Rome/IK; b: The Arch of Constantine, De Luca, Rome/IK

Pages 124–127: Bibliography & Index

p124: *l (detail)*: MS 2981, Magdalene College, Cambridge p126: MS Lat 2° f384 v, Berlin, Staatsbibliothek zu Berlin – Preußischer Kulturbesitz – Handschriftenabteilung

Special photography:

Michael Dunning: **p6:** tr Peter Hayman: **p17:** br

Author's acknowledgments:

To my wife Nancy who untiringly typed and corrected my manuscript pages. To Miss Pemberton and the staff of the Bodleian Library for their kind help beyond the call of duty, and to Liz Brown and Louise Candlish of Dorling Kindersley who stopped me straying too far from the chosen path. And finally to family and friends who have also suffered a little with me over the last years.

Dorling Kindersley would like to thank:

Janos Marffy and Sally-Anne Reason for their artworks; Richard Bird for the index; Jane Carter, Stephen Croucher, and Mark Johnson Davies for design assistance; Lol Henderson and Helen Castle for editorial assistance; Jo, Simon, Liz, and Louise for their hands; and Morag Hislop for all her help.